WET FELTING

creating texture, pattern and structure

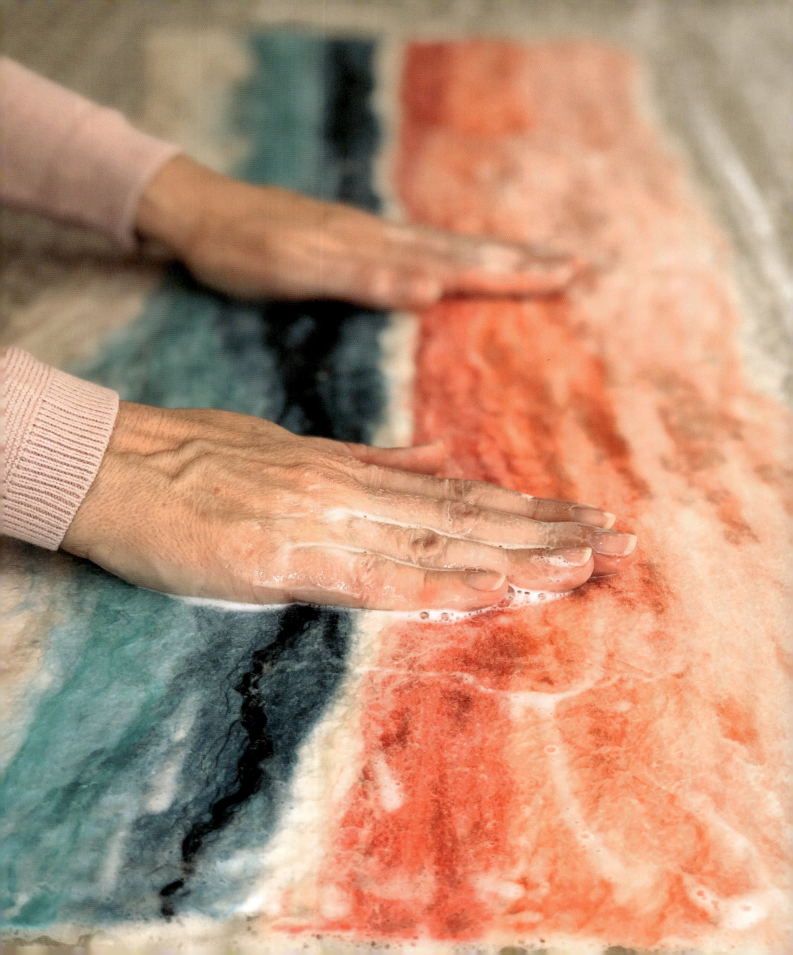

Natasha Smart

WET FELTING

creating texture, pattern and structure

THE CROWOOD PRESS

First published in 2022 by
The Crowood Press Ltd
Ramsbury, Marlborough
Wiltshire SN8 2HR

enquiries@crowood.com
www.crowood.com

This impression 2023

© Natasha Smart 2022

All rights reserved. No part of this publication may be reproduced or transmitted in any form or by any means, electronic or mechanical, including photocopy, recording, or any information storage and retrieval system, without permission in writing from the publishers.

British Library Cataloguing-in-Publication Data
A catalogue record for this book is available from the British Library.

ISBN 978 0 7198 4039 5

Cover design: Sergey Tsvetkov

Graphic design and typeset by Peggy & Co. Design
Printed and bound in India by Parksons Graphics

CONTENTS

	Introduction	7
	Acknowledgements	9
1	Materials and Equipment	11
2	Getting Started	27
3	2D/Flat Wet Felting	45
4	3D Wet Felting (with Flat Resists)	75
5	3D Wet Felting (with 3D-Shaped Resists)	111
6	Developing Your Work	143
7	FAQs/Troubleshooting	149
8	Template and Tables	153
	Glossary	155
	Useful Resources	156
	Main Project Guide	158
	Index	160

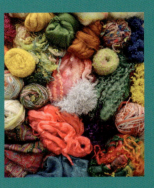

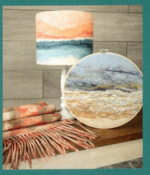
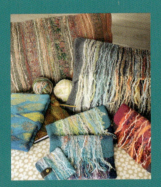
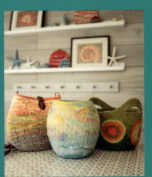
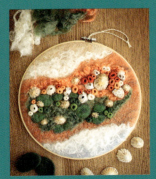
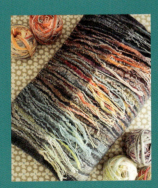

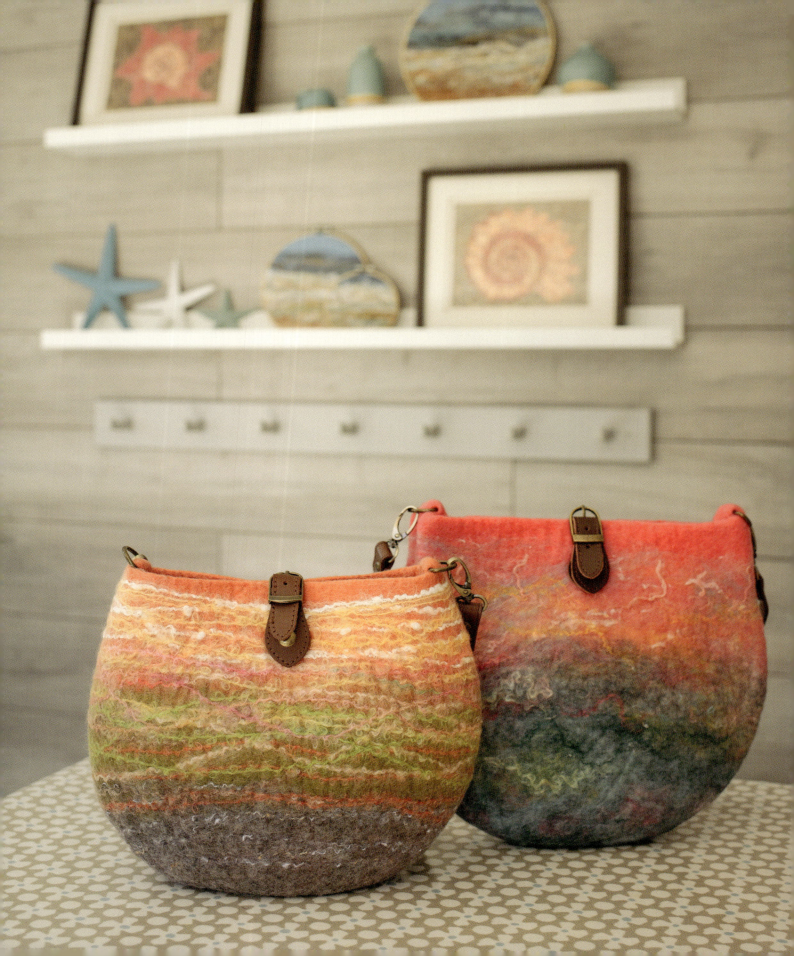

INTRODUCTION

Welcome and thank you so much for picking up this book and joining me in my feltmaking world! My aim is to introduce you to the magic of wet felting with wool fibre and the amazing variety of things you can achieve with it: from a decorative piece of flat fabric to seamless, shaped, three-dimensional forms which hold their structure (like a bag or bowl), all with incredible texture and pattern.

This book is all about encouraging you to experiment and play with wool fibres by following the techniques shown to create successful felt in all its structural forms (by which I mean two-dimensional flat felting, three-dimensional flat felting and fully three-dimensional shaped forms). By including lots of examples and step-by-step demonstrations, I'm aiming to give you the confidence to both practise the techniques and then adapt them, enabling you to follow your inspiration in making your own wet felted creations. I've also included a variety of embellishment fibres, which you might have heard of but never tried and weren't sure how to use, or perhaps have never even heard or thought of, but which you can use to create wonderfully textured and patterned surface designs.

There's a progression in the order of the three project chapters, as well as the nine main projects, starting with smaller and simpler project makes and building up to bigger and more complicated versions using the same or similar techniques. I recommend reading the whole book, or at least the whole chapter, before starting on one of the projects so you get an understanding of the progression element and don't miss tips in the earlier projects when completing the next one. I've also included at least one variation at the end of each main project, which might show you a slightly different version of the main project to try or it might highlight a new technique to inspire you in a different direction. You'll also see similar techniques or embellishments appearing and being reused throughout the main projects and their variations, to illustrate that you can mix and match the projects and their decoration to achieve different effects.

One of the key things I've learned during my time as a felter over the last fifteen years is that there isn't just one way to create a particular piece of felt, there are many ways! Every felter has their own set of tried and trusted techniques and preferred way of working. There are a few hard and fast rules in wet felting, such as you need to apply water and friction to wool fibre to make the felting process work at all (with soap in particular being invaluable to making the process work better). Also, there are two distinct stages of the wet felting process: the **felting** stage, where the fibres start to bond together to create a very loose fabric (called **prefelt**, sometimes spelt pre-felt); and the **fulling** stage, where the fibres bond completely and contract to create a firm fabric. Neither of those stages can be rushed; they happen when the fibre is ready! But there are lots of ways of achieving those processes, along with many other variables to consider, like the different shrinkage rates of different wool fibres, which might also affect your choice of technique. So it's important to have a good armoury of techniques you can deploy in different felting scenarios, which is what I'm hoping you'll find in this book. This will then help you

to go on to develop your own projects, so that you can tackle anything, or, if things don't seem to be working, you have a variety of techniques to deploy to help get things back on track.

So, my recommended approach to this book, if you're already an experienced felter, is that the projects and materials will inspire you or perhaps get your brain ticking in another direction about an idea you'd like to test out. The way I do things might encourage you to try a completely different technique or embellishment material. But don't feel that you need to slavishly follow my method of working. If you prefer working on a sheet of plastic to bubble wrap, then use plastic; if you like to use an electric sander rather than a rubbing tool, use a sander. Just adapt my methods of achieving the project to suit yourself.

On the other hand, if you're new to felting, and not sure where to start, then the main projects will give you a tried and tested recipe that has worked for me (as well as students on my courses). Just follow the step-by-step instructions shown, as these should ensure pretty successful results and help you grow your confidence as to what's possible. I'd also encourage you to take courses, watch videos and read other books to broaden your all-round experience of felting techniques. I hope there's something for everyone here.

Wet felting is a fantastic art form, offering lots of opportunities for genuine creativity and innovation. I'm conscious that what I'm sharing in this book is just a fraction of what felting can do, but I hope you find it useful and inspiring, nonetheless. Above all, please enjoy your own felting journey (I'm still on mine), keep experimenting and have fun!

METRIC OR IMPERIAL?

I've included measurements in both metric and imperial throughout the book. Please note, however, that the projects were all created using metric forms, so I've rounded the imperial versions up or down (depending on what was being measured and how precise it needs to be). For greater accuracy in using the imperial forms, you might like to double check any measurements using the conversion table at the back of the book (these have also been rounded up or down but are much more accurate).

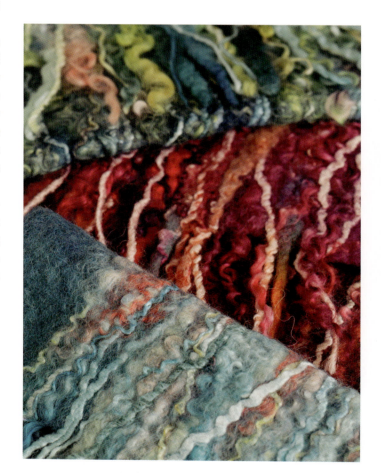

ACKNOWLEDGEMENTS

This book is dedicated to my fabulous creative friends and supportive family, who have all encouraged my feltmaking endeavours over the years, especially my parents, who have provided unwavering and much-appreciated encouragement for whatever I've been doing. And very special love and thanks to my husband Steve, who continues to be my biggest supporter, has always been an essential sounding-board with sensible advice and who has been stalwart in the face of living on the front line with me for the past year whilst I've been writing this book – I've really appreciated your help so much and I couldn't have done any of this without you. (My adored cats have been no assistance whatsoever, but I feel they deserve a mention too.)

Big thanks to talented photographer Ellie Burgin, who has provided the majority of the photographs in this book (except the main project step photos, taken by the author).
Ellie Burgin Photography, Instagram @ellieburgin2.0

I must also give a big credit to US feltmaker Ruth Walker, who taught me the original 'felting on a ball' technique (developed first as a 'hat on a ball' by feltmaker Beth Beede in 1975) and who so generously shared her knowledge some years ago on an International Feltmakers Association workshop I attended. Thanks also to all the feltmakers whose courses I've attended (including Leiko Uchiyama), online tutorials I've watched or books I've read, which have all contributed to my own journey as a feltmaker.
Ruth Walker, Feltmaker, Facebook @RuthWalkerFeltmaker
Leiko Uchiyama, www.leikofelt.com

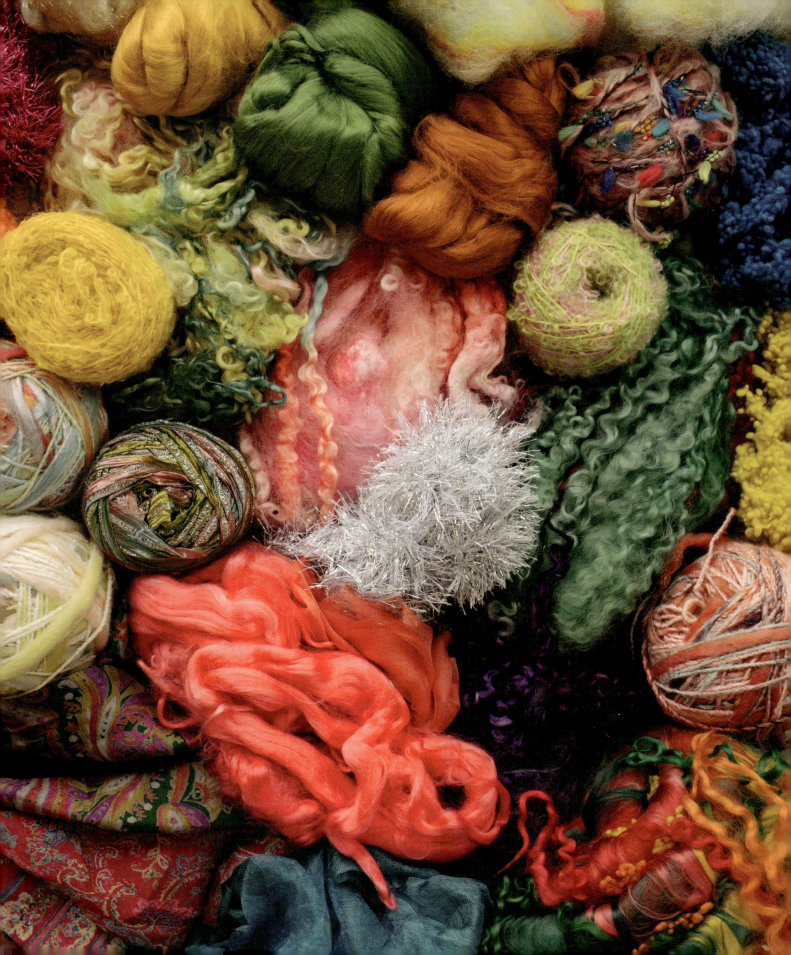

CHAPTER 1

MATERIALS AND EQUIPMENT

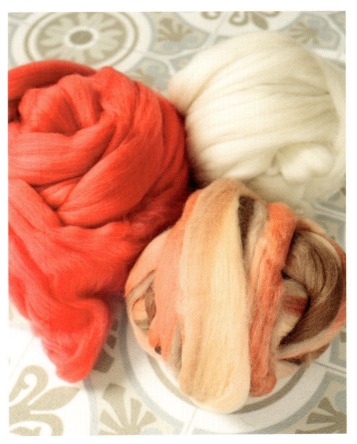

Merino wool tops in plain and variegated colours.

Wool fibre is obviously the core component required for felting, so let's look at that first. Many animal fibres will felt (that's a whole new area of feltmaking to explore!), but for the purpose of this book I've restricted our scope to sheep's wool fibre, and specifically those that are most commonly available and can be found in the widest range of colours (both natural/undyed and dyed).

WOOL FIBRE

Merino Wool Fibre/Wool Tops (Roving)

Even if you're new to feltmaking you've probably heard of Merino wool fibre, which is probably the most popular fibre for wet felters and is where most beginners start. From the Merino sheep breed, it's a fine and soft fibre which felts easily, comes in a huge range of colours and can easily be found worldwide. It is usually manufactured in the form of **tops** (or **roving**). This is where, at the end stage of the processing of the wool, it is combed into long straight ropes of fibre, with all the individual fibres stretched to smooth them out and laid in the same direction. This makes it very easy to work with. Merino is a fine fibre which particularly lends itself to felting anything which will lie next to your skin, needs to be thin or needs to drape well, so is often used for clothing or scarves.

Merino wool fibre is almost synonymous with wool tops, although you can find other wool fibre in tops or roving form (and increasingly so, as wool fibre prepared for felting and spinning becomes more readily available from suppliers). I've mostly found other breeds of wool fibre in tops form from smaller-scale independent hand-dyers, or in a more limited colour range from bigger suppliers, so Merino is definitely your best option if you're looking for a fibre in tops form that gives reliable results and has a vast choice of colours. You can also find Merino in carded batt form (*see* below), but less commonly and not in the extensive range of colours found in tops.

Carded Wool Batt Fibre (Carded Fleece)

The other main format you'll find wool fibre in is **batt** form (or **carded fleece**), which is a stage before tops in the wool processing, when the fibres have been carded into sheets and are lying in all directions rather than being combed into one direction like tops. Batts can be peeled and torn apart to use and can be quicker to work with than tops because the fibres are already intermingled so you don't have to be as precise with the layout. Batts are commonly used for wool breeds other than Merino, so as a general guide they are likely to consist of a coarser fibre and be used for a more hardwearing end result like a bag or slippers.

Sheets of wool batt fibres: Finnwool (blues) and Maori (pink).

How to Compare Wool Fibre

Wool is measured and graded by the thickness of each individual fibre using **microns**: one micron = one millionth of a metre (or one thousandth of a millimetre). The smaller or lower the micron count, the finer the fibre. This is the most consistent method of measurement used worldwide, which enables you to compare fibres from different breeds and different suppliers.

Other terminology is also used, such as descriptive terms (like fine or coarse, although there is no industry standard for this), staple length (the length of a wool lock), lustre (sheen) or crimp (natural waviness) to give you an idea of what the fibre is like. There is also a more traditional way of measuring and referring to the thickness of each fibre called the **Bradford count**, which is based on the number of 560-yard hanks that can theoretically be spun from one pound of wool roving. The higher the number, the more hanks can be spun per pound and therefore the thinner the fibres. You'll see this reference still used, in particular when buying Merino wool tops, where you'll commonly see 64s (23 mic, fine) and 66s (22 mic, fine), but they do go up to the 100s (18.5 mic and lower, super fine and ultra fine).

As a very brief guide, here are some commonly available wool fibre breeds, including those used in this book, and their approximate measurements/qualities (but note that these can vary even within the same breed). These all offer good dyed colour ranges, but you will find lots more details online and from supplier websites:

Breed (Supplier)	Microns	Terminology
Merino	14.5–19	Ultra fine/Super or Extra fine
Merino	20–25	Fine
MC-1 (Living Felt)	25	Medium–Fine
Maori (DHG)	27	Medium–Fine
Finnwool (Piiku)	26	Medium-Fine
Bergschaf	30–36	Medium-Coarse
Norwegian	33–36	Medium–Coarse

Working with Wool Fibre

It's worth making the point here that you can felt any project with any wool fibre, they will all work! However, part of the art of feltmaking is using the right fibre for the right job. So, you are less likely to want to make a scarf to go around your neck with a very coarse fibre, which isn't going to drape as well or feel as soft against your skin. And you probably won't use a

very fine fibre to make a pair of slippers, which really need to be made of something a bit coarser and more hard-wearing. Those are obvious examples. But for everything in between (for example, the Fringed Clutch Purse Project in Chapter 4), it really doesn't make much difference what you use. Often your choice will be dictated by what you've got available to you and what colours you want to use. It's worth experimenting with different fibres to see which you like best and then building up your colour stash. For instance, I've got a vast range of Merino tops (fine and extra fine) and Finnwool batts, which is why you'll mostly be seeing those appear in the projects. But if you've mainly got a collection of a different batt fibre you prefer to use, feel free to use that instead (it shouldn't make much difference in terms of finished sizes, though you'll want to test this for any of the projects with very specific end sizes).

SURFACE DESIGN EMBELLISHMENTS

Now that we've considered our options for wool fibre to create our felt, we might want to think about decorating the felt. We might do this by creating patterns simply using different colours of the wool fibre (there are also lovely, variegated mixes available from suppliers). But there is a whole world of different materials out there that can be combined with the wool fibre during the wet felting process to create incredible patterns and textures. These materials do not just sit on the surface of the felt (although we'll also consider the additional surface design techniques we can apply to finished felt in Chapter 6), they combine with it and sink in to become an integral part of the final felt. Let's look at some of the embellishment materials on offer, starting with other wool products.

Prefelt

Prefelt (or **pre-felt**) is a sheet of wool felt which has been only partly felted. The fibres have started to bond together, but the fulling/shrinking stage has not yet happened, so it is still quite soft and delicate. You can buy ready-made prefelt (which has been needle-punched together and is relatively firm) or make your own (by following the felting process and stopping midway through once the fibres have started to bond – *see* Chapter 2 for the exact process). You can also create prefelt with any surface embellishment layer on top, for example a nuno or viscose prefelt.

A sheet of commercial needle-punched Finnwool prefelt.

So why would you want to do this? The main advantage of creating designs and patterns with prefelt is in order to create a more definite shape or design on your felt. If you lay out your wool fibre background and then add wisps of different wool viscose or fibre colours on top in a design and then apply the whole felting process, you'll find that the design will shift, blur and become smudgier, and the colours will lose their purity as they bond with the background fibre colours. So one way of creating more definite shapes with defined edges and purer colours in your surface design is to use prefelt, which you can make in advance, dry and then use to cut out shapes. You would add your prefelt pieces as a surface design to a new fibre background and then follow the felting process to integrate them. Because the prefelt has already been through the felting process a bit, and as you've cut the fibres, they all mingle less with their neighbours (but still enough to felt with the background). This gives you more control and precision when creating a design, and results in more definition and truer colours in the finished design on the felt. *See* the Journal Cover Projects in Chapter 4 for examples using viscose prefelt.

Another way of working with prefelt is to use it as a base/background layer (instead of laying out fibre) and then create your design layer on top. This can save you time (by not having to lay out the fibres), especially with a large layout, and can be useful if you struggle with your hands as it makes the whole layout process a bit easier. It can also be helpful if you want to create a very even end result (especially if you use commercial prefelt).

You can also create added texture with prefelt, for example if you cut out shapes from very thick pieces (or layer up two or three shapes) and then cover them with further wool fibre or other embellishments (*see* the Hoop Art Variation Project for an example of this in Chapter 3). Although prefelt should ideally have not yet gone through the fulling/shrinking stage, if you overfelt it you can help it felt to a new fibre background by roughing up the reverse to help the fibres bond with the fibres beneath it. There is also no fixed rule for making prefelt, just rubbing it might give you the loose prefelt you want, or you might rub it and go through a whole rolling process too, which would give you a firmer prefelt. The more felted the prefelt, the more defined the shapes you can create with it when combined with new fibre (but beware that it might be slightly more difficult to felt to the new fibre).

Curly Wool Locks

Many sheep breeds produce long **curly locks** (popular ones include Wensleydale, Teeswater and Masham), which are often hand-dyed and are perfect to use as embellishments in wet felting. They aren't heavily processed, so they retain their curly, ringlet-like shape, even after felting, and are an excellent way of creating texture and interest. And because they are a wool product, they felt in easily with other wool fibre. You can either lay the locks directly onto your wool fibre layout and felt them in, or a popular method is to use them as a fringe or edging by just laying the thicker 'root' end of the lock into the edge of the fibre layout and leaving the tip end of the lock unfelted and free to hang off the edge.

You can find other similar locks like **mohair** (from the hair of angora goats) which also work well in felting.

Wool Yarns

I'm a big fan of using **wool yarns** in wet felting to build up patterns, and you can add a lot of textural interest by also using a variety of yarn types in addition to a standard smooth knitting yarn: **mohair** (which is hairy), **mohair bouclé** (which has loops), **slub** or **thick and thin yarns** (which have thinner and thicker parts), and **art yarns** (which are often hand-spun and might have multiple strands and added slubs and fibres). As a general rule, the more hairy, multi-stranded or loose a yarn is, the easier it felts (the same goes for non-wool yarns). However, you'll see I've also used a standard smooth wool yarn for the crochet design in the Yarn Basket Project in Chapter 5. As long as the yarns have high natural wool content you can just lay them on top of your wool fibre background and they'll felt in quite happily (but watch out for wool yarns labelled as superwash as these have been chemically treated to avoid shrinkage).

Examples of hand-dyed long curly wool locks.

A selection of thin, thick, slubby and bouclé mohair yarns.

A range of dyed Finnwool pencil rovings (unspun pre-yarn).

Chapter 1 – Materials and Equipment

Pencil Roving

Pencil roving is a single, pencil-thickness length of wool fibre that has not yet been spun to create yarn, so is classed as a pre-yarn. It's still very delicate (although thicknesses vary), but can be used in felting to create lines and patterns just by laying it on top of a fibre background. You can also (but very carefully because it can break apart so easily) knit/crochet/weave a complete textile piece from it before felting.

Wool Nepps

Wool nepps are tiny balls of felted fibres which are by-products of commercial wool processing and can be found in a range of dyed colours. They are great for adding texture and pattern to wet felting projects, particularly if you're aiming for realistic landscape designs because adding their little dots of colours can give an impression of natural elements like flowers in fields. They can be difficult to felt in because they are already felted, but the trick is to add some wisps of wool fibre on top to anchor them in and be very gentle with them in the early stages of the felting process.

Art Batts

Art batts are beautiful sheets of different colours of wool fibres which have been carded together, often with additional embellishment fibres mixed in, and then rolled into a bundle. You can make them yourself or you'll often find them at textile craft shows being sold by small-scale producers. They're mini works of art in themselves, which are used by spinners and felters to create their own work. As they're handmade, usually with a drum carder, the batts won't be as uniform as commercial wool batts, but you can still peel them apart in the same way and just add them on top of your main fibre background as a surface design (and a little goes a long way).

Protein Fibres

Protein fibres are those that originate from animals, such as wool and mohair. **Silk fibres** are also a popular animal fibre to use in wet felting. They're easy to combine with wool fibre (just lay them on top and the wool fibres will happily grab hold of and bond to them) and they provide beautiful sheen and organic patterns (and, again, a little goes a long way). There is a large

Close-up of dyed wool nepps.

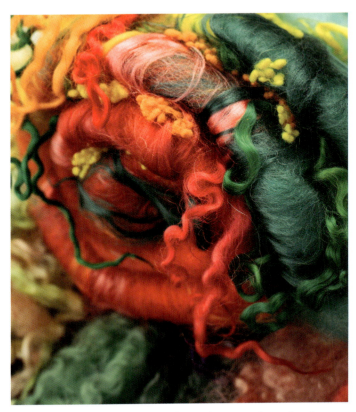

Art batt with Teeswater curly wool locks, wool nepps and seacell and silk fibres.

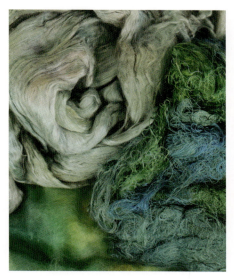
Examples of hand-dyed silk fibres: Mulberry silk tops (light sea green), silk throwsters waste (bright green and blue) and a silk hankie (green and yellow).

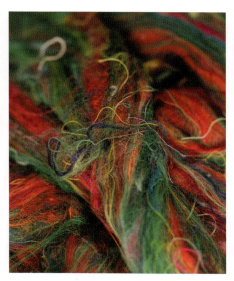
Colourful sari silk tops.

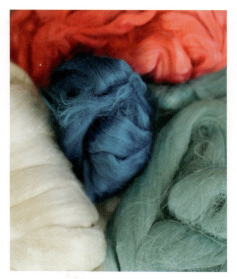
Plant fibre tops: viscose (cobalt blue), bamboo (pink), linen/flax (light turquoise) and mint (white).

variety of silk fibres available in slightly different forms, such as **dyed Mulberry silk tops or roving** (long fibres combed into lengths), **silk hankies** (squares of silk made from spread-out cocoons), **silk throwsters waste** (recycled silk waste threads), **sari silk tops** (recycled sari silk waste threads), **silk laps** (which come in sheets like batts), and **silk noil** (silk waste made from short fibres, so more slubby with less sheen).

There are also newer protein fibres such as **milk protein fibre**, which is generally found undyed, but will add a similar organic sheen to the felted surface.

Plant Fibres

There is a vast (and ever-increasing) array of plant fibres on the market, from the most popular ones like **viscose** (made from cellulose/wood pulp), **bamboo** and **ramie** (nettle), which are available in an extensive range of colours, to more obscure ones like **seacell** (seaweed), **mint** and **pineapple**, which are mainly found just in white or natural. They all function in a similar way to silk fibres: you just add wisps of them on top of your wool fibre, which happily bonds with them, and they provide a lovely sheen and organic pattern to the finished felt. They also mainly come in combed tops or roving form and are very silky and shiny. It is often difficult to tell the difference between them because they are so similar in appearance and function.

A plant fibre which looks quite different to most of the above is **flax** or **linen fibre**, which has a more hairy and less smooth appearance with less of a sheen, so gives quite a different finished result.

Synthetic Fibres

There are lots of glittery and shiny synthetic fibres that you can add to your felting, such as **Angelina**, **Stellina** (polyester and nylon) and **Trilobal** (nylon). You can lay them on top of your wool fibre with wisps of fibre on top to sandwich them in, or a more effective way to help them felt in is to card them in with your fibre so that they are more integrated with it already. You'll often find sparkly fibres included in this way in art batts, and you can also buy manufactured blends like Merino tops with glittery fibres already mixed in.

Synthetic Yarns

Although wool yarns are ideal for embellishing felt as they bond with the wool fibre so easily, there are obviously lots of other yarns out there with interesting colours and textures that aren't made of wool, but which give unique effects. These include **novelty yarns**, **yarns made of acrylic, polyester and nylon**, **metallic yarns** (like eyelash tinsel) and even **superwash yarns**. The golden rule here is that if you know you are dealing with a synthetic yarn or are in any doubt about the wool

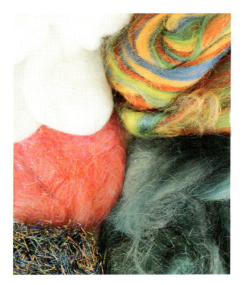 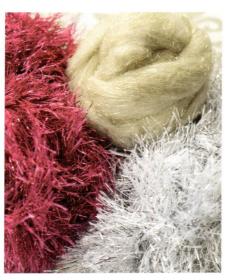 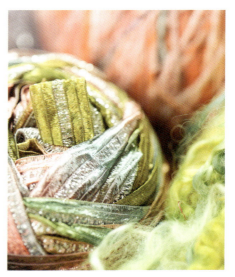

Synthetic fibres: trilobal (white, rainbow and teal green), and Angelina (peacock and pink).

Eyelash tinsel yarns (pink and silver) and Merino tops blend with gold Stellina.

Metallic sari ribbon yarn with visible weave holes.

content, then you need to add some wisps of fibre on top to sandwich the yarns between the top wisps and the full fibre background layer below, to lock them in place. You don't need much fibre on top, so you don't need to completely cover the yarns, just a very fine layer of wisps is enough to bond with the main layer of fibre.

It's a good idea to test out whether your non-wool yarns will felt, not least as some of them might felt in quite easily. As with wool yarns, the more hairy, multi-stranded or loose a yarn is, the greater chance it has of felting, so some synthetic yarns might surprise you. Also look out for synthetic yarns with visible holes or weaves, such as **metallic ladder yarns** and **sari ribbon yarns**, which felt in easily as the fibres can migrate through the holes.

Fabric/Nuno Felting

Nuno felting (*nuno* is the Japanese word for cloth), invented by felter Polly Stirling, involves felting wool fibre into cloth to create a new combined and completely integrated fabric, also known as **laminated felt**. For the process to work effectively, the cloth should ideally have an open weave structure, which enables the wool fibres to migrate through the holes and bond fully with it. Once bonded, and the felt starts to shrink, the process makes the cloth ruche and crinkle into beautiful organic and textural patterns, which differ depending on the

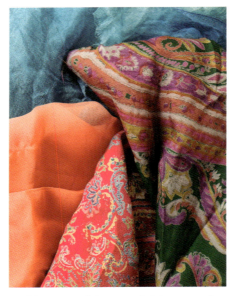

Silk fabrics: sari silk (green and pink patterned), silk chiffon (pink) and Margilan silk (blue).

material used (from tiny all-over ruching to larger rectangle-like shapes).

Fine silk fabric is very popular for nuno felting, notably silk chiffon and very fine Margilan silk from Uzbekistan, which is often combined with a very thin layer of extra fine Merino tops to create garments. The combination of felt and fabric enables you to create very thin but strong felt with good drape. Other fabrics that work well are very open weave fabrics like

Chapter 1 – Materials and Equipment **17**

cotton cheesecloth and scrim. Patterned fabric, like sari silk and silk scarves, can create interesting effects when ruched up into nuno felt. Any other fabric which has holes in it, like lace, should also felt in.

Nuno felt doesn't have to be a complete layer of fabric and wool. A technique that works well for items like scarves, which can be more decorative and delicate than a garment, is to use a whole layer of fabric, but just partly covered with a pattern of wool fibre. This creates some flat areas that are just fabric, some partly ruched areas of fabric where it lies near to the wool fibre, and some completely ruched parts where the fabric joins the fibre. You might also want to leave deliberate holes in the fibre layout, which get filled up by the scrunched-up fabric, creating another different effect. Alternatively, you can create nuno elements within your felt, by having a complete layer of fibre and adding just pieces or a patchwork of fabric pieces to create nuno effects (*see* the Silk Stripe Cushion Cover Project in Chapter 4 for an example). However you approach it, using cloth in your felting is an excellent technique to give your felt more structure (so that you can make very fine felt with inherent strength) and/or to add organic pattern and texture.

As a general rule, it's harder (but not impossible) to combine man-made fabrics (like polyester) with fibre to create nuno felt. However, what's more important than what a fabric is made of is the openness of the weave, so a synthetic fabric with an open weave will probably work better than a thicker silk with a tight weave. If a fabric's weave is very tight and the fabric is thick, it may not work at all, regardless of what it's made of. It's therefore really important to sample all your fabrics (with the wool fibre you want to use) for feltability before you commit to a project, and that includes silk which can be very variable. You'll also want to test how the fabric ruches, and by how much, as this will affect the shrinkage of the felt. That's why you should really make a sample first before making something important, or where the exact shrinkage or an exact look is critical.

The process of nuno felting is the same as that for standard wet felting, although if you're just using one fine layer of wool fibre then you can lay out the fibres in any direction, as the fabric helps to give the finished felt more strength and structure. Once you start the wetting and agitation process, it helps to start very gently and slowly with nuno felting, as you want to ensure that the fibres have time to bond fully with the fabric (and not just with each other, which can happen if the bonding happens too quickly). So, to slow things down some felters use very cool water. I find it also pays to be quite hands-off at the start, as it's very easy to disrupt the fabric and the delicate bonds that the fibres are developing with it, so generally I do less rubbing and more rolling and avoid moving on to higher agitation methods until I'm sure the fibres have fully bonded to the fabric.

Working with Embellishments

As with the wool fibre I've used in the projects in this book, my choice of embellishment materials has mainly been dictated by my own stash and preferences, but you can swap these for materials you already have or would prefer to use. I've tried to use similar materials in different projects to illustrate how they can be used to different effect, for example the Fringed Clutch Purse and Fringed Cushion Cover Projects in Chapter 4, so the surface design techniques shown are all interchangeable. You can also layer up multiple techniques for greater effect and interest, for example the Nuno Silk Scarf Project in Chapter 3 includes not just nuno felting but also a viscose fibre top layer.

Here are some general tips on combining wool fibre with embellishment materials:

- Wool fibre will bond to other wool fibres, and protein fibres (like silk) and plant fibres (like viscose), quite easily, so you can pretty much just lay those on top of your wool base and they'll felt together.
- Wool fibre will also bond well to open weave and fine fabrics like cotton cheesecloth and silk chiffon because the wool fibres can migrate through the holes in the fabric and bond to the fabric that way.
- Once you start introducing man-made embellishment elements (like acrylic yarns or nylon fibres) or non-open weave or synthetic fabric (like polyester), you're going to have a much more difficult time getting them to bond (if at all). This is because the yarns don't have feltable properties and the fabric can't easily let the wool fibres through it to bond. So your main options to secure yarns are to lay more wisps of wool on top to sandwich them between layers of wool and lock them within the felt, or choose synthetic yarns which are very hairy, slubby or open-stranded, as this gives the wool fibres something to grab hold of. If you really want to persist with using a particular fabric, then an option to try is to be very painstaking at the start of the felting process, going very slowly and using cool water until the fibres start to migrate through.

- It's always a good idea to do test samples with your embellishment materials, both to check that they will felt in and to see what sort of effect they create.
- A little goes a long way with most of the embellishment fibres, so try adding just wisps of fibres as highlights, although you can add complete layers for a different effect. Add them to your design in the same way as you would a wisp of wool fibre.
- Colour wise, remember that you need to view your surface embellishments and your wool fibre base as an integrated whole (rather than completely separate elements), as the process of the wool fibres coming forward to grab the embellishments to lock them in will mute their colours. So choosing brighter or more contrasting embellishment colours will help them stand out more in the finished felt.
- Embellishment fibres like silk and viscose tops are incredibly fine, soft and silky, and can be very flyaway and tricky to handle, especially if your hands are wet or have any rough parts. If you're having real trouble, try using disposable gloves to see if that helps.

The final thing to say about surface design embellishments is that there are many more materials out there than just those I've listed, and suppliers are constantly introducing new ones. So keep your eyes out for what's on the market, or what you might be able to pick up from a small-scale producer at a craft show, and remember that it's always worth experimenting!

TOOLS/EQUIPMENT

As with the wool fibres and embellishment materials above, you'll want to experiment to see what you like to use best, and your equipment is no different. One great aspect about feltmaking, however, is that there isn't much specialist equipment required; you'll find that most of it can be repurposed from around the house. Purpose-made tools have come into popular use over time, but you certainly don't need to have these at the start until you've decided what type of felting processes or equipment you prefer. I've given a run-through here of the main types of equipment you'll need for the projects in this book, ordered according to the main stages of the feltmaking process, as well as some alternatives for you to consider if you prefer. I've also included explanations about how you use them.

Fibre Preparation Tools

In wool textile production, carding is the process of separating/brushing individual fibres into sheets of fibre (batts). These may then also be combed into tops or roving, with all the fibres lying in the same direction to make them even finer for use in felting and spinning. Wool fibre that you buy commercially will have been carded on industrial machines, but **hand carders** are commonly used by felters to mix up small quantities of their own colour blends. They can also be useful for separating older wool fibre which has slightly felted to itself, or for colour blending embellishment fibres, or mixing them in with the wool fibres. Hand carders come in pairs and are used to transfer wool fibre from one to the other until the fibres are more integrated/aligned and blended. An inexpensive, smaller version of a pair of hand carders are two **dog brushes,** which are useful for very small quantities of fibre. Or, if you would like to create your own larger batts, you could upgrade to a small tabletop **drum carder** machine.

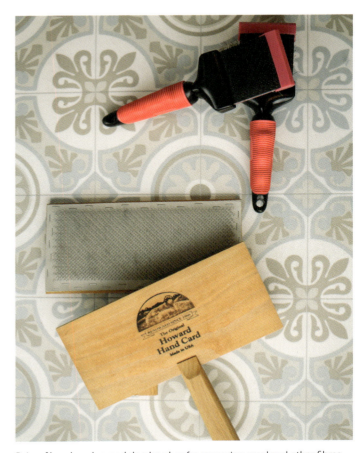

Pairs of hand carders and dog brushes for preparing wool and other fibres.

Weighing/Measuring Tools

Digital scales in particular are invaluable for several reasons. If you're following a project, you'll need to know at the start that you have the right amount of fibre. Scales can also be used to help you achieve an even layout and will make the layout process easier: divide your fibre into the number of layers you need so that you are using an equal weight per layer (you could even divide it further into equal sections per layer). For a new project, I will often weigh the finished felt (once it has fully dried), so that I can either adjust the weight for the next time (if I decide I need a thicker result, for instance) or I can base the next version on the same amount of fibre. If you want to achieve consistent and repeatable results, it is really important to weigh your fibre.

If you divide your fibre into weight allocations for different layers, it's helpful to keep the amounts separate until you need them. **Plastic bowls** are useful for this, or any kind of container or bag.

If you're working on a new project, you'll probably need to calculate the shrinkage, so a **calculator** makes this easy. Once you know your project measurements, a **tape measure** and **ruler** are vital to setting out the right size of your fibre layout. You'll also need a tape measure for inflating a felting ball to the correct size. A ruler doubles as a useful tool for marking cutting lines in wet felt.

Cutting Tools

You'll want various sizes of **sewing scissors** to hand during the wet felting process: a large pair if you're cutting shapes out of the felt and cutting large pieces of fabric; and a small, sharp pair for making small holes and snipping yarns and other embellishments.

You'll see that for some of the projects, especially where very accurate cutting is useful (such as the individual fringes in the Nuno Silk Scarf Project in Chapter 3), I use some standard patchwork and quilting tools, namely a **rotary cutter**, **self-healing mat** and **large cutting ruler**. You don't need to go and buy these especially, but they do make accurate cutting much easier, so use them if you have them.

Templates and Resists

I've used the same wave-shaped template (*see* Template and Tables) for several projects in this book. To make a similar template that you'll use dry, a **thick piece of card** (I use cereal packets) is as durable as anything. You'll just need a **pencil** and **household or paper scissors** to create your templates.

For a flat resist template, **thin plastic** (for example, from a thick plastic bag) or thin **1mm (0.04") packaging foam** is ideal if your resist needs to be thin, yet flexible. I've used slightly thicker **5–6mm (0.25") packaging foam** for the three projects in Chapter 4, because it is a bit more substantial than the 1mm (0.04") foam, yet still flexible enough to use throughout the wet felting process (such as rolling). Other options for resist materials include cardboard wrapped in clingfilm/shrinkwrap, lino offcuts, and thick plastic sheeting (used by builders).

For the three-dimensional resist projects in Chapter 5, I've exclusively used a purpose-made **felting ball**. I would recommend getting hold of one if you can, but any other kind of rubber ball would do the trick (as long as you can inflate and deflate it). You could also try a balloon, although ideally you'd want a more durable and round-shaped resist to create the projects. A **permanent marker pen** for marking out guidelines on the felting ball is also useful.

Work Surface Tools

Working on a **hard, waterproof work surface** is a good idea to start with, as there's no avoiding water pooling on the surface during wet felting. I use an **oilcloth tablecloth** (or oilskin/PVC/vinyl tablecloth) to help protect the surface. A kitchen worktop works well for a smaller project and has the added bonus of being a really good height for most feltmaking projects (a normal table height makes you bend over too much so can be tough on your back). If you have the luxury of space, an adjustable-height table would be perfect.

With your work surface underneath, I find it useful to have a working surface layer onto which I can lay out my fibre. My definite go-to material for this is **bubble wrap**. As well as being inexpensive and easy to get hold of, it's the perfect working surface for lots of reasons: you can sandwich your fibre within two layers, which keeps everything in place whilst you go through many of the wet felting processes such as rubbing and rolling; it keeps the wetness within the project when you need it to; you can easily turn your sandwiched package around or over to access the other side of the felt; and you can fold in the edges of the bubble wrap to help create straight edges in your felt. Just ensure that your bubble wrap gives you a slightly bigger surface area than your project size. It doesn't matter if you use one piece folded or two separate pieces for this. I use bubble wrap with small bubbles and with the smooth side facing the fibre because I feel that this disrupts the delicate fibre layout less than the other way around. However, other felters will use

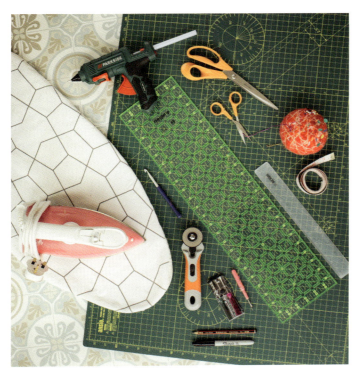

Cutting, measuring, sewing and other finishing tools.

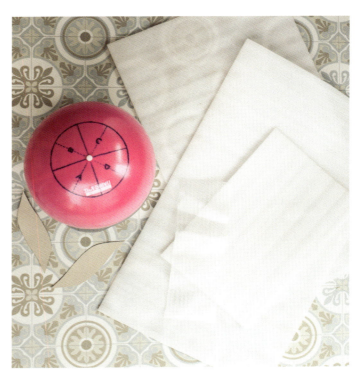

Typical wet felting resists and templates made of thin foam, rubber and card.

the bubbles facing the fibre specifically to assist with agitation and to retain more water right next to the project. I'm not sure it makes very much difference really but it's something to test!

A **large towel** is another option for a working surface, which I always use when working with the felting ball and the Papier Mâché Layout because the process involves dunking pieces of fibre and then placing them on the ball, which inevitably causes water to drip all over the work surface.

Wetting Tools

Once your fibre layout is complete, the next stage is to wet the fibre completely through all the layers – without this it's difficult for the wet felting process to work effectively. The ideal is for the fibre to be completely soaked, without too much extra water pooling everywhere. That's why I would recommend some kind of **spray bottle**, as this enables you to control the amount of liquid going into your project. It also has the major advantage of, if you spray directly from above, wetting the fibre gently and uniformly with the least disruption to your layout. For all but the largest projects in this book you'll see I've repurposed a household cleaning spray bottle.

For larger projects, it's really useful to have a much larger spray bottle, so a **garden pump/pressure sprayer** is ideal. Another popular option for felters is a **ball brause** (or **brauser**) **water sprinkler/sprayer**, which gives a concentrated shower of water where you need it and is again useful for wetting down without too much disruption to the fibres.

Once you've added your water, you'll want to ensure it is distributed evenly throughout the fibre. I tend to use my hands or a rubbing tool for this (through a layer of bubble wrap), but you could also use a rolling tool.

When we're soaking our fibre, there's a vital ingredient we need to add to the water to make the felting process work effectively, which is **soap**. Soap helps to open up the scales on the fibres, which helps them to lock together. Soap also helps with the agitation process, by allowing your hands or rubbing tool to move more smoothly over the fibre. So when we wet our fibre, we aren't just using water we're using a soapy water solution of some kind.

What soap should you use? This is one of the areas of felting where every felter will have their own favourite recipe – none is wrong, it's just down to personal preference. I use a combination of standard **washing-up/dishwashing liquid** for my soapy

water solutions in my spray bottles or in my bowl for use with the felting ball, and solid **olive oil soap** (which is very popular with felters) to create extra targeted soapiness for things like rubbing edges and the inside of felt. Adding solid soap on top of tricky embellishments and fibres before moving into the more vigorous fulling stage can act a bit like temporary glue to help stick everything in place long enough for the fibres to grab onto the embellishments and secure them better. For many years, I used old-fashioned wool soap flakes for adding targeted soap, but these no longer seem to be manufactured. As an alternative, many felters like to grate soap to make their own liquid solutions.

How much soap should you use? Throughout the wet felting process, until towards the end of the fulling stage, the overall consistency of the fibres/felt should be wet and slimy – dryness is really the enemy of the felting process. Obviously there's a balance to be had in the amount of soap. If there are thick suds everywhere this is going to hamper the felting process, but that's easily remedied by laying a tea towel over the piece to soak up and remove some suds. I generally prefer to err on the side of too wet and soapy (as you can remove water/soapiness), rather than not enough (as then the wet felting process won't work). I tend to use a big squirt of washing-up liquid in my spray bottle (and a very big, long squirt in my bowl for use with the felting ball), always after adding the water to avoid suds developing. If you're unsure that you've used enough soap, test the soapy solution in your hands – it should feel slimy.

Water temperature can be used in extra ways to assist the process. For example, during the fulling stage many felters like to shock the felt with alternating very hot and very cold rinses (which acts a bit like fibre agitation). By contrast, in nuno felting, particularly at the start, felters will often use very cool/lukewarm water to avoid any heat affecting the process too soon (since with nuno felting you want the felting process to happen slowly to ensure good integration between the fibres and the fabric). As a general rule, I use warm or lukewarm water, which isn't going to upset the fibres (and warm water feels nicer on your hands). I also use warm water for rinsing the felt at the end.

Rubbing Tools

Rubbing is usually the first stage of agitating the fibre. Luckily, the best rubbing tool at your disposal is available to every felter and is free: your **hand**! Or your hand holding a **dish cloth** (to increase the surface area and give a bit more agitation power). I used a dish cloth for many years until I was introduced to a **Palm Washboard**, a beautifully made wooden felting tool with a ridged surface, and now I'm completely converted. It definitely speeds up the felting process and is much kinder on your hands. You'll see I've used one in all the flat felting projects. The originals are handmade in the US by HeartFelt Silks, along with a range of other wooden felting tools with specific uses, and are designed to take the strain out of rubbing and to eliminate or reduce the need for rolling (which some felters find physically difficult). Other versions are now on the market (or you can improvise with things like plastic jug lids, wooden massage tools and other household items that have a ridged surface). Additional things you could try are pieces of textured plastic or mat (such as textured drawer liner).

Another piece of popular kit is an **electric sander**. I haven't used one myself yet, but you'll see plenty of online videos in which felters use a sander, particularly in nuno felting. It's a good way of getting maximum fibre agitation for minimum effort or disruption of the fibre layout. Health and safety is obviously a big consideration, so do get some advice from a felter experienced in using a sander before you try this yourself.

An important consideration before starting to rub your fibres at the start of the wet felting process is how to avoid disrupting them and your careful design layout. If you wet the fibres and then start rubbing them then the design is clearly not going to stay in place for long. So after we've soaked the fibres we need to put a thin layer of something on top to protect them whilst we rub (so the agitation is more indirect). There are plenty of options for this: **net curtain**, **thin plastic sheeting**, **plastic mesh**, **bubble wrap**, or **tights/pantyhose** (for rubbing the felting ball). For many years I used net curtain (along with the dish cloth), but the fibres quickly migrate through it (it has a nuno felt effect), which can be disruptive when you peel it back if you're not very diligent. And once I started using the wooden Palm Washboard, the fibres were migrating through even quicker. So to eliminate this completely, I now just use bubble wrap on top. I find it sturdier than thin plastic sheeting and it works perfectly with the higher level of agitation created by the washboard. However, some kind of net can be helpful in certain circumstances, particularly when you have small or non-standard shapes to cover and rub and you need something more flexible than bubble wrap to rub through. You can wrap net around a shape and hold it tight whilst you rub, which is a really effective way to do it.

Once the fibres have started to bond together, so there is less chance of disrupting the design, I like to peel back the top

layer of bubble wrap and rub the fibre directly with my hands. This increases the agitation and enables you to feel the changes in the fibre. Once it starts to feel firmer, thicker and slightly coarser, then you'll know you're around the right point when you can move to the fulling stage.

It isn't easy to generalize about how long you would spend rubbing, other than that the bigger/thicker the piece, the longer you would need to rub initially to start the fibres bonding. For a small sample, five minutes each side might be enough to move on to rolling, but for a bigger project (like the Cushion Cover Projects in Chapter 4), I spent at least forty minutes rubbing. It's important to keep an eye (and a hand) on the fibre so that you notice when it is ready for you to move to another technique or stage in the process – this will get easier as you gain more feltmaking experience.

Rolling Tools

Rolling is a further agitation technique, which you might use in two main ways during wet felting: firstly, after rubbing, but still during the felting stage, to help bond the fibres together; and secondly, during the later fulling stage when you are trying to shrink and harden the felt. Rolling involves sandwiching your fibre within layers to keep it together, for example within bubble wrap, and then rolling the package around some kind of rolling tool. Typical tools are **pool floats/noodles**, **foam pipe insulation** or a **rolling pin**. Generally, the softer foam rollers are useful for gentler rolling during the felting stage, whereas you might use a harder wooden roller later during the fulling stage, possibly directly against the felt, to help firm it up.

Another option is to roll the felt within something, rather than around a roller, for which a **bamboo mat** is a popular choice. If you're rolling early during the process, you might still want to protect your delicate fibre from the relative hardness of the mat by sandwiching it between bubble wrap first. If using the bamboo mat later in the process, you might then remove the bubble wrap and roll the felt directly within the mat for maximum firming/hardening purposes.

In terms of further increasing the agitation we need, rolling up the fibre is generally a level up from rubbing. The exception to this, in my experience, is when nuno felting. It's so easy to break the bonds between fabric and fibre that I've found that being as hands-off as possible at the start is helpful. So, I might start with gentle rubbing and then move to gentle rolling and do more rolls than for a normal piece of felt (so the rolls are replacing the rubbing). This seems to give the fibres

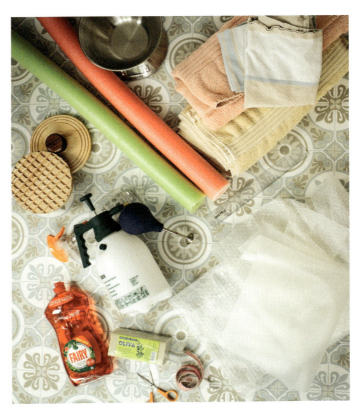

A selection of key wet felting process tools.

more of a chance to bond with the fabric before you introduce harsher techniques.

Whether rolling the fibre around or within a tool, you might want to use something extra around the outside of the package to help keep it together and to help with your grip. I tend to use a **tea towel** for this (which has the added bonus of soaking up any excess water which starts to leak from the package). You might want to use some kind of ties at each end, for instance a cut up strip of T-shirt or the legs of tights/pantyhose (you'll have some spare from using the felting ball).

In terms of the rolling process itself, standing is much easier than sitting as you can use more of the power of your body (rather than just your upper arms). Kitchen worktop height is ideal for this, as it enables you to keep your back straight. A standard roll would be to start with the roll laid horizontally and close in front of you. With your hands apart at each end of the roll, push it away from you, so that your arms are outstretched, and then roll it back close to you again. That counts as one roll. Some felters count their rolls in minutes, though I prefer to count in groups of 50 or 100 for greater accuracy. After each set of rolls, turn the package 90 degrees

clockwise, unwrap the roll, check the fibre hasn't moved out of shape (adjust it if so), then roll it back up again and repeat until you have completed the same number of rolls on each of the four compass point edges. This ensures that a piece is being rolled evenly on all sides. After the initial set of rolls, I usually turn it over and repeat the process on the reverse. 100 rolls might seem a lot, but you can complete it in less than a minute.

Felters are an inventive bunch when it comes to tools, so there is a relatively recent wet felt rolling machine called the **Gentle Roller** now on the market. Back trouble and difficulty with rolling felt is often a problem for felters, so tools like this are aimed at making the process easier for you.

Fulling/Shrinking Tools

Once the felt has moved into the fulling stage and is starting to shrink, there are some tools that you might want to try to speed this up. I've already mentioned rolling the felt directly around a harder roller, like a rolling pin, or within a harder material like a bamboo mat. The ridged wooden Palm Washboard and other tools can also be used to rub directly against the felt at this stage. Another thing to try is to rub the felt directly against a hard, ridged surface, like an old-fashioned **washboard** or a **ridged mat** (such as textured drawer liner). In the latter stages of wet felting, rolling the felt up on itself is also effective. Some felters like to use a **tumble dryer** to agitate the felt, which is again particularly useful if you want to take some of the physical work out of the process (but of course you need to be careful not to overfelt the piece, as you can lose some of your control over the process once you introduce mechanical tools).

Rinsing Tools

Once the felt is made, you'll need to rinse out all the soap, so you can do this in a **sink** or a **washing-up bowl** filled with warm water, ideally leaving it to soak for a few minutes and gently squeezing the water out (rather than wringing, which could stretch it). You might need to refill the water a couple of times until it runs clear. Some felters like to add **vinegar** or **lemon juice** to the final rinse to help restore the pH balance of the wool, although this is not something I've ever done.

I usually then roll the finished piece up in a **towel** and squeeze to get rid of further excess water, before reshaping and leaving to air dry. You could leave it somewhere warm like an airing cupboard or on a radiator, but avoid putting it in a tumble dryer as this will agitate and shrink it further.

Specific Equipment for 3D Felting

I've already mentioned a few specific tools for use with three-dimensional resist felting (*see* Chapter 5): a **felting ball resist**, **tape measure**, **towel** as a work surface, **washing-up liquid and warm water solution** in a bowl, and **tights/pantyhose** for rubbing the fibre through. Here are a few more, along with extra details about some of them.

A **handheld or foot pump** is useful for inflating the ball to the correct size, along with a **tape measure** to check this. You'll also want several large towels to hand as you might use two during the felting process, plus a third clean towel for removing excess water from the finished felt.

I use several differently-sized **plastic bowls** when working with the felting ball (these are Wham Casa brand):

- 28cm (11") diameter round bowl (to prop up the ball).
- 32cm (12.5") diameter square bowl (to push/roll the ball within – for the Art Batt Bowl and Cross Body Bag Projects).
- 36cm (14") diameter round bowl (to push/roll the ball within – for the Yarn Basket Project).
- A large bowl of any size to hold the washing-up liquid and warm water solution.

Once you have laid out the fibre on the felting ball, you need to encase it in a layer of something to help keep the fibre in place whilst you work on it. **Tights/Pantyhose** are ideal for this because they are stretchy. Here are the sizes I use, but as long as the hip size is a bit bigger than the ball circumference (and the tights are stretchy yet won't ladder easily, for which 20 denier seems to work well) then you could try other sizes or a couple of old pairs you have to hand:

- two pairs of Medium/Large (102–122cm/40–48" hips) tights/pantyhose, 20 denier
- two pairs of XXL (up to 152cm/60" hips) tights/pantyhose, 20 denier.

Prepare the tights by turning them inside out (so the seam line is not on the inside, next to the fibre). Tie a tight knot in each leg approximately 7cm below the crotch part, then cut off the tight legs. Using two pairs, adding one at a time with the ball placed in a different position each time, helps to ensure that you cover the whole ball without having to do too much stretching of the tights and potentially disrupting the

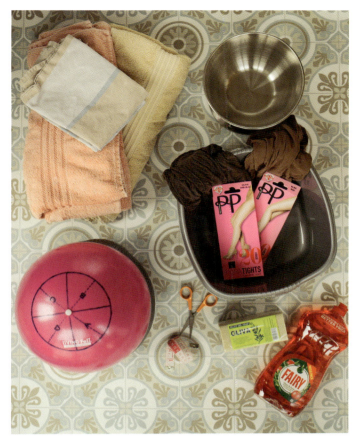

Equipment you need for 3D felting with a felting ball.

Some of the project finishing materials you'll need.

fibre. Actually getting the fibre-covered ball within the tights can be a bit of a challenge on your own, but if you stretch the tights over your largest bowl first that will help you (or enlist the help of a friend).

Finishing Materials and Tools

This isn't a book about making felt fabric and sewing things with it, this is about creating seamless shapes with felt or using flat felt in ways that don't require sewing. So I've mainly avoided you having to sew anything other than simple **magnetic clasps** (and even these are optional). Some of the other specific things you'll need to complete the projects include:

- **Embroidery hoop** or hoops, strong glue or a **glue gun**, a **small screwdriver** and **hanging cord** or ribbon for the Hoop Art Project in Chapter 3.
- **Lampshade kit** and **textile glue** for the Seascape Lampshade Project in Chapter 3.
- An **A5 notebook**, **interfacing**, **fusible web** and **magnetic clasps** for the Wave Journal Cover Project in Chapter 4.
- **Cushion pad insert** and **magnetic clasps** for the Silk Stripe Cushion Cover Project in Chapter 4.
- **Leather magnetic buckle clasps**, **detachable bag strap** and **metal D-rings** for the Cross Body Bag Project in Chapter 5.
- **Crochet hook** for creating the crocheted circles in the Yarn Basket Project in Chapter 5.

There are also some useful tools for finishing off your felt, including: a **steam iron** (to smooth the finished fibre surface, press folds and reshape or stretch the felt if necessary) and **ironing board**; **sharp scissors** to trim hairy fibres; **pins**, needle, embroidery thread, tape measure/ruler for sewing clasps; and a **seam ripper** for attaching pronged clasps.

Chapter 1 – Materials and Equipment 25

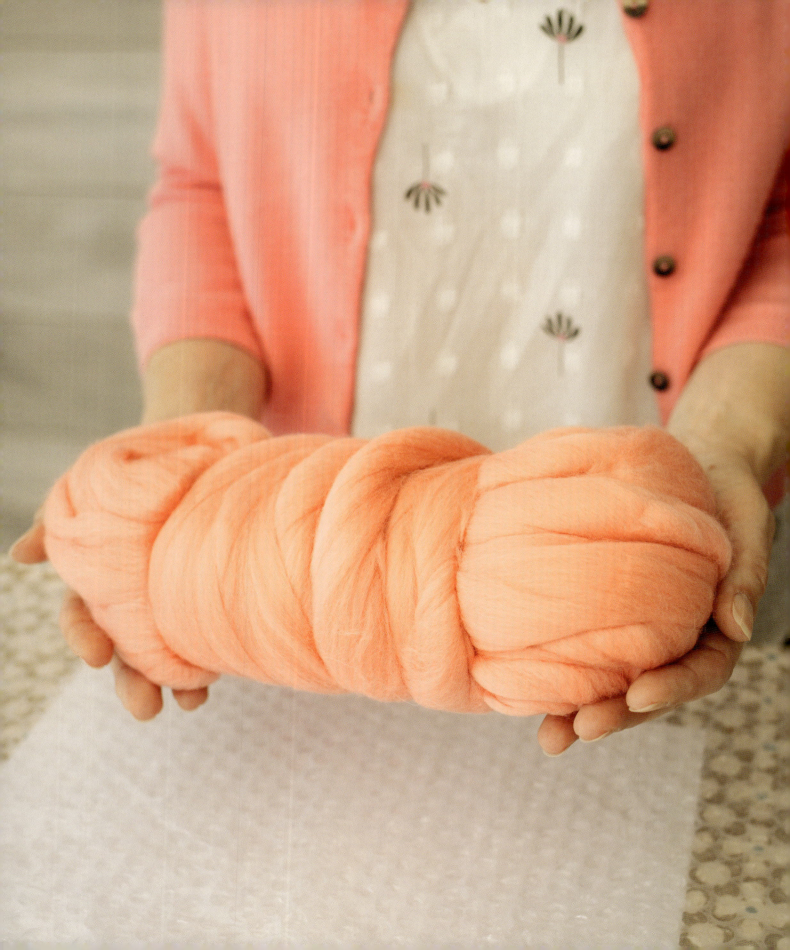

CHAPTER 2

GETTING STARTED

Now that we've looked at the main materials and equipment we need to make and embellish our felt, in this chapter, we look at how we apply them all together to actually create our felt. We'll cover the different fibre layouts you could use and a detailed run-through on how to make a sample piece of felt, which includes lots of extra tips. We'll also look at structuring your felt and how to work out shrinkage.

In the main introduction to the book, I briefly mentioned some key feltmaking principles and stages of the process, so we'll start by going into those in a bit more detail.

WHAT IS WET FELTING?

Wet felting is a process that you apply to wool fibre. By wetting and rubbing the fibre, helped by soap and heat, the microscopic scales on the individual fibres start to open up and lock together. The more you continue to agitate the fibres, the more they lock together, until eventually they are locked so tightly that they cannot be pulled apart. This creates felt: a sturdy non-woven fabric which is essentially a dense mat of tangled fibres. This is an irreversible process.

There aren't that many rules in wet felting, but there are two key principles you must follow to actually initiate the felting process:

- **You need water** (to open up the fibre scales).
- **You need friction** or agitation (to lock the fibre scales together).

There are also two other principles which most felters would agree on:

- **You need soap** (which helps to open up the fibre scales and smooth the process of agitation).
- **You need heat** (if you want to speed up the process – although you need to be cautious about this as it won't be appropriate in all circumstances).

If you follow these principles for starters, then you will be able to make wet felt.

Although **felting** is the general overall term for creating felt, there are actually two main stages of the wet felting process:

- The **felting** stage, when the scales lock together and the fibres start to bond to create a very loose fabric (called **prefelt**). The fibres could still be pulled apart at this stage, and the prefelt hasn't yet started to shrink. Typical agitation actions you would deploy in the felting stage are gentle rubbing and rolling. The fibres during this stage are characterized by being quite delicate, smooth, thin and spread out.

- The **fulling** stage, when the fibres bond completely and, as they grab each other more tightly, the loose prefelt shrinks to create a firm fabric. Typical agitation techniques you would use in the fulling stage are rougher ones like throwing and rubbing the felt directly against something textured (like a mat). A more delicate technique might be to scrunch up the felt. Typical changes you would expect during fulling are the felt shrinking, feeling thicker and taking on a textured, bumpy surface (like orange peel or crocodile skin).

You might be wondering how you know the difference between the felting and fulling stages? The transition point between the two stages isn't just one moment in time, it is more a development of the fibre from a loose prefelt into a firmer, thicker piece of fabric over a period of time. You need to use gentle agitation techniques during the initial felting, because the fibres are so delicate at this stage. Your aim is to get them to

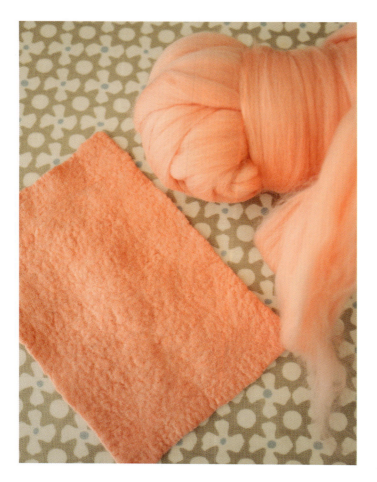

FLAT FELT SAMPLE

WHAT YOU WILL NEED

Materials
- Approximately 15g of Merino wool tops (I've used light coral pink)

Equipment
- Minimum 40cm × 60cm (16" × 24") piece of small bubble bubble wrap (or two 40cm × 30cm/16" × 12" pieces)
- A4 (30cm × 21cm/12" × 8.25") piece of paper as a template
- Scales
- Tape measure
- Spray bottle
- Washing-up liquid and warm water solution
- Hard soap (for example, olive oil)
- Rubbing tool
- Rolling tool
- Tea towel
- Medium towel

bond together in whatever design you have created, or with whatever embellishments you are using, and you need to start gently to encourage the bonding to happen and avoid disrupting your design. Once you can see that the fibres are starting to bond, and the piece is less delicate, you'll want to transition to the fulling stage and increase the level of agitation to help speed up the process. However, it's worth pointing out that you could continue to use your more delicate felting techniques like rubbing and rolling to create felt in its entirety – it wouldn't be wrong to do this, it would just take longer. Wet felting is definitely a process where you will start to feel and see changes in the felt as it is made, so once you have gained some experience in making felt and know the changes to look out for, you will be better able to judge.

To help you understand the process and the different techniques to deploy at which point, as well as see how the fibres turn into felt, let's run through the basic wet felting process for a small rectangular piece of flat felt using two layers of Merino wool tops in the most common tops layout technique, Overlapping Tiles.

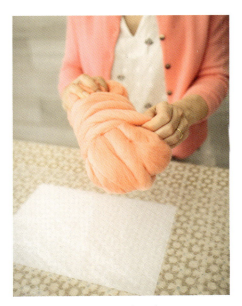

Step 1: Preparing your work surface

On a hard, water-resistant work surface, open out the bubble wrap, smooth side up. Position it so that you use half as your 40cm × 30cm (16" × 12") working area. Place an A4 sheet under the bubble wrap to act as a template for the fibre layout.

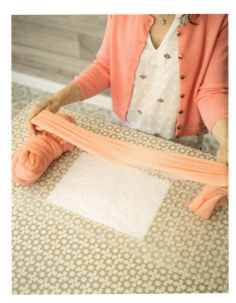

Step 2: Pulling apart the fibre

Unroll the Merino wool tops and, with your hands holding the tops 'tube' quite far apart, gently pull to create a break. Because the long fibre strands are combed in one direction, if your hands are too close together the 'tube' is too strong to break.

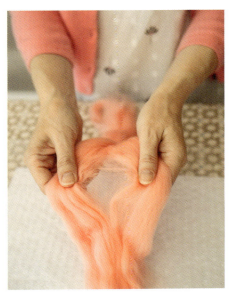

Step 3: Separating the fibre

To make the fibre easier to handle, divide your length of tops in half lengthways (and divide again into quarters if the tops are quite thick). To make the laying out of even wisps of tops easier, spread out the 'tube' into more of a flat rectangle in your hand.

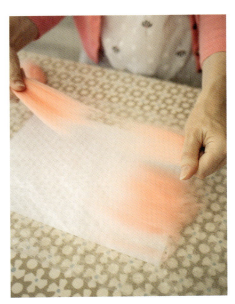

Step 4: Pulling off a wisp of fibre

Holding the length of tops in one hand, with the other hand gently pull a thin, even wisp of fibre from the end, using the tips of your fingers against the base of your thumb. This creates a weak grip which helps to pull off a wide, thin and even wisp.

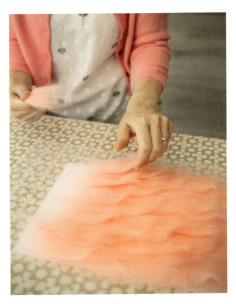

Step 5: Laying out the fibre (layer one)

Starting at the top left corner of the template, lay the fibre wisp on top of the bubble wrap in an east to west direction. Repeat with further wisps, laying them either in rows or columns, but ensuring they overlap each other slightly like roof tiles.

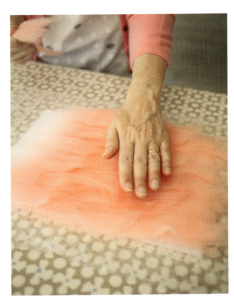

Step 6: Checking the layout

Aim to create an even layer of fine, overlapping fibre. Keep patting to test for thin areas and add extra wisps to infill these until the overall thickness of the fibre feels and looks even.

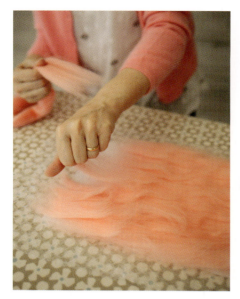

Step 7: Laying out fibre on the edges

When you pull off a wisp of fibre, the end where you pull is usually slightly thicker than the wispy end. You can take advantage of this during layout to create firmer edges by reversing how you lay down the wisps to lay the thicker end at an edge.

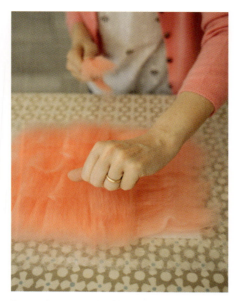

Step 8: Laying out the fibre (layer two)

Repeat Step 5 to create the second layer of fibre, but this time laying the fibres in a north to south direction. Pat to check the evenness and infill with extra wisps as necessary. Repeat to create a third layer (or more), if required (I used two here).

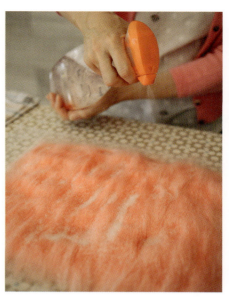

Step 9: Wetting the fibre

Gently spray warm soapy water solution all over the fibre rectangle until soaked. Spray from above to avoid disrupting the fibres. Fold the other half of the bubble wrap over the fibre rectangle to sandwich it.

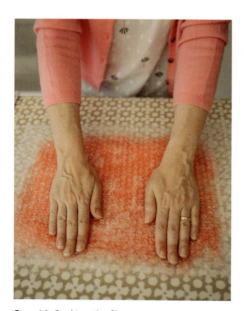

Step 10: Soaking the fibre

Press down gently to disperse the soapy water throughout the fibre, either using your hands or with the rubbing tool. Turn the whole fibre package over, peel back the bubble wrap and check the water has soaked through to the reverse. If not, spray.

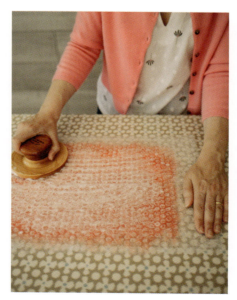

Step 11: Rubbing the fibre

Replace the bubble wrap, spray the bottom of the rubbing tool to help it move more easily and gently rub it all over the package through the bubble wrap for a few minutes whilst a soapy lather develops. Peel back the top layer of bubble wrap.

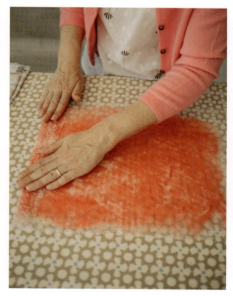

Step 12: Neatening the edges

To straighten and firm the edges, fold each edge back to the reverse by 2–3cm (1"). To make this easier, use the bubble wrap to make the fold: fold the bubble wrap at the point you want the fibre edge to fold, then press down along the fold to secure it.

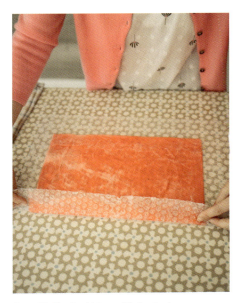

Step 13: Final rubbing with the tool

Once all the edges have been neatened, replace the bubble wrap and continue rubbing the fibre reverse for a further 5–10 minutes. Turn the package over and rub all over the front side for a further 5–10 minutes.

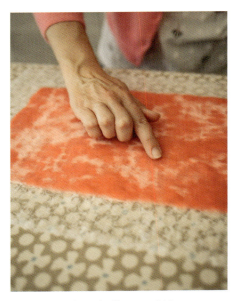

Step 14: Checking the fibres are felting

Check the fibres for movement by gently rubbing a finger over the surface or apply the pinch test (*see* page 33). If there is considerable movement, replace the bubble wrap and continue to rub until the fibres are mostly staying in place.

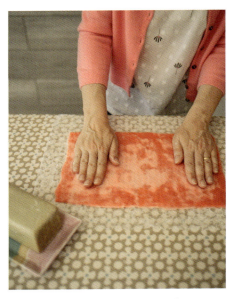

Step 15: Final rubbing with your hands

Peel back the bubble wrap and rub all over with your hands on both sides for 5–10 minutes until none of the fibres are moving. Ensure your hands are very soapy (I like to use olive oil soap for this) to help them slide across the fibre.

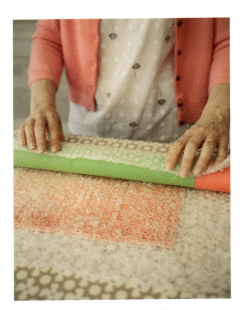

Step 16: Preparing to roll the prefelt

The fibre is now bonded enough to use as a loose prefelt (or finish all or some of the rolling process for a more felted prefelt). Replace the bubble wrap to sandwich the prefelt. Roll up the package around the rolling tool, then roll up in a tea towel.

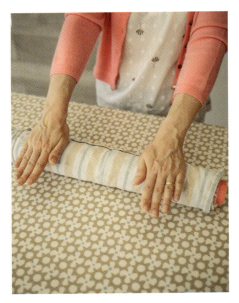

Step 17: Rolling the prefelt

Roll the package away from you to arm's length and back again, counting as one roll. Roll 100 times. Unwrap the package and gently tug the prefelt back into shape if misshapen.

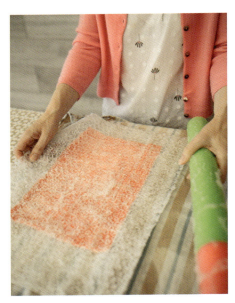

Step 18: Continuing to roll

Turn the package 90 degrees clockwise and repeat Step 17 three more times until the fibre has been rolled 100 times on each edge. Then turn over and repeat on the reverse, to make 800 rolls in total. Unwrap the package and discard the bubble wrap.

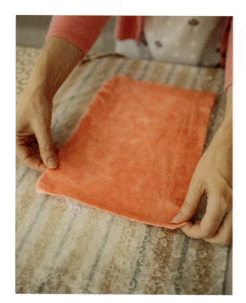

Step 19: Moving to the fulling stage

The prefelt is now at the point where the fibres are fully bonded and it feels thicker and more substantial (and is becoming felt). This marks the transition to the fulling stage, when we can increase the agitation to fully firm and quickly shrink the piece.

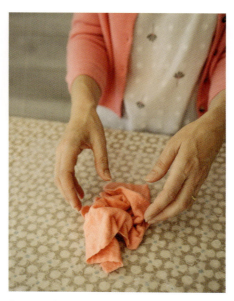

Step 20: Throwing the felt

With the felt still wet and soapy (but if it is very wet and dripping, gently squeeze out some of the water), loosely pick it up and throw it down hard onto the work surface 100 times to thicken and shrink it. Reshape it to straighten it.

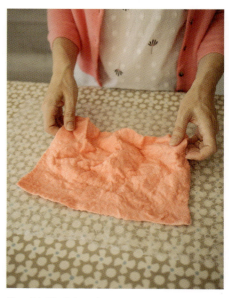

Step 21: Final throwing

Repeat Step 20 to throw the felt a total of 300–500 times, in blocks of 100 and reshaping after each 100 (reduce this to blocks of 50 or 20 once the felt is nearing the desired size). The felt should be developing a natural crinkle, like crocodile skin.

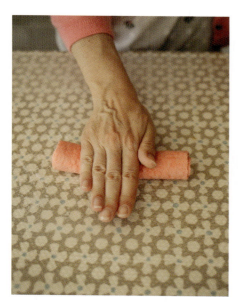

Step 22: Final rolling

Another option to full the felt once it's reaching the desired size is to roll it up on itself on all sides for groups of 20 rolls, reshaping each time. Finish fulling the felt when satisfied with the size, thickness and texture (I stopped at 21.5cm × 15cm/8.5" × 6").

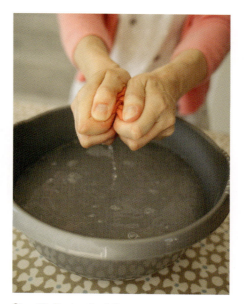

Step 23: Rinsing the felt

Rinse the felt under warm running water to remove the soap, or soak in a bowl of warm water, until the water runs clear. Squeeze to remove excess water (avoid wringing as this stretches it out of shape). Roll up in a towel to remove further water.

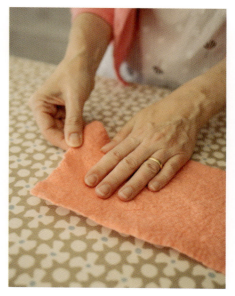

Step 24: Finishing the felt

Reshape the felt and leave to air dry. Once dry, steam iron flat to smooth the fibres and it is ready to use.

Here are some further useful techniques to try when making your sample felt.

The Pinch Test

As well as rubbing a finger across the surface fibres to see if they move, another way to check how well the fibres are bonding is to gently pinch them. If the surface fibres lift up from the main piece (but the main piece stays put), then you can see that they are not bonded together. But if the surface fibres lift along with the main piece, then this shows that the fibres are much better integrated. You can test this at any stage of the felting process; it's a useful indicator of how well all the fibres in a felt piece are bonding (not just the ones lying on the visible surface).

Straightening Felt Edges and Corners

For some projects you don't need to worry about keeping the edges of your felt straight, particularly if you are going to cut it up anyway to use. But if you deliberately want to keep your edges and corners as straight and neat as possible (especially if you are creating rectangle or square shapes, which have a tendency to flare out at the corners), then here are a few tips to help achieve that. You can deploy them at any time during the fulling process or as soon as the felt feels firm enough (but not too early as the felt is a bit too floppy to handle in these ways then). Having wet soapy hands always helps with these processes.

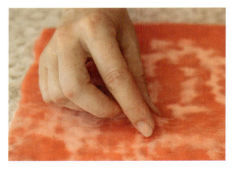

Pinch test 1: Surface fibres not yet bonded and pulling away from the main piece.

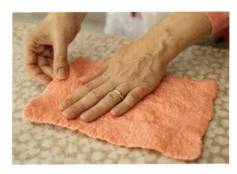

Edge tip 1: Stretch any receded areas along the edges with your fingers to create an even edge line.

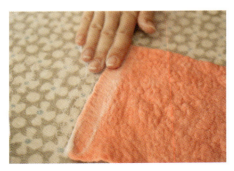

Edge tip 3: Rub two fingers along the edge (one just on top of the edge, one along the side) to firm and straighten the edge, or use an edge rubbing tool.

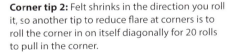

Corner tip 2: Felt shrinks in the direction you roll it, so another tip to reduce flare at corners is to roll the corner in on itself diagonally for 20 rolls to pull in the corner.

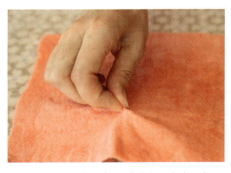

Pinch test 2: Surface fibres fully bonded to the main piece.

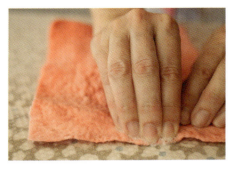

Edge tip 2: Shrink or reduce any extended areas against the edges by rubbing them along a textured surface, like a plastic mat or a washboard.

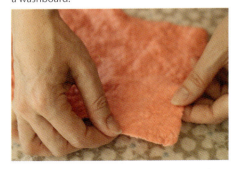

Corner tip 1: To reduce flared corners, stretch the edges either side of the corner to straighten it and reduce the flare.

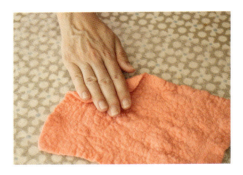

Chapter 2 – Getting Started 33

LAYOUT METHODS FOR WOOL TOPS

Now that we've gone through the basic wet felting process using Merino wool tops in the Overlapping Tiles Layout, let's look at this layout in more detail along with another couple of ways you might lay out your wool tops and why you might want to use each of the different methods. Note that the wet felting process is exactly the same for these layouts, the only difference is how you lay out the dry fibre at the beginning. Also note that the names I've given to the different types of layout are the ones I feel most accurately describe the process – you'll see the same layouts given various different names by other felters (there isn't really an industry standard for this).

Overlapping Tiles Layout

This is a standard layout for creating strong, even felt which works for most felting projects. Lots of overlapping wisps of fibre laid out like tiles or shingles creates lots of opportunity for all the individual fibres to bond. Changing direction for each layer (north to south, then east to west) also ensures a good bond between layers as the fibres are then lying in all directions. It doesn't matter which direction you start with, although I like to lay fibres in the final, uppermost layer in the most sympathetic direction to the design (for example, in the Hoop Art Project in Chapter 3 I laid the top layer of fibres running east to west, which was more consistent with a largely horizontal design). So, once you've worked out which direction you want the fibres in the final layer, you can work backwards to decide on the direction of the fibres in the first layer. Multiple layers (commonly you might use between two and four layers, alternating direction each time) also help to even out any thin or thick areas.

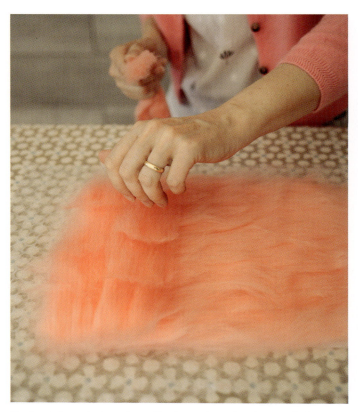

Starting to lay out wisps of tops fibre in an alternating direction for layer two of the Overlapping Tiles Layout.

Stretched-Out Layout

This is a good method for creating a single layer of very fine felt and gives a very cobwebby or lightweight effect (I particularly like to use it for lampshades). Just take your length of tops and stretch it out width-wise, taking time to thin out any thicker parts until the layer looks and feels even. It doesn't have multiple layers so it's a less robust method, although it can work well combined with a layer of fine fabric (as in nuno felting) or with a fine layer of embellishment fibre like viscose or bamboo on top, which gives it more stability. It can often be used to create items that need to drape well, such as scarves. You can really push how fine this layout will work, even splitting a length of tops in half lengthways to use just the smallest amount spread out as finely as possible.

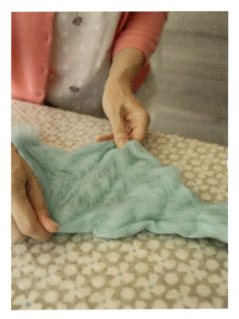
Initial stretching out of a length of tops fibre.

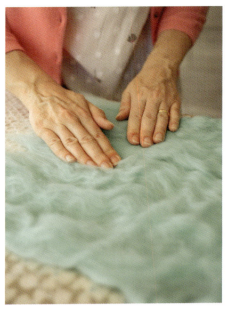
Gently stretching out thicker areas of fibre to thin them.

Filling in the wispy edge of the layer of tops fibre.

Chevron Layout

This is another method used to create very fine felt, usually with one layer of fibre and often combining it with a layer of fabric and/or embellishment fibre on top for stability. Lay out the wisps of fibres in columns, angled in a chevron or herringbone pattern and alternating the direction for each column, with the thicker pulled ends of the next column's wisps slightly overlapping the wispier ends of the previous column's wisps (or vice versa). The advantage of this layout is that it helps to give some stretch to the final felt, so is particularly useful for making clothing and similar items.

Starting the Chevron Layout on silk fabric to create nuno felt.

LAYOUT METHODS FOR WOOL BATTS

Now that we've looked at common layouts for wool tops, let's do the same for wool batts. The layout process is different because of the different form of the fibre. With tops, in which the fibres are lying in one straight direction along its length, laying wisps of fibres perpendicular to each other in each layer helps the intermingling and bonding of fibres. With batts, the fibres are already going in all directions, so we don't have to work so hard with our layout to achieve that intermingling between fibres and layers. Here are two main methods for laying out batt fibres, as well as some initial steps on preparing your fibre to make it easier to work with (NB I'm using variegated Finnwool batt fibre for all of these). Bear in mind again that the wet felting process is exactly the same as for wool tops, it's just the dry layout that differs.

Preparing Batt Fibre

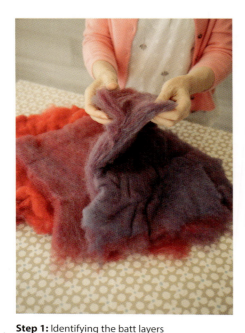

Step 1: Identifying the batt layers

The batt will have been carded into layers of fibre. Look at the edge and you should be able to see the distinct fibre layers.

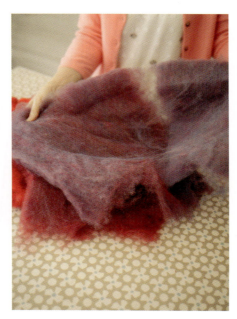

Step 2: Separating the batt layers

Start to peel apart the layers. Keep peeling them apart to divide them until each layer is quite fine and you cannot easily divide it further.

Step 3: Tearing the layers to size

For a large project, keep the layers the same size as the batt. For smaller projects, tear each layer into a more manageable size to make the fibre easier to handle.

Patchwork Layout

The standard way of laying out batt fibre is to use a patchwork style, placing together pieces of fibre to build up the overall shape and thickness you want. The advantage is that this is a much more freestyle (and quicker) layout than using wool tops, although you might find it harder to judge when you have laid out enough fibre and if the thickness is even. This is where weighing your fibre and dividing it into equal amounts before you start can be really helpful, because if you then divide up your project size into the same number of parts and lay one allocation of fibre in each area, you know that you will have largely laid out an even amount. Patting the fibre to check the evenness is also helpful, and you can infill with small pieces of fibre to even up any thin areas.

In terms of the overall thickness, you can use any number of individual layers to build this up, and it will depend on the hardiness you need for the end product as to how thick it needs to be. At a very minimum, make sure you cannot see the work surface through the fibre. You can also pick up the full thickness of fibre and squeeze it between your fingers to get an idea of what the final thickness will be. You may need to test out using different amounts of fibre before you get the desired result.

Building up a patchwork of pieces of batt fibre to create an A4-sized shape.

Papier Mâché Layout

The process of papier mâché involves building up overlapping pieces of paper held in place by glue, usually over some kind of shape or form to create a structure. We can use a similar concept in resist felting, by tearing up the batt fibre into small

Step 1: Tear the thin batt fibre layers into smaller, more manageable pieces.

Step 2: Aim to create similar palm-sized pieces.

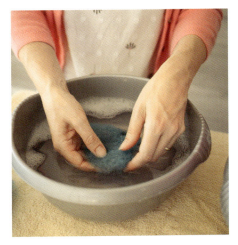

Step 3: Dunk a fibre piece into warm soapy water.

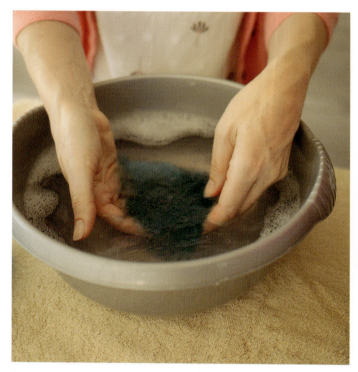

Step 4: Allow the fibre piece to soak completely and freely.

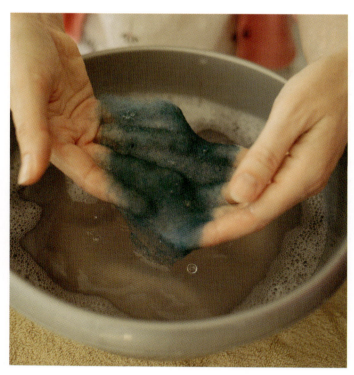

Step 5: Gently lift the fibre piece out of the water, still dripping and with wispy edges.

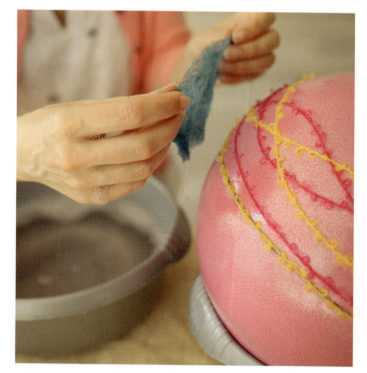

Step 6: Carefully place the piece on the ball, smoothing out the edges and any lumps.

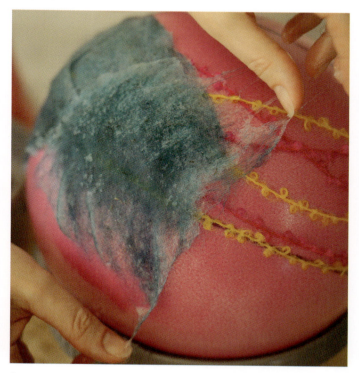

Step 7: Repeat with more pieces, overlapping slightly, until the ball is evenly covered.

manageable pieces and then adding them to a resist to create the shape. The pieces of fibre are held in place by soapy water. This is a really good method to use with resists (both flat and three-dimensional), as it helps to create a really tight layout around the resist. The previous pages give a run-through of preparing and adding fibre to a felting ball resist using the Papier Mâché Layout method.

It's also worth noting that this technique wouldn't work well if you tried to achieve it with wool tops, due to their fine, wispy nature and the fact that the fibres are running in the same direction. A wisp of tops has little structure to it, whereas a small piece of batt fibre has some inherent structure due to the integrated fibres within it, so you can dunk and place it much more easily.

FURTHER LAYOUT TIPS

Here are some general tips to help you with your fibre layout:

- Keep your hands dry: dry fibres stick to wet hands and it's then really difficult to lay them out neatly (except in the Papier Mâché Layout method, which works because both your hands and the fibre pieces are wet).
- Keep the fibre wisps or pieces thin with wispy edges: this helps all the fibres to bond more easily and creates a more even result. Spread them out with your fingers before laying them down and aim for fine, overlapping wisps rather than thick, lumpy ones.
- Having several thin layers usually helps to create a more even layout than having fewer thick layers.
- When using the felting ball, bear in mind that each layer is not literally made up of a single layer of fibre, but will be made up of multiple overlapping pieces (until you have used the full weight allocation of fibre for that layer). I generally use three layers of fibre.
- Pat the fibres throughout the layout stage to check for thin and thick spots and add more fibre wisps if necessary (regardless of whether you've already laid out the full weight allocation – the amounts I've included for each project are minimums). Unless you're specifically aiming for very fine felt, it's always better to err on the side of slightly too much than too little fibre. A thicker area will largely even itself out during the felting process, or won't be noticeable to the eye at least, but a thin area is always in danger of becoming a hole, which you really want to avoid.
- For larger, thicker, three-dimensional projects in particular (for example, those using the felting ball) which already use quite a lot of fibre, I've found that adding another 5, 10 or even 30g of extra fibre does not make much difference to the end result. There's a minimum ideal amount you need to provide for the structural integrity of the felted form, which I've recommended in the projects, but after that, if you need to add more for evenness purposes, add away as it is unlikely to adversely affect the end result.

HOW TO APPROACH A NEW WET FELTING PROJECT

If you are following projects designed by someone else, as in this book, you'll have a basic recipe to follow to help you achieve a specific end result. But at some point you'll want to start adapting these or creating your own projects entirely, so how do you go about that? Here are some things to consider before you start (which I've outlined separately, but which need to be considered together as they all have an impact on each other).

Structure

Having your desired end result and its future usage in mind will help you work out some of the structural aspects, such as: how soft and drapey, or hardy and sturdy does the finished felt need to be (which will determine which sort of wool fibre you use and how many layers you need); and do you want to create flat felt or a shaped form like a bag (for which you will need a resist)? Your approach to making a scarf, for example, when you would likely choose very fine and soft wool tops fibre like Merino, laid out in one thin layer, would be quite different to your choice of fibre for a hard-wearing bag, which needs to maintain a three-dimensional shape. In such a circumstance, you would probably choose a coarser wool batt fibre like Norwegian using multiple layers.

Surface Design

Once your core fibre base or background is decided, which means your basic structure for the felt is sorted, you can then add whatever embellishments you like on top to create your pattern or design. As they aren't really there to add impact on the structure of the piece (although a notable exception to that would be the fabric you add with nuno felting, which is often there to help provide structure to a thin layer of fibre), these don't have to be complete layers of materials; they can be purely decorative. If you decide to add a complete layer of surface design embellishments, bear in mind that this might add an extra thickness to the overall felt, which might be too much for your end result, in which case you might consider reducing the number of fibre layers to counteract this.

Of course, you might not want to include surface design elements at all and instead choose to use different colours of your wool fibre to create colour and pattern. Or your choice might be influenced by the specific embellishment materials you want to include. You might want to create a realistic design or image, so you would bring together materials to help create a particular end result. Or you might base your project on a particular colour theme. I often tend to go by colour and texture, so I pull out from my stash a range of materials in sympathetic colours to see how they will all look together and audition them until I'm happy with the combined selection. If a specific end result is important, it is a good idea to make a sample using the wool fibre and the embellishment materials so you can see how they will work together.

Colour Mixing

Colour mixing is an interesting aspect of wet felting that you might not have thought would be important, but it can have a major influence on the end piece. First, it's important to understand that wool fibres, when they bond together, do not just bond within their layers or going left and right. They bond in all directions throughout the full thickness of the fibre, which includes up and down through the layers. So, if you're creating a piece with many layers, it makes a difference what colours you use in each layer. If you choose the same colour for all your layers, then you will end up with a pure version of that colour in your end piece. But if you use different colours for each layer, the colours will merge together. So, for example, if you use two layers, one black and one white, you will end up with a halo of black on the white side (and vice versa on the other side), with neither colour remaining pure. You need to be aware that this will happen and choose your colours accordingly. When making a felt bag, for instance, I usually use three layers of fibre. I tend to use exactly the same combination of colours in the outer and middle layers, to give that colour combination more strength and purity, and a different colour for the inside layer. A halo of the inside colour will still appear on the outside by the end (and vice versa), so I ensure that all the colours I include are sympathetic to one another.

This colour mixing also has an impact on your embellishment materials on the surface. Fibres from both the surface wool, as well as those coming through from the reverse of the piece, need to grab hold of the embellishment materials to bond with them and felt them in. This process also means that the embellishments are being slightly covered by the wool fibres and, the more felted and fulled the piece, the further the embellishments will sink into the wool fibre. This usually has the effect of muting down the colours of the embellishments. For this reason, I generally recommend going a bit brighter than you think you want with your embellishment colours to counteract the impact of the wool fibres on them. Again, making a test sample is a good idea to check how your fibre colours, and your fibre colours combined with specific embellishment materials, will felt together.

Shrinkage

Shrinkage is another major consideration in any felting project. But the answer to the question, 'How much will this shrink?' isn't hard and fast. It's the compacting process of the fibres during the fulling stage that gives the finished felt its thickness and strength, as well as adding to the pattern and texture of the surface. But it can be unpredictable and there are many variables to consider, such as the type of wool (some felt more tightly than others) and whether you want a really hardy, thick, fully fulled result (for example, for a pair of slippers) or a thin, barely fulled result, which won't get any wear (such as for an artwork that will go behind glass). It also makes a difference whether you need a very specific end size with no room for error (like slippers) or the end result doesn't make much difference a few centimetres either way (as in a bag).

Your own techniques as a feltmaker can also affect the shrinkage rate, as can your choice of embellishment materials and how you lay them out. This is why it's so important to make samples and test out both your wool fibre and, ideally, your wool fibre along with the embellishment materials you are using, to see how everything combined impacts on the final result.

So how do we calculate shrinkage? There are two main calculations you'll want to use: the **shrinkage rate** (or **percentage change** in mathematical terms) of a particular wool fibre in order to give the desired effect you want, and the **reverse percentages** to calculate what the original size should be when this is unknown.

The Shrinkage Rate

We can calculate this by creating a small sample and carefully measuring the size both before and after felting. So, taking the A4-sized pink Merino wool tops sample above as an example:

- The percentage change is calculated by dividing the difference between the two sizes by the starting size, then multiplying by 100.
- So, if we apply that to one of our sample measurements, the starting width was **30cm** and the finished width is **21cm**. The difference between the two figures is **9cm** (30–21 = 9).
- (The difference) **9** ÷ **30** (the starting width) = 0.3 × 100 = **30 per cent**.
- It's worth noting that shrinkage isn't always even in all dimensions. If we apply the same formula to the height, we get a slightly different shrinkage rate (the starting height was **21cm** and the finished height is **15cm**): 21–15 = 6; 6 ÷ 21 = 0.285 × 100 = **28.5 per cent**.
- For our purposes in calculating the rate, I'd err on the higher shrinkage figure, that is, 30 per cent (you can adjust the odd percentage difference during the fulling stage).

Reverse Percentages

Now that we know our pink sample gave us a shrinkage rate of around 30 per cent, let's look at the reverse percentages to see how we calculate the size of the fibre layout we need to start with, using the same sample piece sizes as an example. Our desired finished size is 21cm × 15cm. Here's how we can calculate how big the starting size should be:

- Reverse percentages help us to work out the starting size of our fibre after it has shrunk. They are calculated by taking the finished size and dividing that by the percentage of the size that remains after shrinkage, then multiplying by 100, to work out what 100 per cent (the starting size) of the finished size would be.
- If we apply that to our sample piece, starting with the width, we know that the shrinkage rate from our sample is 30 per cent, which means that **70 per cent** of the starting size remains (this is the **remaining percentage size**). So, if we divide the finished width size by the remaining percentage size and multiply by 100 we get the starting width: **21cm** (finished width) ÷ **70** (remaining percentage size) × 100 = **30cm** (starting width).
- Similarly, if we apply the same calculation to the finished height size: **15cm** ÷ **70** × **100** = **21**, our starting size needs to be **30cm** × **21cm**.
- You can double check your calculations by subtracting 30 per cent (the shrinkage rate) from each of the starting sizes, and you should arrive at the same finished size figure. So, for the width, **30** (starting cm size)–**9** (30 per cent of 30) = **21cm**. And for the height, **21** (starting cm size)–**6** (30 per cent of 21) = **15cm**.
- Now you might be wondering whether it would be simpler to just add 30 per cent to the finished sizes to work out the starting sizes. Sadly, this won't work as 30 per cent of the finished size is not as much proportionally as 30 per cent of the bigger starting size. If we try it, you'll see: for the width, **21** (finished cm size) + **6** (30 per cent of 21) = **27cm** (and not **30cm**). And for the height, **15** (finished cm size) + **4.5** (30 per cent of 15) = **19.5cm** (and not **21cm**). So, if you used those calculations and felted the piece in exactly the same way as you had made your sample, your finished size would end up slightly too small. Of course, you could try and adjust this by shrinking it less, which is an option. But bear in mind that this is a small sample piece – if you were miscalculating on a much bigger piece, you would really notice the lost difference and wouldn't easily be able to recover it.

Apologies for bringing maths into this, but I hope you can see how important it is to create samples and to calculate shrinkage properly, especially if you are aiming for a specific end size.

All that being said, if you aren't aiming for a specific end size you can be a bit more relaxed about shrinkage. You're obviously aiming to shrink a piece enough so that it is well felted and the fibres won't come apart or the surface embellishments peel away from the surface. If your aim is to create something hard-wearing, it's probably better to heavily felt it. But if the piece isn't going to take much wear and tear (like an artwork) then you can felt it very lightly, just to the point of being felted or even underfelted, and that shouldn't be a problem. Once you've started the fulling stage and you're seeing the shrinkage signs (the piece getting smaller, feeling thicker and developing a bumpy texture), you've got quite a lot of scope to make a piece that's felted from loose to well to fully.

You can also use shrinkage to your advantage to create different effects from your embellishments, as a heavily fulled piece will cause the surface design to sink more into the fibre, whilst a lightly fulled piece will leave the embellishments much more visible and lying on the surface of the wool (*see* the Journal Cover Projects in Chapter 4 for a comparison of this using viscose fibres).

The upshot is that there's a structural aspect to shrinkage, to create the right amount of shrinkage for the end result, but also a design element depending on how you want your embellishments to appear in that end result. The good thing is that you have full control over this as a feltmaker.

Here are a few final thoughts and tips about shrinkage:

- The less wool fibre you use, the greater the shrinkage. You will get more shrinkage from a thin, fine layout (like a scarf) than from a large, thick layout. The reason is because if there are fewer neighbouring fibres for each fibre to interlock with, they have to move closer to each other to achieve full bonding.
- You don't have to shrink a piece of felt evenly if you don't want to, although this is mainly what we're looking to do during the felting process (hence rolling the felt an even number of rolls on all sides). Sometimes, despite you treating the felt equally on all sides, it doesn't respond; a square shape might end up as a rectangle for instance. To counter this, it's helpful to know that felt shrinks in the direction you roll (or agitate) it. To reduce the length of the longer sides and bring the shape back to more of a square, you would just roll the felt on the two shorter edges. So, if you're trying to maintain a particular shape it's useful to know that you can shrink some edges more or less to achieve the right outcome.
- Always save a little bit of shrinkage for the rinsing stage. Just before you're ready to stop fulling, stop and rinse out your piece. Due to the extra manipulation the felt gets during rinsing (when you're squeezing out soap and water, using warm water, rolling the felt in a towel and reshaping it), there's a risk that you end up overfelting the piece. So if a precise end size is important, rinse it just before it's ready. Once you've dried it off in a towel and reshaped it, you'll find it will have shrunk just a fraction more. And if you think it needs further shrinking, you can use some of the usual fulling techniques at that point anyway, but at least you will have full control over any further shrinkage.

DEVELOPING YOUR WET FELTING CONFIDENCE

By now I hope that you are starting to understand how the wet felting process happens and the things you need to consider when starting a new project. I've also tried to explain why the different aspects are important, which is particularly relevant if you are keen to achieve a beautifully even, well-considered result. It's my version of best practice, so following this and the project recipes set out in the next three chapters should ensure you get good results and will help you develop your confidence in the process and in using the different materials.

However, part of the fun of this whole technique is to experiment and be creative and see where this takes you. So, before you even start, I just want to make it clear that, aside from the three key principles of applying water, soap and friction to your wool fibre, there are no WRONGS in wet felting. What a relief! Although I might recommend a thin, stretched-out layer of Merino wool tops to make a scarf, if you decide to use three patchwork layers of a coarser batt fibre instead IT IS NOT WRONG! The felting process will still work, and it might give you just the result (a thick chunky scarf) that you want. Or, in terms of the layout, if you're not worried about having a very even felt in the end, or perhaps you quite like the idea of a very bumpy, textural surface, then lay out your wisps of fibre in any direction you like, or in any shape or configuration. Just make sure they overlap in plenty of directions and the thickness feels right for your end purpose. Again, it's not wrong, if you follow the felting process it will still felt.

Another area you can adapt is the surface designs shown for the projects in this book. For example, you might want to create a purse like the Fringed Clutch Purse Project in Chapter 4, but you don't have any batt fibre or any of the embellishment materials, although you do have a big collection of Merino tops. You could use the same amount of fibre as stated in the project to create your fibre base/background out of Merino, then use lots of differently coloured strips of Merino tops on top to create interesting patterns on your purse and create a fringe by overhanging the ends and rubbing them separately to create thin cords. I'm a firm believer in using what you've got available (you don't need to go out and buy lots of new supplies). So feel free to adapt the projects to the materials you've got – and if you're not sure if something will work, try it (what's the worst that can go wrong?). The content of this book is meant to guide you, not to constrain you into thinking there is only one way of doing things.

The same goes for the actual techniques of felting. Once you've got soapy water into your wool fibre (so you've satisfied two of the key principles), you've got a lot of options for satisfying the third principle: friction. There are multiple options for rubbing the felt, with all sorts of tools to use: your hand, a cloth, a wooden rubbing tool, a hair scrunchie, a piece of textured plastic mat, a sander; and you can rub through net, mesh, plastic or bubble wrap. Rolling offers the same scope for different tools: you can roll your felt around a core (like a towel, a rolling pin, a pool float/noodle) or roll your felt within something, like a bamboo mat, or just roll the felt up on itself. You might have watched videos and tutorials from different felters and felt confused because everyone is doing a slightly different version of wet felting. That's because everyone has been experimenting with the technique they like best and come up with their own recipe for wet felting a particular type of thing. But none of them is wrong, it's just whatever suits – and sometimes felting processes are determined by health/energy issues and the desire to avoid a certain technique (for example, because of back-related issues).

So keep an open mind about different tips and techniques you will see from different felters, and don't be put off or overwhelmed by people doing things differently. Just because one felter might always use a sander for the initial felting stage when making a large scarf doesn't mean that's the only way to do it – you can achieve a similar result by rolling the felt around a pool noodle (it might just take a bit longer). Just go back to the core principles of using gentle techniques first to encourage initial bonding, leading to stronger agitation techniques later to move into the full bonding/shrinking stages. The techniques I've used in the projects are the ones I've found to be the simplest and involve the most easy-to-find equipment. Gaining as much experience as you can of different techniques and materials is really useful to any felter, as is sampling and experimenting to test how things work and also to find out how they work best for you. If I can recommended just one thing to help you on your felting journey, it would be to experiment (and have fun)!

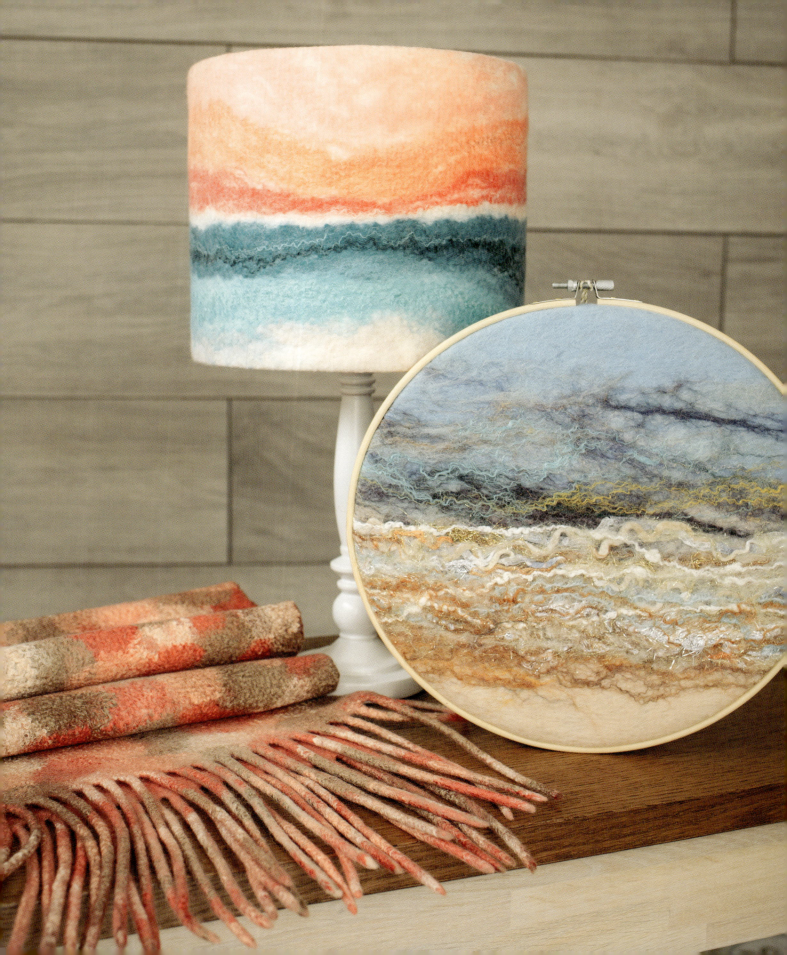

CHAPTER 3

2D/FLAT WET FELTING

Now that we've learned the different processes to make a flat piece of felt, let's look at how we can apply them to some example projects. We're also going to make our projects more interesting by adding a surface pattern or design. There are many ways we can do this, but a really simple way to start is just by using different coloured wool fibres. So consider the wool fibres in all their amazing colours exactly as you would view a set of artist paints. Just as a painter begins with a blank canvas or piece of paper, we can start with a plain layer of wool fibre as our canvas. And just as a painter then adds paint to their canvas to create a pattern/design/picture, as felters we can add wisps of other fibre colours on top of our background fibre to create our design.

With our colour palette decided, we might then want to add some highlights or outlining to our design, or to create texture or some stronger shapes or patterns. We can do this by adding other textile elements, such as different animal or plant fibres to add sheen and pattern (for example, Mulberry silk or viscose fibre), fabric to add texture and shape (such as silk or lace) or yarns to add lines and outlining (using fine wool yarn or a sparkly acrylic yarn). Each of these elements needs slightly different treatment to ensure that the felt will incorporate them effectively, but by building up our felt designs as we use them, we can create highly textured and patterned felt as a result. I'm going to show you how to use some of them in this chapter, and the different results you might expect from each.

Although this chapter is about flat felting, I've also introduced structure in the first two projects, which show you how you can use your flat felt to create structural pieces through the use of different finishing materials (to create hoop art and a lampshade, respectively).

USING MERINO WOOL TOPS FIBRE

We're going to stick with using fine Merino wool tops fibre for our exploration of flat felting in this chapter, because by its nature a piece of flat felt probably isn't going to be used for a hardy end result: it's likely to be for a more decorative purpose (like a picture that might be covered in a frame) or for when we deliberately want a thin, fine, translucent piece (like a lampshade) or for something soft and drapey because it will be worn next to the skin (like a scarf). Of course, you can make flat felt out of any wool fibre you like, but to make our choice less complicated and to suit the end purpose of the projects shown in this chapter, we're solely going to use Merino wool fibre. Merino is probably the easiest fibre to get hold of and comes in the most available colours, plus it's easy to felt and work with because it's a soft, fine fibre that felts easily, so it's a really good all-round fibre for wet felting.

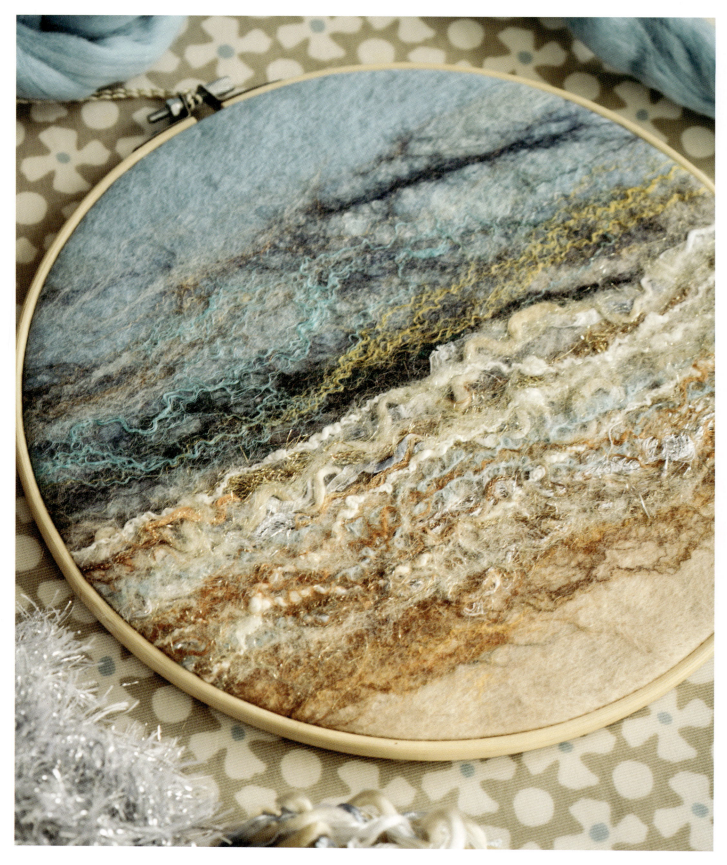

HOOP WALL ART PROJECT

Let's start off by creating a decorative piece of felt in an abstract seascape-style design, which we'll mount in an embroidery hoop. Using an embroidery hoop is a great technique to add an instant frame and neat edge to your work. You can choose exactly the part you want to include, and somehow taking just a portion of a piece gives it more impact. Hoops come in a variety of sizes, are inexpensive and easy to hang anywhere using a cord or ribbon.

The felt needs to be relatively thin to be able to mount in the hoop (if it's too thick the hoop screw won't tighten), but still needs to be thick enough not to have holes or thin spots in it. We're going to aim for two fine layers of coloured fibre as our base and background using the Overlapping Tiles Layout (see Chapter 2), with our design of coloured fibres and other embellishments on top. These include: a thin layer of art batt to set some background colour; wool and sparkly synthetic yarns for our main seascape; and viscose fibres for highlighting. This is a good example of layering up different materials to create a rich and interesting result.

I've explained in detail below how I built up this seascape design, but you can create yours however you prefer and using whatever embellishments you have to hand. Perhaps collect up a variety of surface design embellishments that complement each other and give an overall colour feel of a beach landscape (sky, sea, sand, and so on) and then create a design from those. Once you're happy with your design layout, I'd recommend adding a wispy layer of fibre on top to help sandwich everything (I used a sparkly Merino blend for this).

An advantage of this project is that we don't need to worry about neatening the edges of our felt as we'll be cutting those off, so we're just going to leave them wispy. Size-wise, you'll find the felt doesn't shrink evenly in this project, so our square starting size (48cm wide × 48cm high/19" × 19") becomes a rectangle in the end (42cm wide × 38cm high/16.5" × 15"). This is because the amount of surface design embellishments going across the piece hinders the felt from shrinking along its width. You'll get more shrinkage in the two fibre-only strips of felt above and below the embellishments, which means the height shrinks more. There's flexibility with the project, however, as you can adapt the felt size to whatever size hoop you're using. You can also adapt your hoops to fit the felted piece best. I tend to have a few sizes available and make a large enough felted piece to cover all the possible sizes. That way, I can use

WHAT YOU WILL NEED

Materials
- Approximately 20g each of dyed Merino wool tops in two main background colours for layers one and two (I've used sky blue and light sandy beige, 10g of each colour per layer = 40g total)
- Approximately 2–3g of art batt fibre (I've used a stormy sea-coloured batt with wool fibre colours ranging from light blue to turquoise to navy blue, with copper sparkle fibres, plus golden yellow and turquoise viscose fibres)
- Approximately 1–2g of Merino glitter fibre (natural off-white Merino tops blended with gold Stellina fibre)
- Up to 1g each of viscose fibres in complementary colours (I've used three of these to match the art batt colours in golden yellow, turquoise and copper)
- 1–2m (40"–80") each of two mohair bouclé or slub wool yarns (these are high content wool yarns. I've used a variegated blue bouclé yarn and a white slub yarn)
- 1–2m (40"–80") each of two sparkly knitting yarns (these are polyester/metallic mix knitting yarns. I've used a silver tinsel yarn and an autumn brown nylon/polyester eyelash yarn with gold sparkle)
- 1–2m (40"–80") of another decorative yarn (I've used a variegated blue/white polyester ribbon yarn)
- 26.5cm (10.5") diameter round embroidery hoop (I used a bamboo one 9mm/0.38" thick)
- 30cm (12") length of cord or ribbon for hanging

Equipment
For the wet felting
- Minimum 100cm × 50cm (40" × 20") piece of small bubble bubble wrap (or two 50cm × 50cm/20" × 20" pieces)
- Tape measure
- Scales
- Small scissors
- Spray bottle
- Washing-up liquid and warm water solution
- Rubbing tool
- Rolling tool
- Tea towel
- Large towel

For the hoop-making
- Iron and ironing board
- Large scissors
- Glue gun

whichever hoop frames the piece in the best way. The only extra thing to remember is that whatever the size of hoop you use, you'll need a minimum excess around the whole edge of 4cm (1.5") to account for constructing the hoop art. So, for my 26.5cm (10.5") diameter hoop I needed a minimum round size of felt 34.5cm (13.5") in diameter (although you would ideally want this a bit bigger to enable you to place the hoop in the best position).

The finished hoop art size is 26.5cm (10.5") in diameter.

Step 1: Assembling your materials

Collect your Merino wool tops, wool art batt and glitter fibres, viscose fibres and yarns together and ensure that you are happy with your colour palette before getting started. Divide each 20g colour allocation of Merino wool tops in half lengthways, reserving 10g each of blue and beige fibre for each of the two main fibre layers.

Step 2: Laying out the background fibre (layer one)

On a hard, water-resistant work surface, open out the bubble wrap, smooth side up. Position it so that you use half as your 50cm × 50cm (20" × 20") working area. Lay out fibre in fine overlapping wisps oriented north to south to build up a square 48cm × 48cm (19" × 19"). Use blue for the top half, beige for the lower half.

Step 3: Laying out the background fibre (layer two)

Repeat Step 2 to create the second layer of fibre, keeping the blue top half and beige lower half, but this time laying the fibres in an east to west direction. Aim to create an even layer of fine, overlapping fibre. Keep patting to test for thin areas and add extra wisps to infill these until the overall thickness of the fibre feels even.

Step 4: Adding the art batt design area

Aim to create a surface design area on top of the fibre, 18–20cm (7"–8") high and the width of the fibre square, placed centrally along the blue/beige fibre colour join. Start by adding a thin layer of art batt. Peel off a 50cm (20") minimum section and spread it apart to make it finer and wispier. Add all or strips of it to create the design area.

Step 5: Adding the yarns

Add up to three lengths of each yarn across the bottom half of the design area (on top of the beige fibre area only). Keep the yarn lines organic and wavy, ensuring they overlap the edges of the fibre each side by 1–2cm (0.5"). Adding the non-wool yarns first before the wool yarns helps to bond them within the layers.

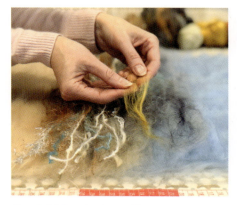

Step 6: Adding the viscose fibres

Add wisps of viscose fibres on top of the design area to add highlights. Treat them the same as the wool fibre, spreading wisps apart with your fingers, creating wispy shapes or peeling fine, thin strands from their length before adding them to the design. NB I used turquoise and yellow in the top half, copper in the lower half.

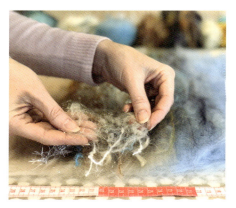 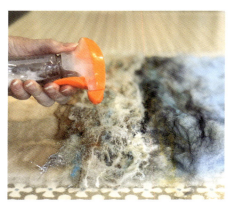 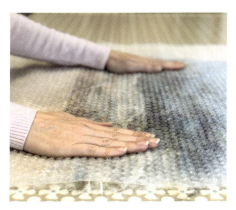

Step 7: Adding the Merino glitter fibre

Peel off a 50cm (20") minimum strip of the Merino glitter fibre and spread it apart to make it finer and wispier. Add all or strips of it to the lower half of the design area only, to help lock in all the different surface design embellishments. Finish all the dry layout of the design, adjusting until happy with the arrangement, before moving on.

Step 8: Wetting the fibre

Gently spray warm soapy water solution all over the fibre square until soaked. Spray from above to avoid disrupting the fibres and make delicate adjustments with your fingertips to reposition stray fibres. Fold the other half of the bubble wrap over the fibre rectangle to sandwich it.

Step 9: Soaking the fibre

Press down gently to disperse the soapy water throughout the fibre, either using your hands or with the rubbing tool. Then turn the whole fibre package over, peel back the bottom layer and spray the reverse until soaked. Replace the bubble wrap and again press down, ensuring the fibre is completely soaked through and flattened.

Step 10: Rubbing the fibre

Turn the package back to the front, spray the bottom of the rubbing tool to help it move more easily, and gently rub it all over the package through the bubble wrap for 10–15 minutes whilst a soapy lather develops. Then turn the package over to repeat on the reverse. Turn the package back to the front and peel back the bubble wrap.

Step 11: Final rubbing

Check the yarns and fibres for movement by gently rubbing a finger over the surface. If there is considerable movement, replace the bubble wrap and continue to rub until the fibres are mostly staying in place. Then remove the bubble wrap and rub all over with your hands on both sides for 5–10 minutes until none of the fibres are moving.

Chapter 3 – 2D/Flat Wet Felting

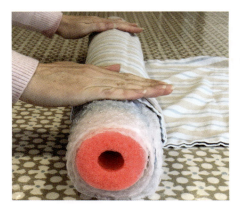

Step 12: Rolling the fibre

Replace the top layer of bubble wrap to sandwich the fibre. Roll up the package around the rolling tool, then roll the whole lot up in a tea towel. Roll the package away from you to arm's length and back again, counting as one roll. Roll 100 times. Unwrap the package and gently tug the fibre back into shape if misshapen.

Step 13: Continuing to roll

Turn the package 90 degrees clockwise and repeat Step 12 three more times until the fibre has been rolled 100 times on each edge. Then turn over and repeat on the reverse, to make 800 rolls in total. Unwrap the package, discard the bubble wrap and squeeze some of the excess water out of the fibre, which is now becoming felt.

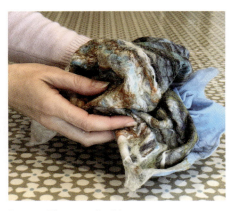

Step 14: Throwing the felt

Reshape the felt. Loosely pick it up and throw it down hard onto the work surface approximately 300–500 times, to shrink and thicken it, in blocks of 100 (throw 100, reshape, throw 100, and so on). Stop when the felt has shrunk to no smaller than 42cm wide × 38cm high (16.5" × 15") and the surface has developed a natural crinkle.

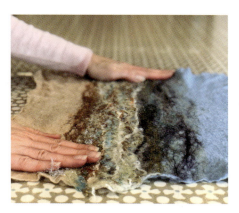

Step 15: Finishing the felt

Rinse the felt under warm running water, or soak in a bowl of warm water, until the water runs clear. Squeeze out excess water by rolling the felt up in a dry towel, then reshape and leave to air dry. Once dry, steam iron flat on the reverse (to avoid melting any of the sparkly yarns) and it is ready to use.

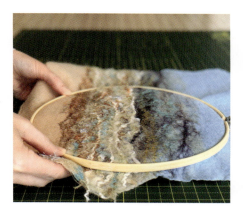

Step 16: Positioning the hoop

Loosen the hoop screw and separate the outer and inner rings of the hoop. Position the outer ring on top of the felt design until happy with the placement. Place the inner ring beneath the felt, exactly underneath the outer ring. Press the outer ring down onto the inner ring and tighten the screw slightly with your fingers to secure.

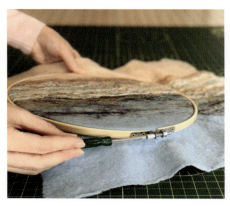

Step 17: Securing the hoop

Gently stretch the loose felt all around the hoop to pull it tight within the hoop and adjust the design placement slightly if necessary. Ensure that there is at least 2cm (0.75") of excess felt all around. Once the fabric is taut across the hoop, use a screwdriver to tighten the screw as far as it will go to secure the felt in place.

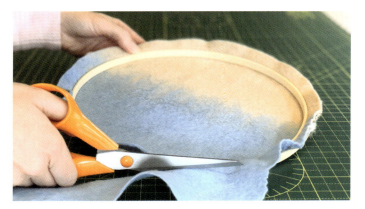

Step 18: Neatening the edges

Turn the hoop to the reverse and carefully cut the fabric around the edges of the hoop, leaving a 2cm (0.75") strip of excess felt around the entire edge. NB The aim is for the cut fabric edge to neatly sit inside the reverse edges of the hoop, so if your hoop has deeper edges you may need to increase the size of the excess fabric strip.

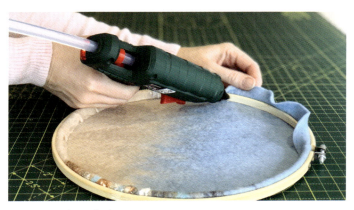

Step 19: Finishing the hoop

Use strong textile glue or a glue gun to secure the excess felt to the inside of the hoop edges on the reverse. If using a glue gun, glue short sections at a time, then quickly fold the excess fabric inwards over the edge of the inner ring and hold for a few seconds to secure. Once complete, attach a hanging cord around the screw.

Project Variation

HOOP WALL ART COLLECTION

One variation of the hoop art project to consider is to make more hoops using the same or similar materials, but in different sizes. Hoop art can look really effective in groups, so I made a further piece of embellished felt in exactly the same way and created two smaller hoops to go with the main original, measuring 20.5cm (8") and 13cm (5") in diameter respectively.

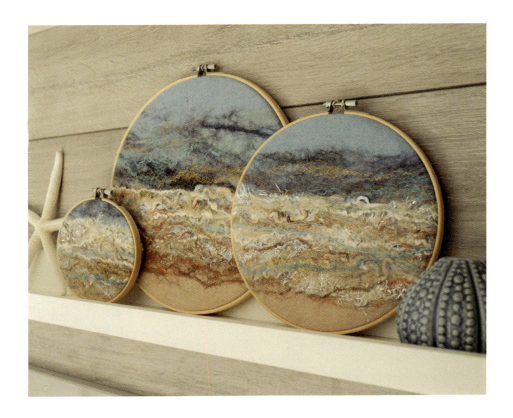

Project Variation

ORCOMBE POINT HOOP ART

I created another hoop art variation using two different surface design techniques. The first creates raised texture in the felt by the addition of some thick prefelt shapes underneath a top layer of fibre. The second is to add surface embellishments after the felt has been made, which have been either glued, sewn or needle felted in place.

This variation is also a beach-themed design, albeit a more literal representation of my local beach at Orcombe Point in Devon. It marks the start of the Jurassic Coast World Heritage Site and has very distinctive Triassic-period terracotta red cliffs. Orcombe Point is accessible only at low tide, so is also characterized by seaweed-covered rocks in a very striking green. I wanted to create an art piece that reflected the colours and textures of this beach. Here are the main steps showing how I put this together:

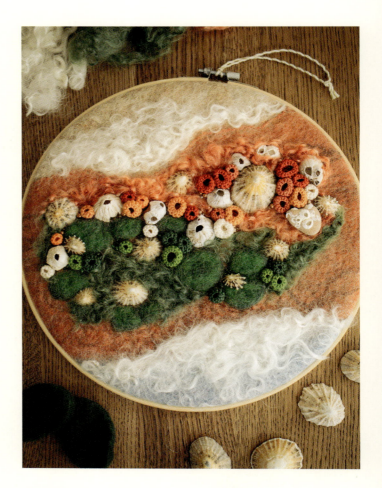

- To make the felt base fabric, I used Finnwool batt fibre in colours to reflect the beach, sea, cliffs and rocks, with some wisps of Merino glitter tops (Merino mixed with Stellina glitter fibre) in gold and blue on top for some sparkle. I also included some white curly mohair locks and white wool yarn.
- To create the effect of rocks, I cut out shapes from a thick piece of dark green prefelt, laid these on the wool fibre base, added some bright green fibre on top and then felted the piece in the normal way (rubbing, rolling and throwing). The main difference was that during the initial rubbing (and whenever I was reshaping the felt throughout the process) I spent extra time focusing on the 'rocks' and rubbing the flat areas around them, to enhance the raised shapes as much as possible.
- I collected some small pieces of rock, barnacles and limpet shells from Orcombe Point to include in the piece, which I glued in place with textile glue.
- A key part of the design was the inclusion of small, crocheted urchin shapes, made by a talented crochet artist (Lisa at Funky Bunny Designs). I sewed these in place.
- The final steps were to needle felt more mohair curly locks onto the piece to represent the terracotta red cliffs, green seaweed and white waves. Finally, I stitched some seed beads in place around the main design elements.

Design inspiration: red cliffs and green rocks of Orcombe Point at low tide.

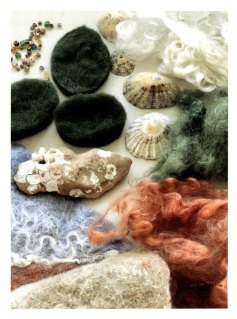
The finished felt, prefelt 'rock' shapes and some of the embellishment materials.

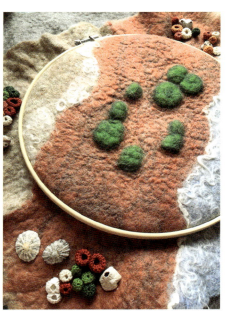
The felted base fabric with raised felt rocks arranged in the hoop.

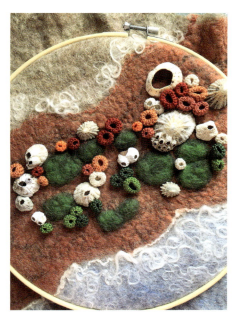
The rocks, barnacles, shells and crocheted urchins glued or stitched in place.

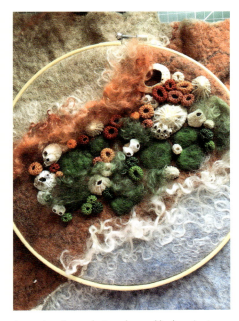
Arranging the mohair curly wool locks prior to needle felting.

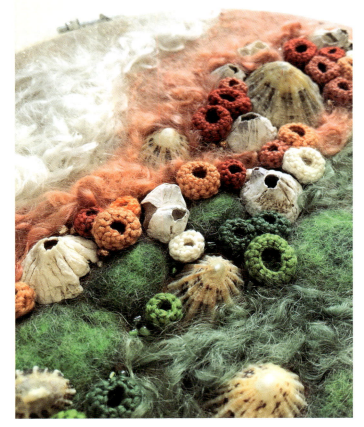
Detail of the finished hoop art piece.

Chapter 3 – 2D/Flat Wet Felting 53

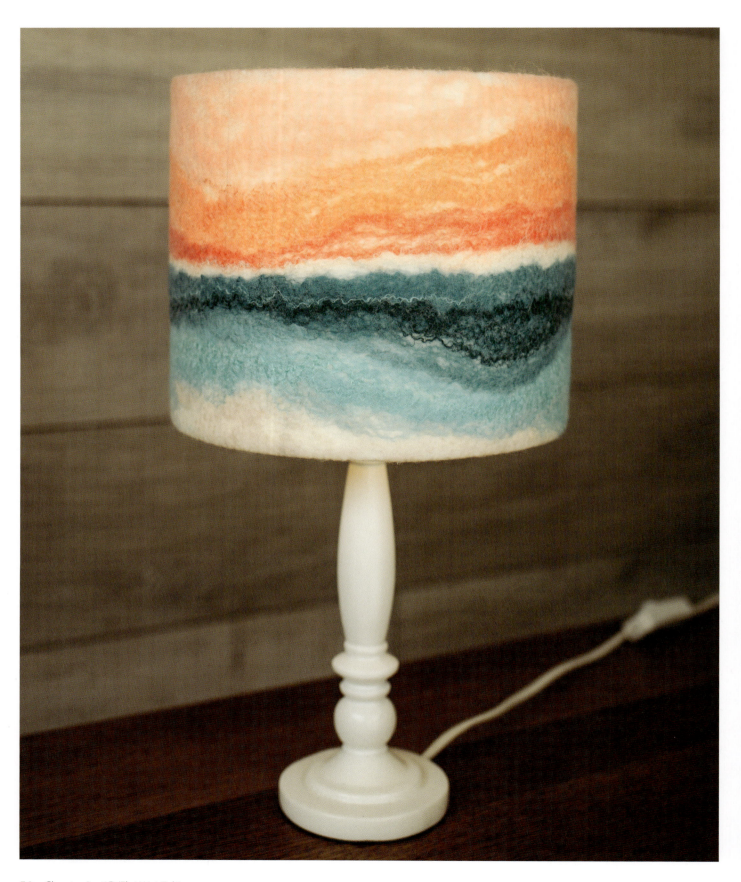

SEASCAPE LAMPSHADE PROJECT

We're changing our layout process for this next flat felting project by creating a much larger piece of flat felt, but one which is also much thinner. We're going to make a very fine, translucent piece of flat felt based on another seascape design that we're going to assemble into a lampshade using a kit. I love making felt lampshades because there's no better way of seeing the beautiful, individual wool fibres in all their crimpy, organic glory than when a light is shining directly through them – have a look at the photos of lampshades in this chapter and you'll see what I mean! But there's a narrow line between fine and translucent and so thin there are obvious holes. So we need to be mindful here of not just the pattern and design, but also making sure the basic structure and form of the felt we create is right for a lampshade.

My seascape design is inspired by a photograph I found online of a very simple, almost abstract view looking out to sea in coral pink and turquoise colours. The plan is to recreate the feel of this seascape in a piece of decorative flat felt using two layers of fibre in total. Layer one is the base layer, using undyed fibre in the Stretched-Out Layout (*see* Chapter 2). This base layer creates our main structure (that is, a piece of felt that won't fall apart or have holes) and helps act as a translucent layer to highlight the pattern/design on top created by the second layer, which will be made of different colours. Layer two will provide the design and will completely cover layer one, but in a very wispy, fine way (the finished lampshade in this project has a 25g undyed layer one, and a 15g coloured design layer two on top). We're then going to add some wisps of viscose fibres in coordinating colours as highlights/lowlights on top. Viscose fibres are lovely to use with lampshades: when the lamp is off, they create a little bit of sheen to contrast with the matte wool fibres; and when the lamp is on, their fibres make beautiful, visible organic patterns.

The kit we're going to use makes a finished lampshade approximately 20cm wide × 18cm high (8" × 7"). Please refer to the manufacturer's instructions for assembling the kit, plus my additional notes in the steps below. If you decide to use a different sized kit, or you're covering an old lampshade frame, just remember to scale up or down the size of your felt accordingly (and if you're not using a kit, please do ensure that your lampshade meets fire safety regulations). I've used seven shades of undyed and dyed Merino wool tops, plus four colours of viscose fibres, but you can use as many as you like.

The finished felt size for this project is a minimum of 68cm wide × 24cm high (27" × 9.5").

WHAT YOU WILL NEED

Materials

- Approximately 100cm (40", 25g) length of undyed Merino wool tops for layer one, plus up to 5g extra for infilling and layer two if needed
- Approximately 15g dyed Merino wool tops in your chosen colours for layer two (I've used seven colours: undyed, oyster white, teal blue, turquoise blue, dark coral pink, mid-coral pink and peach)
- Up to 1g each of viscose fibres in your chosen colours (I've used four to match my wool colours: oyster, dark teal, turquoise and peach)
- 20cm wide × 18cm high (8" × 7") Dannells Drum Shape Lampshade Kit or similar

Equipment

For the wet felting

- 100cm × 80cm (40" × 31.5") piece of small bubble bubble wrap (or two 100cm × 40cm/40" × 16" pieces)
- Scales
- Tape measure
- Spray bottle
- Washing-up liquid and warm water solution
- Rubbing tool
- Rolling tool
- Tea towel
- Large towel

For the lampshade-making

- Iron and ironing board
- Cutting mat
- Large cutting ruler
- Flat head quilting pins
- Rotary cutter
- Scissors
- Textile glue (I used Gutermann HT2 Textile Glue)

USING THE STRETCHED-OUT LAYOUT FOR LAMPSHADE FELT

We could, of course, lay out our base layer in the more common Overlapping Tiles Layout for this project. However, because every fibre ends up being on show when the lampshade is lit, I've found that the overlapping tiles can bring a somewhat unnatural, man-made and uniform aspect to the fibres, which doesn't quite lend itself to showing them off. So I prefer to lay out my base layer a bit differently, using the Stretched-Out Layout, to keep the organic nature of the fibres visible when lit.

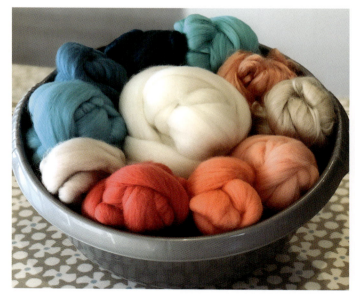

Step 1: Assembling your materials

Collect your Merino wool tops and viscose fibres together and ensure that you are happy with your colour palette before getting started. The viscose fibres, which will act as highlights for the wool fibres, should ideally complement the colours of the Merino wool tops.

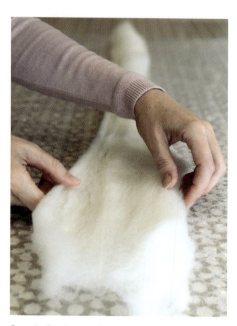

Step 2: Getting ready

On a hard, water-resistant work surface, open out the bubble wrap, smooth side up. Position it so that you use half as your 100cm × 40cm (40" × 16") working area, leaving the other half ready to fold over onto the working half later. Lay the 100cm (40") length of undyed Merino wool tops on top of your bubble wrap working area.

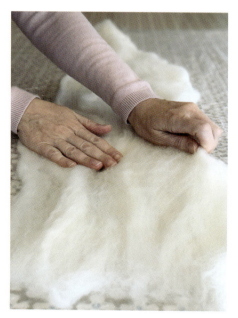

Step 3: Laying out the base fibre (layer one)

Gently stretch the Merino wool tops apart to expand the fibre from a tube to a rectangle shape measuring a minimum of 90cm × 30cm (35.5" × 12"). Spread out any lumpy parts to create an even layer of fine fibre. Pat to test for thin areas and add extra fibre wisps to infill these until the overall thickness of the fibre feels even.

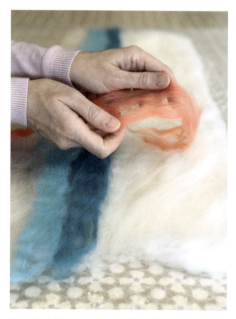

Step 4: Adding the design fibre (layer two)

Spread wisps of coloured Merino fibre apart with your fingers and lay them all over the base layer in your chosen design. Wisps can range from short wisps to long continuous lengths peeled from the length of the Merino wool tops and spread apart. Ensure wisps overlap slightly and cover the entire base layer, including all edges.

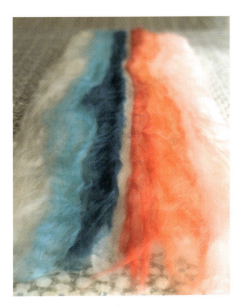

Step 5: Checking the edges

Avoid placing important design elements within 5cm (2") of each long top edge as these will be lost to wastage and making up the kit. Ensure that the short side edges, which will join up in the finished lampshade, have similar elements and colours so that the design is consistent and seamless at the join.

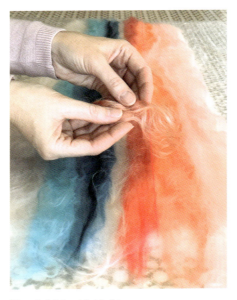

Step 6: Adding highlights

Add wisps of viscose fibres on top of layer two to add highlights to the design. Treat them the same as the wool fibre, spreading the wisps apart with your fingers, creating wispy shapes or peeling fine, thin strands from their length before adding them to the design layout. Finish all the dry layout of the design before moving on.

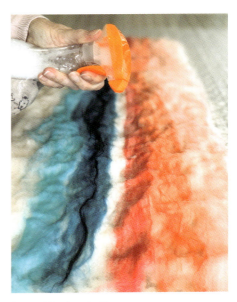

Step 7: Wetting the fibre

Gently spray warm soapy water solution all over the fibre rectangle until soaked through. Spray from above to avoid disrupting the fibres and make delicate adjustments with your fingertips to reposition stray fibres. Fold the other half of the bubble wrap over the fibre rectangle to sandwich it.

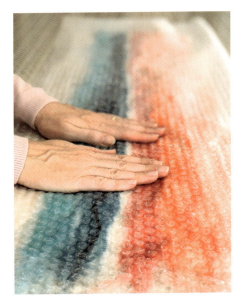

Step 8: Soaking the fibre

Press down gently to disperse the soapy water throughout the fibre. Once the water has soaked through evenly and the fibre has flattened, spray the bottom of the rubbing tool to help it move more easily and gently rub it all over the bubble wrap package for several minutes whilst a soapy lather develops.

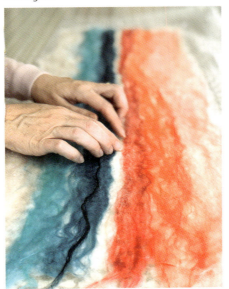

Step 9: Adjusting the fibre

Gently peel back the top layer of bubble wrap to check the fibres and design. If any fibres have moved significantly, gently nudge them back into place with your fingertips. Fold the short side edges under to the reverse to neaten and straighten them. If the fibre seems dry or not soapy, add more soapy water where needed.

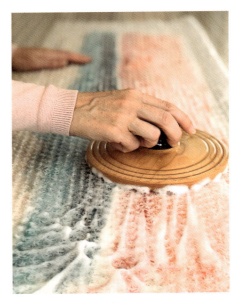

Step 10: Rubbing the fibre

Replace the top layer of bubble wrap and spend 5–10 minutes rubbing the fibre package all over a little more vigorously. Turn the entire package over and repeat on the reverse. Turn the package back to the front, peel back the top layer of bubble wrap and check the fibres for movement by gently rubbing a finger over the surface.

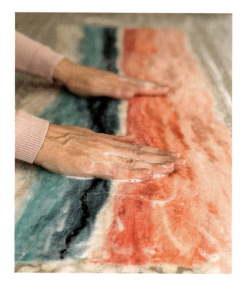

Step 11: Final rubbing

If there is considerable fibre movement, replace the bubble wrap and continue to rub the fibre through it, checking regularly for movement. If not, or once the fibres are mostly staying in place, rub the fibre all over with your hands on both front and reverse sides for 5–10 minutes until completely sure that none of the fibres are moving.

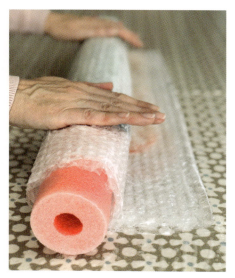

Step 12: Rolling the fibre

Replace the top layer of bubble wrap to sandwich the fibre. Roll up the package around the rolling tool, then roll the whole lot up in a tea towel. Roll the package away from you to arm's length and back again, counting as one roll. Roll 100 times. Unwrap the package and gently tug the fibre back into shape if misshapen.

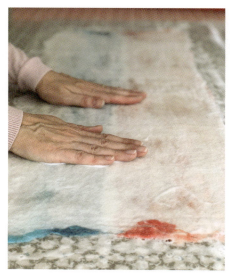

Step 13: Continuing to roll

Turn the package 90 degrees clockwise and repeat Step 12 three more times until the fibre has been rolled 100 times on each edge. Then turn over and repeat on the reverse, to make 800 rolls in total. Unwrap the package, discard the bubble wrap and squeeze some of the excess water out of the fibre, which is now becoming felt.

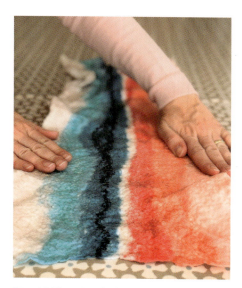

Step 14: Throwing the felt

Reshape the felt. Loosely pick it up and throw it down hard onto the work surface approximately 250–300 times, to shrink and harden it, in blocks of 50 (throw 50, reshape, throw 50, and so on). Stop when the felt has shrunk to no smaller than 68cm × 24cm (27" × 9.5") and the surface has a natural crinkle, like crocodile skin.

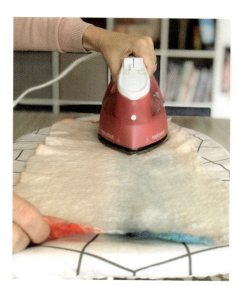

Step 15: Finishing the felt

Rinse the felt under warm running water, or soak in a bowl of warm water, until the water runs clear. Squeeze out excess water by rolling the felt up in a dry towel, then reshape and leave to air dry. Once dry, steam iron flat on the reverse and it is ready to use.

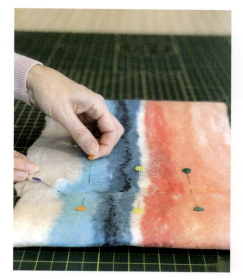

Step 16: Lining up the felt

First match up the short edges of the felt, which will be joined in the finished lampshade. Add three sets of aligned pins along each short edge to help establish a horizontal 'plumb' line to ensure that the design will be straight horizontally. Decide which short edge will be the visible overlap and put a pin in the corner to mark it.

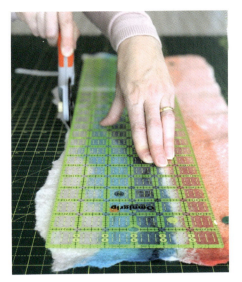

Step 17: Cutting straight long edges

Open out the felt and match up each set of pins to be in line with a horizontal line on the cutting mat. Lay the cutting ruler along one long edge, in line with the horizontal mat lines, and cut off the smallest amount of excess felt possible to create a straight edge. Repeat for the other long edge. Remove all pins except the overlap edge pin.

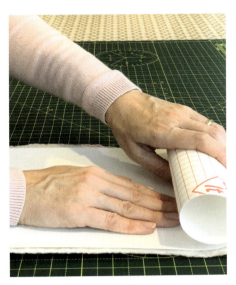

Step 18: Lining up the plastic

Turn the felt face down with the short, pin-marked edge furthest away. Lay the sticky backed plastic on top, paper side down, starting close to the nearest short felt edge (use a weight to keep it fully stretched out). Align the long edges of the plastic with the long edges of the felt (there will be at least 1–2cm (1") excess along each long edge).

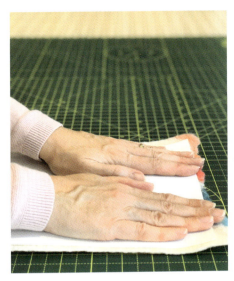

Step 19: Sticking the plastic to the felt

Keeping the plastic and felt edges aligned, slowly peel away the paper backing from under the plastic and, at the same time, firmly press the sticky side to the felt. At the end, where the felt is marked with a pin, ensure there is at least 1cm (0.5") of felt visible after the end of the plastic (stretch the felt slightly as necessary).

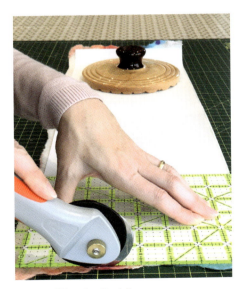

Step 20: Trimming the felt

Trim the two long edges and the short edge not marked with a pin to 3mm from the plastic edges. The end marked with a pin should have at least 1cm (0.5") excess between the uncut felt edge and the edge of the plastic. Add double-sided tape to the short edge of the plastic at the end marked with a pin and to each of the metal rings.

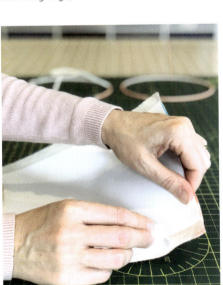

Step 21: Removing the excess plastic strips

Keep the plastic side up. Peel off the excess plastic strips shown in the kit manufacturer's instructions. Remove the tape coverings from the metal rings and ensure they are configured correctly (either for a ceiling light or lampshade) and line them up at the short edge of the plastic which isn't marked by a pin or with tape.

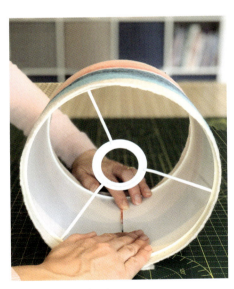

Step 22: Rolling the rings

Roll the rings along each plastic edge simultaneously, always keeping them aligned with each long edge. When the rings reach the remaining short edge, remove the pin from the felt and the tape covering. Roll the rings over the short edge and press firmly along the join to secure.

Chapter 3 – 2D/Flat Wet Felting

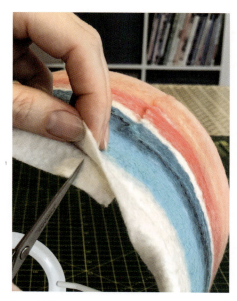

Step 23: Preparing the overlaps

Fold the excess felt tightly over the rings top and bottom. Cut small slits in the felt where the ring has spokes so that it fits neatly around the spokes. Where the felt overlaps at the top and bottom, cut a small square of felt away from beneath the overlap to reduce bulk.

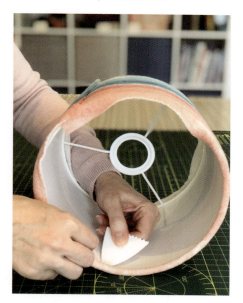

Step 24: Securing the overlaps

Use the plastic triangle tool in the kit to tuck the felt between each ring and the plastic to secure it. Use textile glue along the overlap join on the outside of the lampshade to secure it. Leave to dry before using.

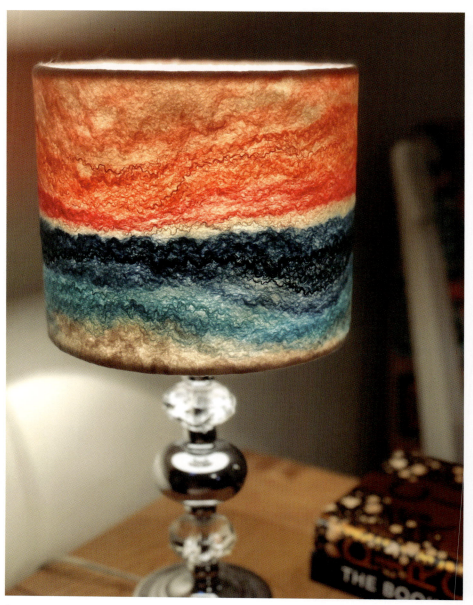

Step 25: The finished lamp

Install the shade on a table lamp (or ceiling light if you have oriented the design that way) and switch the light on to see the fibres in all their vivid colour and detail.

Project Variation

WAVE LAMPSHADE

The first lampshade variation uses the same prefelt technique to create a viscose fibre wave design that you'll see in detail in the Journal Cover Projects in Chapter 4, but adapted to create a much thinner felt so that when the light shines through the shade you can see each individual viscose fibre. Here is a quick guide to making this version:

- Make a prefelt using a very fine layer of undyed Merino wool tops in the Stretched-Out Layout (use a 100cm (40", 25g) length split in half lengthways, so you are using approximately 12.5g, which is half the amount you will use for the main base layer). Stretch out the fibre so that it measures a minimum of 90cm × 30cm (35.5" × 12"). Add on top a very fine layer of viscose fibres (I used approximately 1g each of six colours: peach, coral, mint green, sea green, taupe and teal blue = 6g maximum).
- Once the prefelt is dry and ironed flat, cut out as many wave shapes as possible (*see* Template, Chapter 8). Use the Stretched-Out Layout to create the base layer with a full 100cm (40", 25g) length of undyed Merino wool tops. Arrange the waves vertically on top (I positioned the darkest wave colours along one long edge with the lightest colours along the other). Wet felt the piece and create the lampshade according to the instructions for the main lampshade.

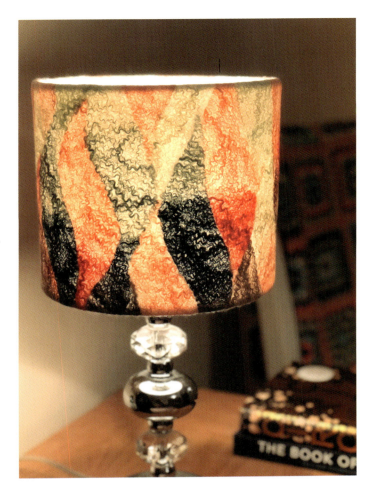

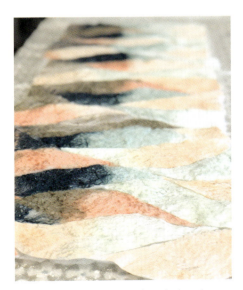

Prefelt wave shapes arranged on the base layer prior to felting.

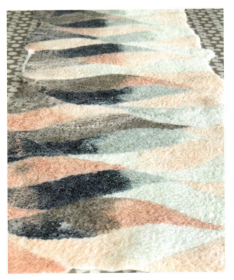

Finished felted piece after ironing.

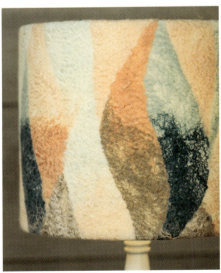

Close-up of finished lampshade in daylight, with the light on.

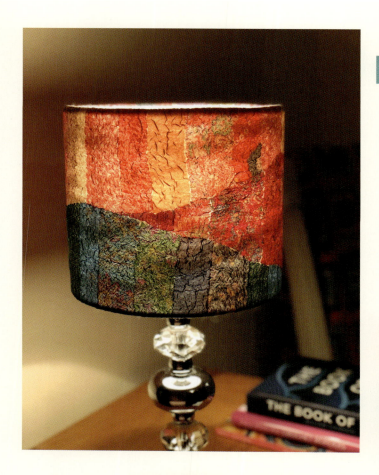

Project Variation

NUNO SILK LAMPSHADE

The second lampshade variation uses a patchwork nuno felt technique consisting of pieces of sari silk laid out in a simple landscape-style design (giving an impression of hills and sky). I used the same 100cm (40", 25g) base layer of undyed Merino wool tops as for the other lampshade projects and then laid out the nuno silk pieces on top (I could also have created nuno prefelt for this). I followed the usual wet felting process (albeit focusing on hands-off rolling rather than rubbing during the initial felting stage, and not moving on to the fulling stage until I was sure the fibres and fabric were bonded). When lit, the lamp creates a unique look as the light travels through the colourful patterned silk pieces.

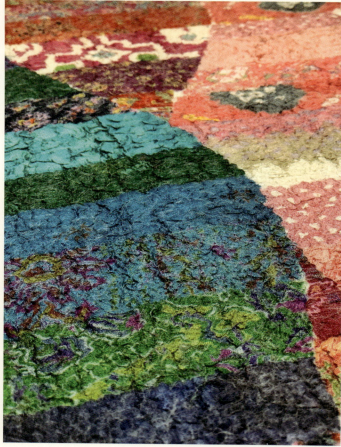

Sari silk pieces arranged on the base layer prior to felting.

Finished nuno felt piece before assembling into a lampshade.

NUNO SILK SCARF PROJECT

This is a very different project again, because this time we're going to combine our wool fibre with silk fabric to create nuno felt, specifically a thin nuno felt scarf.

There are plenty of challenges with this project. Firstly, the nuno felting itself, which needs to be done more slowly and gently to start with to ensure the fibres are bonded fully to the fabric before we move on to more aggressive fulling. Secondly, the size of the project. We're using less fibre to create a finer finished felt fabric, but using less fibre means greater shrinkage. So, to make even an average-sized scarf like this, the starting size is enormous and will probably be bigger than your work surface.

The main challenge of this project isn't so much the nuno felting technique, it's managing such a large piece of felt, especially during the initial fibre layout. However, it's made much easier if we work on the felt in sections, using two rolling tools and transferring the felt from one to another in order to access the different parts. I worked on it in two halves, working from each end each time. But if you don't even have the space for that, you can just start at one end (with the rest rolled up) and, once you've worked on a small section, roll it up on the second rolling tool whilst you unroll the next section to work on from the first rolling tool, and so on. What makes it slightly easier is that we're only doing our rolling from each short end rather than on all four compass points as we have done for the other projects so far. So you don't need to be put off by having a small work surface in order to complete a project like this.

Bear in mind that the bubble wrap (or thin plastic) is crucial to our ability to manoeuvre the project so it's worth investing in this (it's cheap and reusable). Bubble wrap for your working surface and foam pool floats/noodles as rolling tools are the best things to use as they're padded and have a bit of give (rather than thin plastic or a hard pole).

In terms of the felting process, once our layout is finished, the principles are the same but we're going to do less rubbing and more rolling. There are two main reasons for this. Firstly, with nuno felting I've found it's better to be as hands-off as possible. Actions like rubbing can actually be a bit too vigorous for it, and it's easy to catch or move the fabric and break the bonds between the fabric and the fibre. Rolling is a good way of giving the fibre/fabric the agitation it needs, but in as even, gentle and hands-off a manner as possible. Secondly, as we're using rollers to manage the project's size anyway, it makes life easier for us to use rolling as our main agitation method. Your silk fabric should be adhering to the fibre after the initial 2,000 rolls stipulated in the project but, if not, just keep going until this starts to happen. We also want to use lukewarm water to avoid any possibility of hot water felting the fibres before they've had a chance to bond with the fabric.

We're going to use the same Stretched-Out Layout technique as for the lampshade (but for a much longer length of wool tops) – the fibre is much easier to handle like this in a project this size, plus I prefer the organic look of the fibres by laying it out this way. We'll lay the fibre in a long, big piece on top of the silk fabric, and then add a full covering of viscose fibre all over. What we end up with is a silky viscose pattern on one side and the ruched fabric on the other, with quite a fine, drapey structure overall. I used complementary shades of coral pink for all the materials, including a variegated extra fine Merino wool fibre and four colours of viscose. The final weight of the finished scarf is approximately 145g, and it measures 170cm long × 26cm high including the fringes (67" × 10.25"). From an initial starting size of 280cm × 40cm (111.5" × 16"), that gives a shrinkage rate of 35–39 per cent.

It's worth saying that the amounts of fibre I've used for this project are just an example. Because of the extra strength provided by the layer of silk, you could make incredibly fine but still structurally sound nuno felt with half the amount of both the wool fibre and the viscose (especially if you want to see more of a wool/viscose mix on top rather than the complete viscose layer I've used). Alternatively, you could use even more wool fibre to make a much thicker scarf. All of these ways will work, it just depends on the end result you're looking for. So you can be very flexible with this particular project and adapt the sizes/amounts or even the materials to what you've got in your stash.

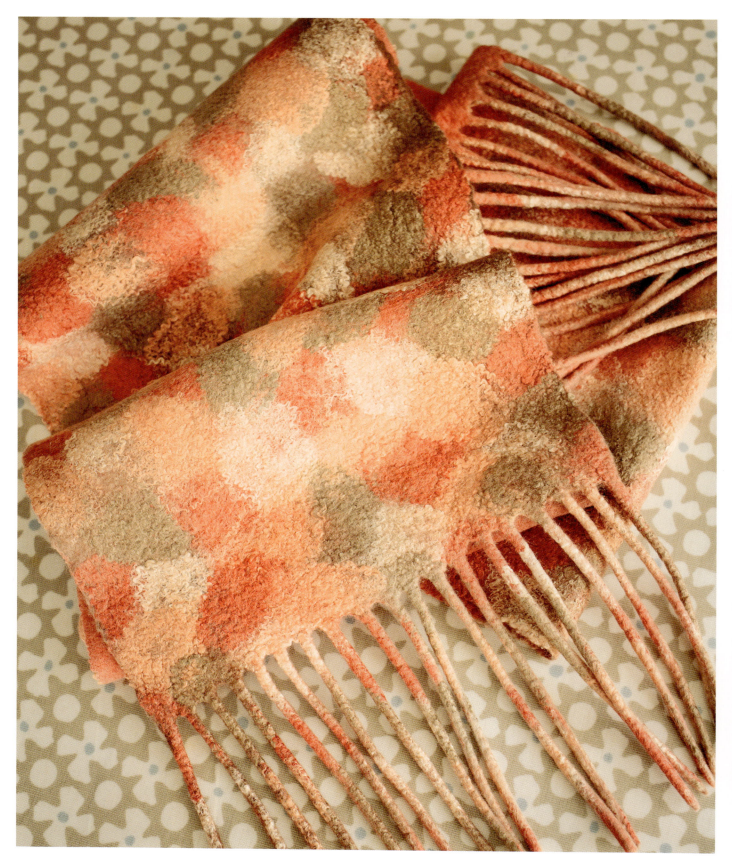

WHAT YOU WILL NEED

Materials
- 280cm × 40cm (111.5" × 16", 15g) piece of silk chiffon fabric (I used coral pink)
- Approximately 385cm (152", 80–90g) length of dyed, variegated extra fine Merino wool tops for the wool fibre layer (I've used variegated coral pink)
- Approximately 10–15g each (50g in total) of viscose fibres in your chosen colours (I've used four to match my wool colours: deep coral pink, coral pink, peach and taupe brown)

Equipment
- Two pieces of 300cm × 50cm (120" × 20") small bubble bubble wrap
- Textured mat or work surface
- Scales
- Tape measure
- Spray bottle
- Washing-up liquid and warm water solution
- Rubbing tool
- Two rolling tools
- Tea towel
- Large towel
- Cutting mat
- Large cutting ruler
- Rotary cutter
- Scissors

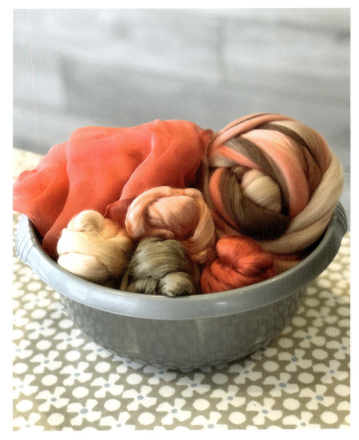

Step 1: Assembling your materials

Collect your silk fabric, Merino wool tops and viscose fibres together and ensure that you are happy with your colour palette before getting started. Remember that the silk and Merino fibre will felt and blend together colour-wise, whilst the viscose fibres will largely comprise their own layer on top of the Merino.

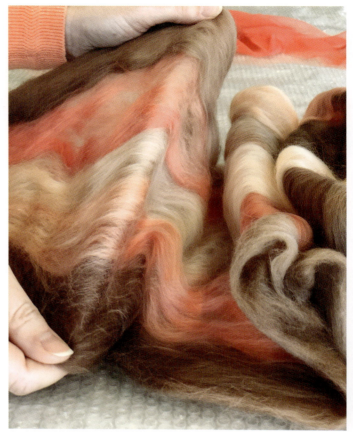

Step 2: Preparing the silk fabric

Cut or tear the silk fabric to size and to remove the selvedge, which helps the edges to felt more easily. To tear the fabric, make a 2cm (1") cut on one edge and, with one hand on the fabric each side of the cut, firmly and quickly tear the fabric apart. Stop tearing just before the end and cut the final 2cm (1") to avoid fabric pulls.

Step 3: Preparing the Merino fibre

Gently stretch the Merino wool tops apart along the entire 385cm (152") length, to expand the fibre from a tube to a long rectangle shape measuring 40cm (16") wide. Whilst stretching out the fibre, spread out any thicker areas to create an even layer of fine fibre without any holes. The dry fibre will shrink lengthwise to c.320cm (126").

Step 4: Laying out the silk fabric (layer one)

On a hard, water-resistant work surface, lay out the first piece of bubble wrap, smooth side up, with the excess hanging straight from the work surface onto the floor as necessary. Lay the silk fabric on top as neatly as possible, smoothing out any folds or wrinkles, again with the excess hanging neatly from the edge of the work surface.

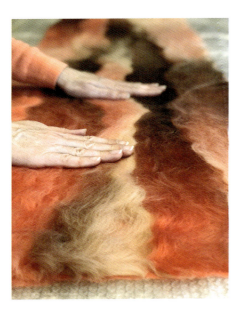

Step 5: Laying out the Merino fibre (layer two)

Lay the stretched-out Merino fibre on top of the silk fabric, again with the excess hanging straight over the edge of the work surface. Line up the wool fibre with each long edge of the silk as exactly as you can. Pat to test for thick areas (stretch them) or thin areas (add extra wisps) until the overall thickness of the fibre feels even.

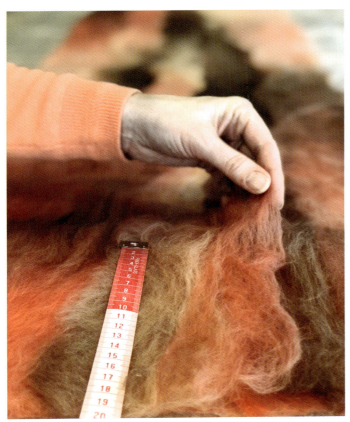

Step 6: Adding extra fibre for the fringe

From the unlaid end of the stretched-out Merino wool fibre, tear or cut a 20cm (8") length (× full 40cm (16") width). Ensure it is a fluffed out, even layer of fibre and lay it on top of the already laid fibre covering the first 20cm (8") end of the scarf. This creates a double layer of fibre ir what will become the scarf fringe, to give it extra strength.

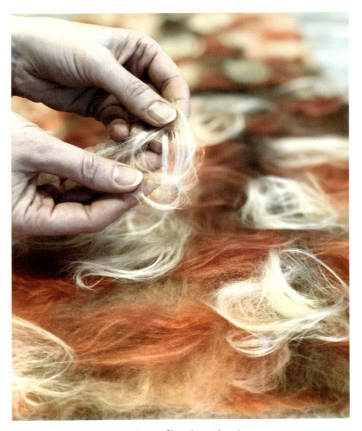

Step 7: Adding the viscose design fibre (layer three)

Spread wisps of coloured viscose fibre apart with your fingers and lay them all over the Merino wool fibre in your chosen design (I've used four colours repeated in wispy round shapes). Ensure the wisps overlap slightly and cover the entire wool fibre layer, right up to the edges. Finish all the dry layout of the design before moving on.

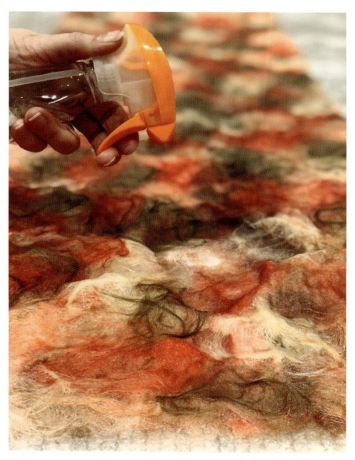

Step 8: Wetting the fibre

Gently spray warm soapy water solution all over the fibre rectangle until soaked through. Spray from above to avoid disrupting the fibres and make delicate adjustments with your fingertips to reposition stray fibres. Lay the other piece of bubble wrap smooth side down on top of the fibre rectangle to sandwich it.

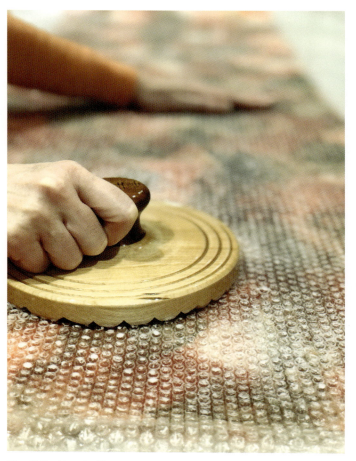

Step 9: Soaking the fibre

Press down gently to disperse the soapy water throughout the fibre. To help the water soak through evenly and flatten the fibre, spray the bottom of the rubbing tool (to help it move more easily) and gently rub it all over the bubble wrap package for a couple of minutes.

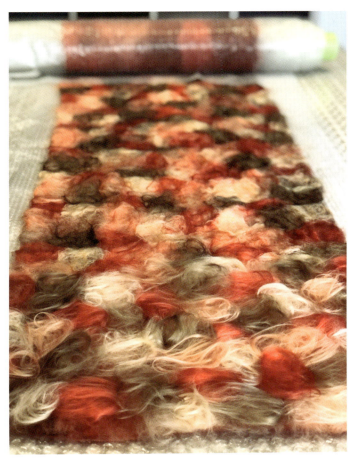

Step 10: Working on the other end

With the first section of scarf wet and secured within bubble wrap, roll it up carefully around a rolling tool so that it is protected and out of the way. Move the roll to one end of your work surface and repeat Steps 4–9 on the second section of scarf (NB Trim any wool fibre extending beyond the second end of the silk fabric).

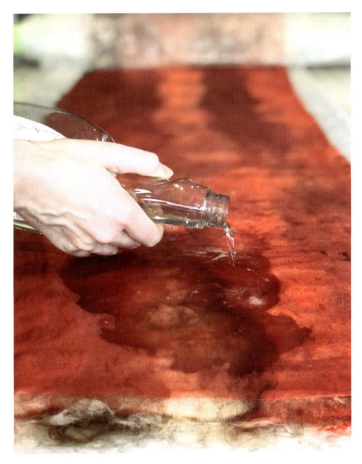

Step 11: Soaking the reverse

Roll up the second section of scarf, turn the whole rolled-up package over and unroll the second section, this time with the silk side up. Carefully peel back the top layer of bubble wrap to check that the water has soaked through the silk. If not, spray or pour more soapy water onto the silk.

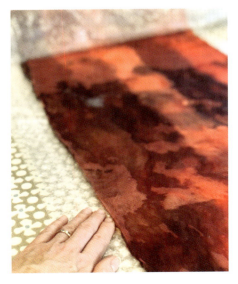

Step 12: Adjusting the reverse

Also check the silk and fibre placement. Smooth out any fabric wrinkles and nudge any fibres extending beyond the silk edges (NB except the fringe end) back in line with your fingertips. Replace the bubble wrap and use the rubbing tool all over for a few minutes to flatten the package and ensure the water is evenly soaked through.

Chapter 3 – 2D/Flat Wet Felting **69**

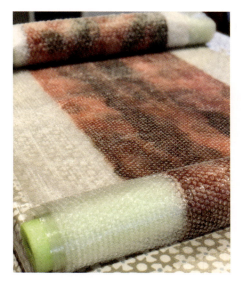

Step 13: Working on the other end

Repeat Steps 11 and 12 for the first section of scarf. To access this and make it more manageable, first transfer the already unrolled section of scarf from Steps 11 and 12 to a second rolling tool. By rolling it up on a second rolling tool, you can keep it out of the way whilst you unroll and work on the first section.

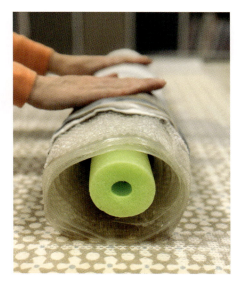

Step 14: Rolling the fibre

Once the whole scarf has been checked for fibre placement and wetness and is again sandwiched within bubble wrap, roll the whole package up around one rolling tool, then roll it up again up in a tea towel to secure. Roll the package away from you to arm's length and back again, counting as one roll. Roll 500 times.

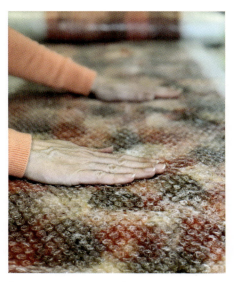

Step 15: Continuing to roll

Transfer the package to the second rolling tool, so that the other end of the scarf is nearest your hands and roll a further 500 times. Turn the scarf the other way up (to the wool and viscose side) and repeat two more sets of 500 rolls in the same way, to make 2,000 rolls in total. Check and straighten any folds or creases each time you transfer between rolling tools.

Step 16: Checking initial bonding

The scarf will still feel very delicate at this point. With the silk side facing up, look for fibres coming through it and rub your fingers across the surface to feel for them. Also do a very careful and gentle pinch test to see if the fibres lift up with the scarf. If not, complete a further 500+ rolls, until the fibres and silk are starting to bond.

Step 17: Preparing the fringe

With the scarf facing silk side up, peel back the bubble wrap both above and below one of the fringe ends and give it a quick press within a towel to get rid of most of the wetness. Place the fringe end on a cutting mat, lining up the short end of the silk with the 20cm (8") mark and ensuring that the long edges of the silk are also straight.

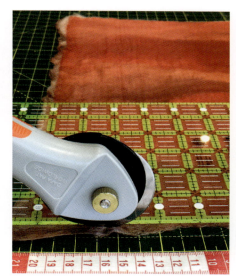

Step 18: Calculating the number of fringes

Measure the width of the fringe end, which should have slightly shrunk from the initial 40cm (16") by 1–2cm (up to 1"). Each fringe will measure 20cm long × 2cm wide (8" × 0.75"), so first trim the width each side so that it is divisible by 2cm (0.75") to ensure evenly sized fringes. Trimming also ensures the first and last fringes have straight edges.

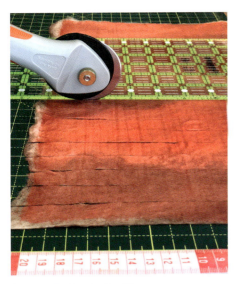

Step 19: Cutting the first fringe

Using the cutting mat to help with alignment, place your cutting ruler 2cm (0.75") from the first edge and make a 20cm (8") long cut with the rotary cutter. Repeat every 2cm (0.75") to create the fringes. You should have either twenty, nineteen or eighteen depending on the overall width of the scarf at this stage.

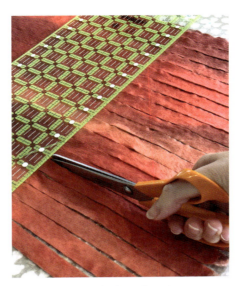

Step 20: Adjusting the fringe length

Once all the widths are cut, place your cutting ruler across the scarf at the 20cm (8") point (from the end of the silk) and use scissors to extend any of the cuts slightly to ensure each fringe is cut to exactly the same length. This is important to ensure an even finish to the fringe.

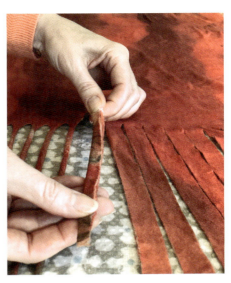

Step 21: Shaping the fringes

Working on each fringe in turn, fold the fringe in half along its length, with the silk side inside and the viscose side outside. Spray it with soapy water and then roll it gently between your palms to create a cord shape. Repeat until each individual fringe has a rolled cord shape.

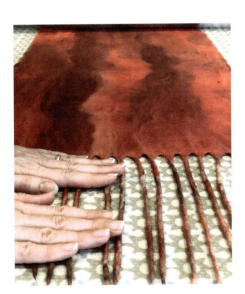

Step 22: Felting the fringe

With a textured surface underneath the fringe, rub/roll the whole fringe firmly on top of the surface to start to felt each cord. Continue for at least 5 minutes until the fringe cords start to feel firmer and are keeping their rounded shape. The cords will have stretched a little, so measure and trim them all to the same length (c. 20cm/8").

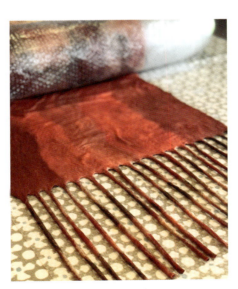

Step 23: Creating the second fringe

Carefully place the fringe end back within the bubble wrap, ensuring the strands remain separate, and roll that end of the scarf back up around the other rolling tool until you reach the other end of the scarf. Uncover it and repeat Steps 17–22 to create the second fringe. Then cover and roll it back up on the same rolling tool.

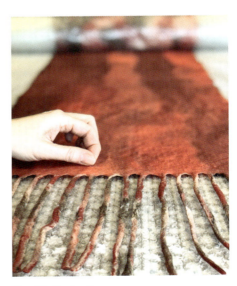

Step 24: Final rolling

Roll the whole scarf for a further 500 rolls before transferring the package to the other roller and rolling from the other end, to make 1,000 rolls in total. Open up the package, with the scarf silk side up, and gently pinch the silk in several places to check it is bonding well with the fibres. If not, re-roll for a further 500–1,000 rolls.

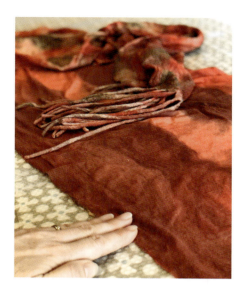

Step 25: Rubbing the felt

Once the silk and fibres feel bonded, remove the bubble wrap and rub the whole scarf for 10–15 minutes, viscose/fibre side down, on the textured surface, to start to thicken and full it. Pay particular attention to the long edges, neatening and straightening them as you rub, and roll the fringes to reshape and firm them.

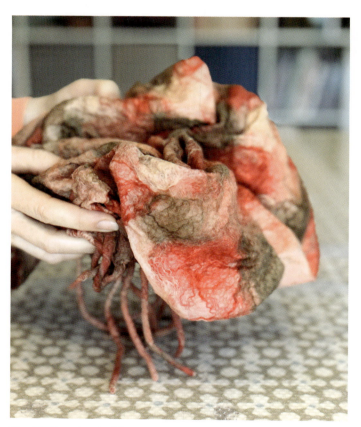

Step 26: Throwing the felt

Squeeze any excess water out of the scarf, then loosely pick it up and throw it down onto the work surface approximately 400–500 times, to shrink and harden it, in blocks of 100 (throw 100, reshape, throw 100, and so on). Stop when the scarf has shrunk to no less than 180cm × 28cm (71.5" × 11") to allow for extra shrinkage during rinsing, and the surface has a natural crinkle.

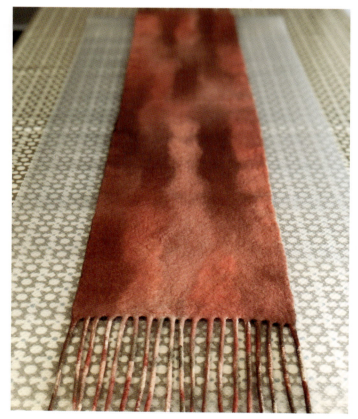

Step 27: Finishing the felt

Rinse the scarf under warm running water, or soak in a bowl of warm water, until the water runs clear. Squeeze out excess water by rolling the scarf up in a dry, clean towel, then reshape, roll the fringes and leave to air dry. Once dry, steam iron flat on both sides (avoiding the fringes) and it is ready to wear.

Project Variation

'PINE NEEDLES' SCARF

There are many different effects that you can create with nuno felting, from a solid layer of wool fibre on top of the fabric, which creates a uniform ruching of the silk fabric as shown in the main scarf project, to using very small amounts of wool fibre on top of the fabric, which leaves the fabric flat and unaltered in many places but incredibly ruched in others. And, of course, there is scope for every variation in between.

This scarf version is one I made on a workshop some years ago with an amazing feltmaker, Leiko Uchiyama, who has developed a technique she calls 'pine needles'. This involves laying out intricate patterns on the silk fabric using small thin strands of ultra fine Merino wool tops before very carefully and slowly felting the piece. It results in a finished piece of nuno felt with beautifully detailed patterns from the wool fibre, along with incredible texture from the non-wool areas of the silk that have ruched up in between. This variation scarf gives you an example of how nuno felting can be applied in a completely different way to give a very different result.

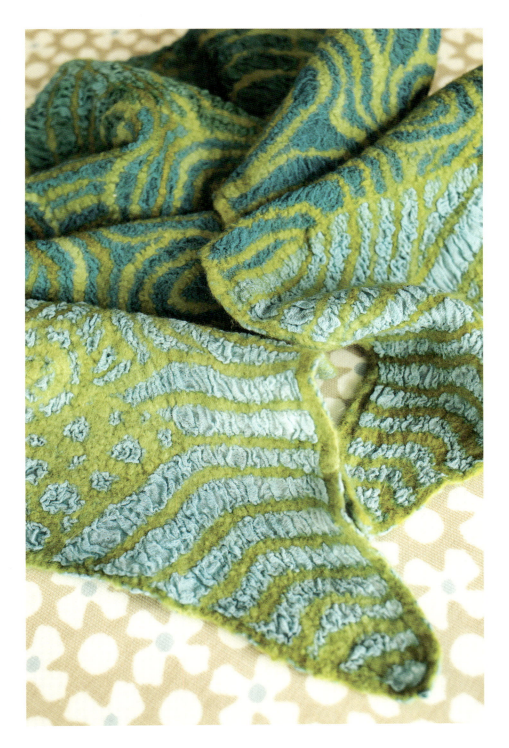

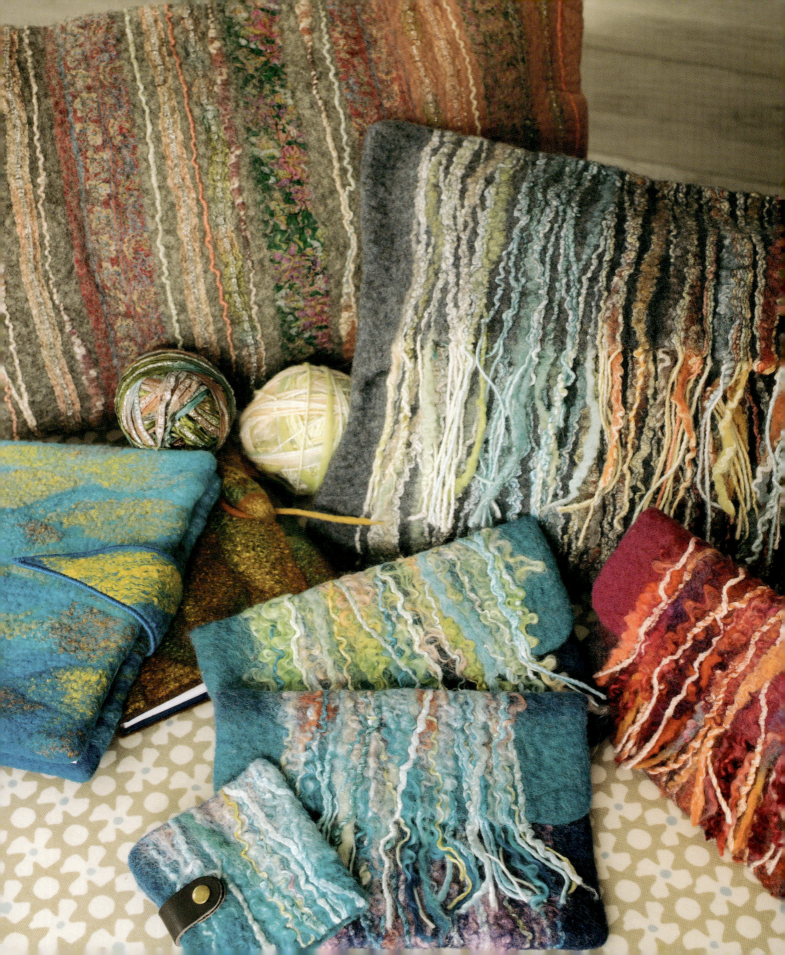

CHAPTER 4

3D WET FELTING (WITH FLAT RESISTS)

WHAT IS A RESIST?

Now that we've mastered the basics of the wet felting process through two-dimensional flat felting, let's expand our felting know-how to create three-dimensional felt. We're going to create felt with structure and some depth to it, which we can achieve using shapes or forms to build our felt around called **resists** or **resist templates**. At its simplest, a resist is a template made from a flat piece of plastic or similar material that wool fibres cannot migrate through. The idea is that if we wrap our fibre around both sides of a flat resist, we can create a felt version of the resist shape. Not only that, but the resist stops the two sides of fibre felting together, yet at the same time allows the fibre around the edges to join, so when we remove the resist we end up with a two-sided hollow pocket form.

You might wonder why we would bother to do that? After all, we could make flat pieces of felt and sew them together to create a hollow form. This is where the magical properties of felting with wool fibre really come into their own. We don't need to sew pieces of felt together because we can create hollow forms that **self-seam** to attach two sides together, so the wool fibres bonding along the edges of the resist is in effect doing the sewing for you. Furthermore, because the felted form doesn't have sewn seams, which is the weakest part when you sew something together, you end up with finished felt which is really strong and durable. That's why resists are used in felting to create hard-wearing items like clothing – it's not just about creating the shape, but also about harnessing the unique properties of wool fibre to create a seamless finished fabric that can't be achieved by any other textile material.

So, once you've got over the amazement of how clever and unique wool fibre is in feltmaking, if you're interested in creating felt with any kind of structure to it then you'll constantly be thinking of how you can use resists to help you create forms, pockets and layers, or to attach things to your felt. In this first chapter about three-dimensional wet felting, we'll start by focusing on using flat resist templates to create shaped (but still essentially flat) hollow felted items. We'll expand on this in the next chapter by using resists with more depth to them to create more structured felted forms.

RESIST MATERIALS

A flat resist template is:

- not made of feltable material and has a solid surface with no holes (so that the wool fibres can neither bond to it nor migrate through it)
- made of a flexible material (as you are likely to want to be able to roll it as part of the wet felting process)
- durable (so you can manipulate it as well as reuse it) and waterproof (as it will be staying wet for long periods).

Ideal materials for a flat resist are: thin plastic (such as a plastic bag), thin packaging foam, lino offcut, or even cardboard wrapped in clingfilm. The best material to use will largely be dictated by what you are making. As a general rule, if you need the resist to create structure, then something firmer is ideal, but if you are using a resist to create separate layers, perhaps more for a design element than a structural one, then a very thin resist works better. So, for example, I have used 5–6mm (0.25") packaging foam for all the projects in this chapter, as it is sturdy enough to hold its shape (and it's possible to feel it through the fibre wrapped around it), yet flexible enough to still be able to roll it. Thin plastic wouldn't have been suitable because it wouldn't have been sturdy enough to hold the weight of the fibre and keep its shape during the process. However, in the next chapter you'll see I use 1mm (0.04") thin foam in the bag project to create an inside pocket, which needed to be as unobtrusive as possible so not to interfere with the main structure; a very thin resist was perfect for that use.

FIBRE LAYOUT USING A RESIST

Laying out fibre on a flat resist template is not much different to simple flat felting, apart from the fact that you are also creating side edges/side seams, so there are a few things to consider when approaching this:

- Work on one side at a time.
- When you lay out the fibre each side, overlap the edges of the template by at least 2.5–3cm (1"), which in effect lays out the fibre on the edge.
- You'll need to fold the overlap around to the other side of the template to create your edge, which you can only do when it's wet. Soak the fibre all over, fluff out the edges of the overlap to make them wispy, wrap them tightly around the edge of the template and smooth them as neatly as possible to the other side without any lumps.
- You can either complete each layer separately on both sides (wetting, flattening and folding the overlap to secure each time) before moving on to the next layer or lay out all layers on one side before completing the second side. I would generally recommend the former as it helps you to better control the layout (thickness/thinness) and make adjustments as you go along, but there are some

situations where it is easier to treat all layers in one go, such as the Silk Stripe Cushion Cover Project in this chapter. *See* also below for the colour implications of this.
- Although you need to wet, soak through and flatten the fibre each side before turning to the next side, you don't need (or want) to start the rubbing process until all the layers are complete. The purpose of wetting at this layout stage is to temporarily secure all the fibres in place until the layout is complete (not to start bonding them yet).
- If you are adding surface embellishments, it is better to add those to each side once all the fibre layout is complete, to avoid the fibre overlapping process interfering with the surface design.

COLOUR MIXING USING A RESIST

There are some extra implications for colours and colour blending to think about when using resists. With simple flat felting, you often aren't worried about what colour the reverse of the felt ends up, for example if you're creating a picture, as the reverse will never be seen. But in resist felting you're deliberately creating a 3D hollow form where the usual reverse of the felt will often be seen, such as the inside of the Fringed Clutch Purse Project in this chapter. So, if the inside colour is important to you, there are a few ways to help control the outcome:

- Use the same fibre colour for all the layers to avoid any colour mixing at all.
- Use the same combination of colours for each of the three layers, so you are controlling how the inside looks (and it will mirror the outside). You could use a random mix or, as I've used in the projects in this chapter, use blending bands of colour to create a gentle ombre effect.
- If you are using different colours for each layer of fibre in a project, fully complete each separate layer on both sides before moving on to fully complete the next layer. This keeps the inside layer a consistent colour. If you lay out all two or three layers together on one side and then overlap them around the template before laying out the fibre on the other side, there's a risk that colours from the top and middle layers will appear on the inside on the other side.

FURTHER TIPS FOR USING A RESIST

Finally, here are a few other things to consider when using flat resists before we get started:

- There are two main methods for using a resist, both of which are included in this chapter: the first is to have an **open** resist, as in the Fringed Clutch Purse Project, where one edge of the template isn't completely covered by fibre and we create an edge there instead by folding the fibre back on itself. This is a good option for creating a neat, thick edge right from the start. The second is to have a **closed** resist, which we cut open between the felting and fulling stages to release the template, such as used in the Journal Cover Projects.
- From the start, aim to keep the fibre as tight around the template as possible, to maintain the shape. However, once we have soaked the felt and started the rubbing stage, the wetness can make the felt slacken and wrinkle slightly, particularly at the side edges. If this happens, which is fairly normal, it's worth taking some time to focus your rubbing on the side edges, pushing any slackness or wrinkles back into and against the template to firm them up. If you leave them or rub them flat against the work surface rather than into the template, there is a risk that the side seams will felt together to form thick ridges.
- When using a closed resist in particular, there will come a point after the felting stage when the felt is moving into fulling/shrinkage mode and, if we don't release the template, it will start to buckle and strain against the felt. This can be quite helpful in that it alerts you to the fact that the felting process is working, and also that it is the right time to cut open the felt.
- When you are using an open template, you'll find that you have greater shrinkage in the felt on the open edge than in the edges covering the template. This is because the closed edges of the felt are constrained from shrinking by the template. This is something to keep an eye on during the process and counter if necessary by stretching those open edges back into position. You will see this happening in the Silk Stripe Cushion Cover Project, which has open flaps, where the shrinkage is greater in the centre of the flaps than at the sides, which are kept in place by the templates.

Fibre-wise, you can use any type of fibre for the projects in this chapter. I've used Finnwool batt fibre to make the Fringed Clutch Purse and Silk Stripe Cushion Cover Projects, and Merino wool tops for the Journal Cover Projects, but these are interchangeable.

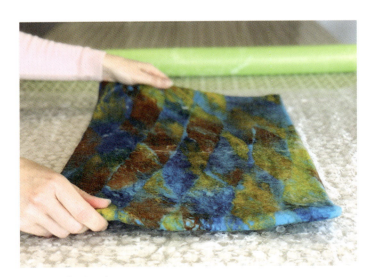

Example of a closed resist.

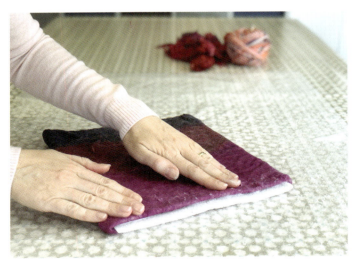

Example of an open resist.

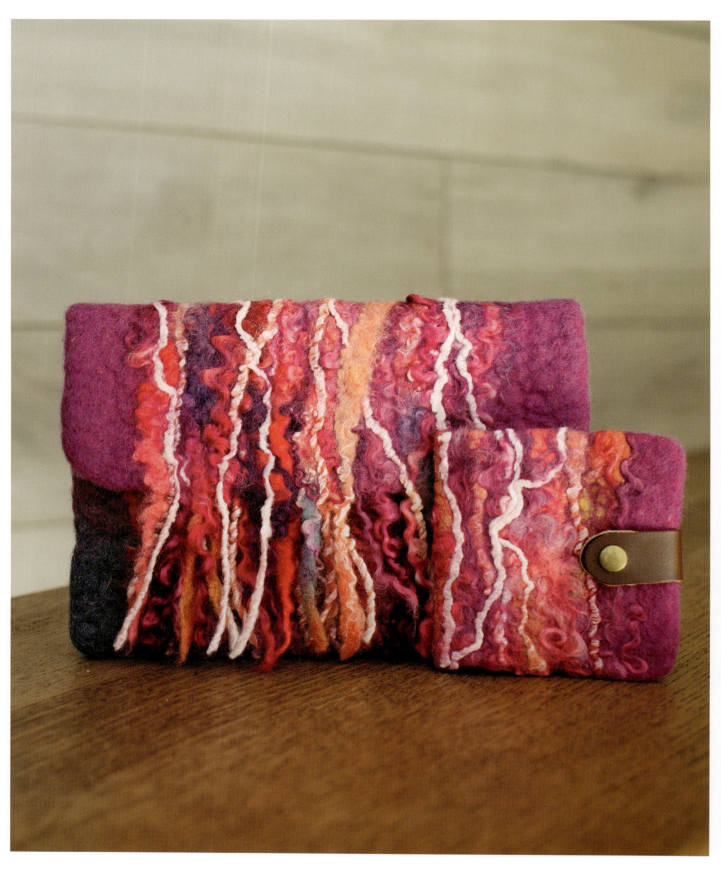

WHAT YOU WILL NEED

Materials

- Approximately 50g of wool batt fibre in your chosen colours, 25g per layer (I've used Finnwool fibre: 20g of violet; 15g of dark violet; and 15g of dark blue-grey, each split evenly between layers one and two)
- Approximately 15g of hand-dyed long curly wool locks (I've used Wensleydale long locks in dark purple and pink)
- Approximately 15m (50ft) in total of two or three slub, chunky or thick and thin-type wool yarns (these are high content wool yarns with thick parts that look like wool tops or roving. I've mainly used a variegated Bamboo Bloom Handpaints thick and thin bamboo/wool mix yarn in pink and purple shades, plus a thick and thin wool yarn in reds and pinks and a multicoloured felt ribbon yarn), approximately 20 yarn lengths of 75–80cm (29.5–31.5") each
- 18mm (0.75") antique brass-coloured sew-in magnetic clasp
- Purple embroidery thread

Equipment

For the wet felting

- 30cm × 23cm (12" × 9") rectangular 5–6mm (0.25") thick foam resist template
- Minimum 75cm × 40cm (29.5" × 16") piece of small bubble bubble wrap (or two 35cm × 40cm/14" × 16" pieces)
- Scales
- Large scissors
- Tape measure
- Ruler
- Spray bottle
- Washing-up liquid and warm water solution
- Olive oil soap
- Rubbing tool
- Rolling tool
- Small piece of folded plastic, bubble wrap or foam
- Tea towel
- Large towel

For sewing the clasp

- Tape measure or ruler
- Pins
- Needle
- Scissors

FRINGED CLUTCH PURSE PROJECT

Our first resist project is a purse with a foldover flap, and a yarn and curly wool lock fringe extending over the edge of the flap (which is also used as the surface design on the rest of the purse). We're using an open resist at the end where the fringe extends and we'll be cutting away a portion of felt to allow the flap to fold down onto the rest of the purse. There are other ways you could achieve this purse shape with a resist (for example, by just using a resist for the main purse pocket area and then creating the flap to extend from it separately), but by doing it this way I find that we can achieve a more consistent thickness of the flap and all the purse edges.

I've used two layers of Finnwool batt fibre in the Patchwork Layout (although you might have more layers, depending on how thin your batt sheets are – the total fibre weight is what's important here). I've used three complementary fibre colours in rough bands of colour, but you can use as many colours as you like and lay them across the resist template however you like. The only rule is to keep the layers an even thickness – the colour combination you use to achieve that is completely up to you.

There is lots of texture and pattern in this project, achieved by layering up curly wool locks with thick and thin art yarns. I've used a few strands of three different yarns at the start, then partly covered them with the curly locks, then added more yarns on top. The high wool content of the embellishments helps to ensure everything felts in, but, as usual, if in doubt just add a few wisps of wool fibre on top.

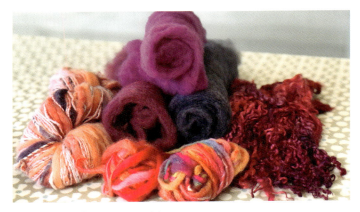

Step 1: Assembling your materials

Collect your wool batt fibre, curly locks and wool yarns together, ensuring that you are happy with your colour palette. Take your 50g of wool batt fibre in your chosen colours and weigh/divide the total into quarters, that is, 4 × 12.5g (two layers for each side of the template), keeping the colour amounts equal. Put each quarter aside.

Step 2: Getting ready

On a hard, water-resistant work surface, open out the bubble wrap, smooth side up. Position it so that half is your 35cm × 40cm (14" × 16") working area, with the other half ready to fold over onto the working half later. Lay the template on top of your working area, oriented portrait-style in front of you, and start to prepare your fibre.

Step 3: Laying out the fibre (layer one, side one)

Taking the first quarter allocation of wool batt fibre, peel the layers apart to make them as fine as you can and tear them into long rectangles (if laying in bands of colour) or smaller pieces (if mixing up colours), and lay them on top of the template. Ensure the edges of all pieces are wispy and overlap each other slightly.

Step 4: Finishing the fibre layout (layer one, side one)

Overlap the side and bottom edges of the template with the fibre by 2–3cm (1") but stop laying fibre just short of the top edge. Keep patting the fibre all over to test for thick or thin areas, either spreading them out to thin them or adding extra wisps to thicken them until the overall thickness of the fibre feels even.

Step 5: Wetting the fibre

Gently spray warm soapy water solution all over the fibre rectangle until soaked through, spraying from above to avoid disrupting the fibres. Fold the other half of the bubble wrap over the fibre rectangle to sandwich it. Press down and rub gently with your hands or the rubbing tool to disperse the soapy water throughout the fibre.

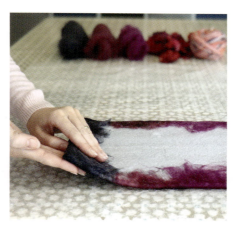

Step 6: Folding the fibre around the edges

Turn the package over to side two and gently peel back the bubble wrap. Smooth the fibre overlap from side one onto side two, starting with the side edges and then the bottom edge. At the bottom corners where there is a fibre fold, fluff out the edges and smooth them down until neat and tight against the template.

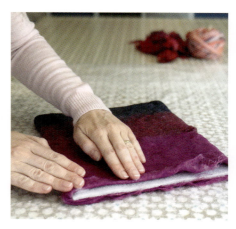

Step 7: Completing the fibre layout

Take your side two fibre allocation and repeat Steps 3–6 to complete the layer one layout on the second side. Then repeat again on both sides of the template to complete layer two on both sides. Fluff out the top edge on both sides of the template, fold it back by 1–2cm (up to 1") and smooth it down to create a neater, firmer top edge.

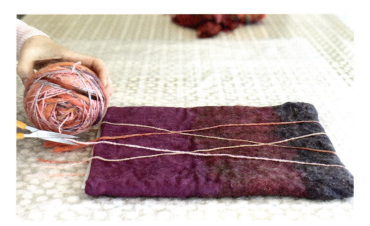

Step 8: Adding the first yarn decoration

Take the first yarn, leave a 7cm (3") fringe at the top end and continue laying it out vertically along the fibre/template, from the top edge to the bottom edge. Carefully turn over the template and lay the yarn back up the other side, again leaving a fringe end before cutting. Repeat two to three times, varying the yarn placement each time.

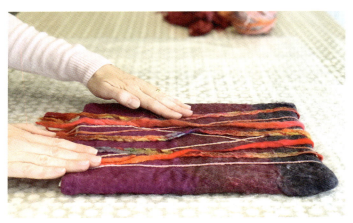

Step 9: Adding further yarn decoration

Repeat Step 8 for the other two yarns, until you have wrapped at least nine pieces of yarn around the template, from the top end on one side round to the top end on the other, leaving a 7cm (3") fringe each end. Press the yarn into the fibre to wet and secure it and avoid laying yarn within 3cm (1") of the side edges.

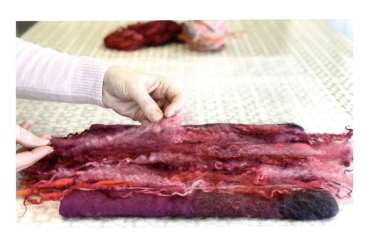

Step 10: Adding curly locks (side one)

Spread long wisps of curly locks apart with your fingers and lay them all over the fibre and yarns on one side of the template, varying the placement and ensuring that some of the locks extend 7cm (3") from both the top edge (as a fringe) and the bottom edge (to overlap to the other side). Spray with soapy water to secure.

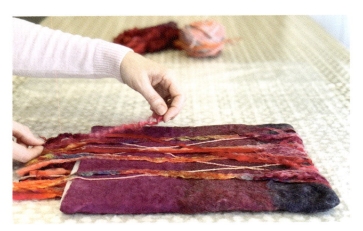

Step 11: Adding curly locks (side two)

Fold the other half of the bubble wrap over the fibre to sandwich it. Press down and rub gently with your hands or the rubbing tool to flatten and smooth the locks. Peel back the bubble wrap and turn the template over. Smooth the overlapping edge locks onto side two and repeat Steps 10 and 11 to complete adding the locks to the second side.

Chapter 4 – 3D Wet Felting (with Flat Resists)

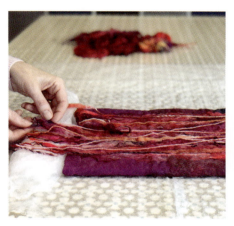

Step 12: Adding final yarns

To add to the texture and pattern, repeat Step 8 to add a final top layer of 5–10 wraps of any of the yarns. Once happy with the design layout, insert a piece of thin folded plastic or bubble wrap between the fringe yarns at the top end to ensure the fringes do not felt together. If the fibre seems dry or not soapy, spray on more soapy water.

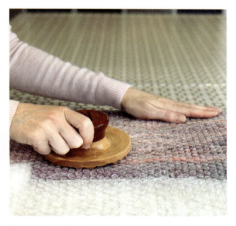

Step 13: Rubbing the fibre

Replace the top layer of bubble wrap and spend 15–20 minutes rubbing the fibre package all over, one side at a time, rubbing in a vertical direction to cause least disruption to the yarn placement. Then peel back the top layer of bubble wrap and check the yarns for movement by gently rubbing your fingers over the surface.

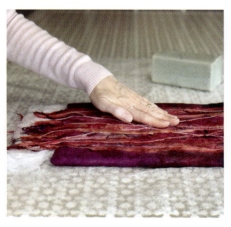

Step 14: Final rubbing

If there is considerable yarn movement, replace the bubble wrap and continue to rub the fibre package through it, checking regularly for movement. Once the yarns are mostly staying in place, remove the bubble wrap and rub the package all over with soapy hands on both sides for 5–10 minutes until they are no longer moving.

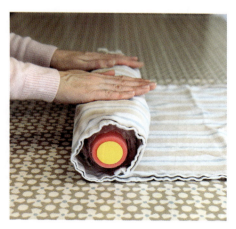

Step 15: Rolling the fibre

Replace the top layer of bubble wrap to sandwich the fibre. Roll up the package around the rolling tool, then roll the whole lot up in a tea towel. Roll the package away from you to arm's length and back again, counting as one roll. Roll 100 times. Unwrap the package, gently tug the fibre back into shape and separate the fringes.

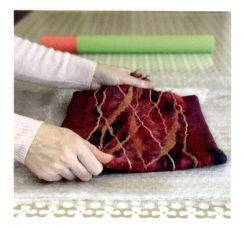

Step 16: Continuing to roll

Turn the package 90 degrees clockwise and repeat Step 15 three more times until the fibre has been rolled 100 times on each edge. Then turn over and repeat on the reverse, to make 800 rolls in total. Ensure you continue to tug the fibre back into shape if misshapen (especially the top edge) and separate the fringes.

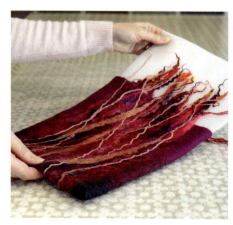

Step 17: Removing the template

Carefully remove the plastic from between the fringes and the foam template. Squeeze some of the excess soapy water out of the fibre, which is now becoming felt. Put your hand inside the felt purse shape and rub all over to check the fibres inside are bonded. If not, spend a few minutes rubbing the inside. Reshape.

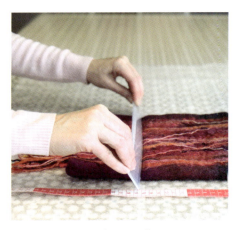

Step 18: Measuring the purse flap

Decide which fringe side you prefer as the purse flap and lay your chosen side face down on the work surface, with the purse laying portrait-style and the fringe ends nearest to you. Measure 16cm (6.25") down from the bottom end. Use a ruler to rub a temporary indented line horizontally across the felt at the 16cm (6.25") mark.

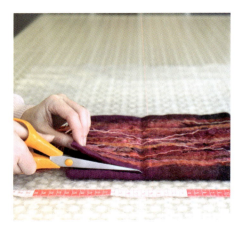

Step 19: Cutting the purse flap

Carefully cut along each side edge of the piece you are removing, up to the 16cm (6.25") mark, ensuring you cut inside of and away from the side edges by 5–10mm (0.25") to account for later shrinkage of the flap. Cut horizontally across the felt along the indented line and remove the felt piece, leaving the felt flap to fold down over the main purse pocket.

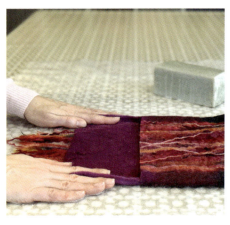

Step 20: Rubbing the purse flap edges

If preferred, cut around the top corners of the flap to round them off. Then spend 5–10 minutes rubbing all three cut edges with soapy hands to firm them up. NB Rubbing along the edges with them in between your fingers is a good way of achieving this.

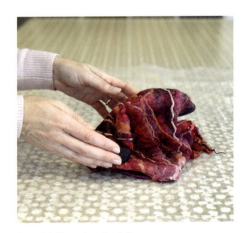

Step 21: Throwing the felt

Loosely pick up the felt and throw it down onto the work surface approximately 300–350 times, to shrink and harden it, in blocks of 50 (throw 50, reshape, throw 50, and so on). Stop when the purse (with the flap closed) has shrunk to around 20cm wide × 14cm high (8" × 5.5"), the felt feels thick and the surface has a natural crinkle.

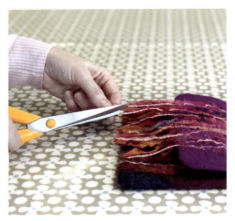

Step 22: Finishing the felt

Rinse the felt under warm running water, or soak in a bowl of warm water, until the water runs clear. Squeeze and then reduce the excess by rolling the felt up in a dry towel, then reshape and leave to air dry. Once dry, trim the fringe to a consistent shape/length just above the bottom of the purse (I trimmed to 5.5cm/2").

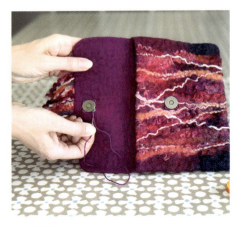

Step 23: Sewing the clasp

If preferred, hand sew a magnetic clasp fastener to the reverse of the flap using embroidery thread in a matching colour to the purse. Position one part of the clasp on the inside of the flap, centrally and approximately 1cm (0.5") from the flap edge. Match the other part of the clasp on the purse front and hand sew to finish.

Project Variation

FRINGED CLUTCH PURSE AND PIN CASE COLLECTION

I couldn't resist making a couple more colour variations for the purse. You'll also have noticed that we cut away quite a large piece of beautiful embellished fringed prefelt in this project. I like to reuse leftover felt wherever possible, so I used this to create a pin or needle case. I couldn't quite make the fringe work with this design, but I'm sure you can think of other ways to use this piece! The only extra thing you'll need is some kind of clasp to keep the case closed – I used a leather popper clasp.

Opposite are the steps for creating the pin case.

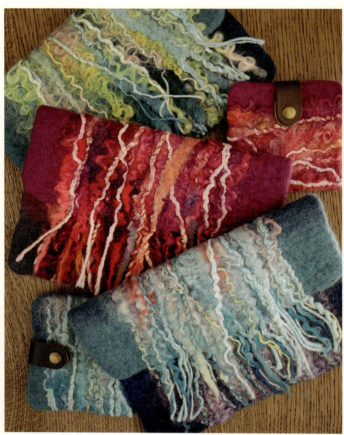

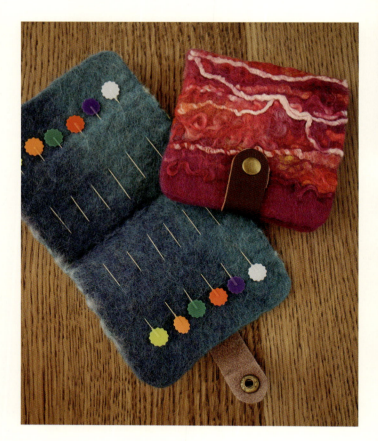

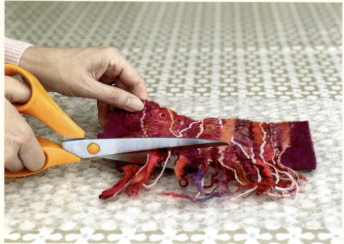

Step 1: Cutting the prefelt to shape

Cut away the fringe from the edge of the dry prefelt leftover piece and cut a small amount from each corner to create a gently rounded shape.

84 Chapter 4 – 3D Wet Felting (with Flat Resists)

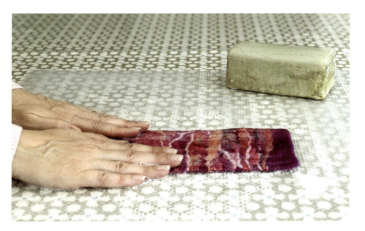

Step 2: Firming the prefelt

Soak the piece in soapy water. Then use extra soap to ensure your hands are very soapy and rub on the front and along all four sides of the piece to firm the edges.

Step 3: Finishing the edges

Rubbing the edge along a textured mat also helps to firm and harden the edges. Trim any stray excess fibres from the edges as necessary.

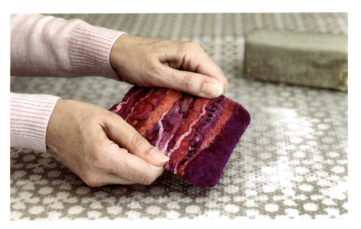

Step 4: Fulling the felt

Throw the felt on the work surface 200 times, in groups of 50 and reshaping each time, until it has thickened, shrunk and developed a crinkled texture.

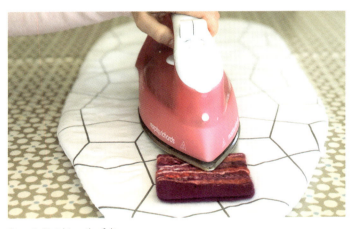

Step 5: Finishing the felt

Rinse the felt to remove the soap, roll in a tea towel to remove excess water, reshape and leave to air dry. Once dry, iron flat, fold in half and iron to set the fold.

Step 6: Sewing the clasp

Hand stitch a popper clasp to the side opening using matching embroidery thread. Add pins ir side to finish.

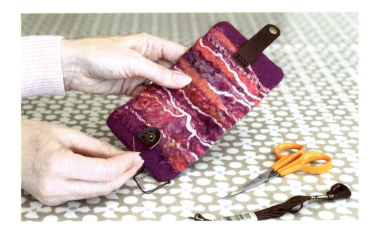

Chapter 4 – 3D Wet Felting (with Flat Resists)

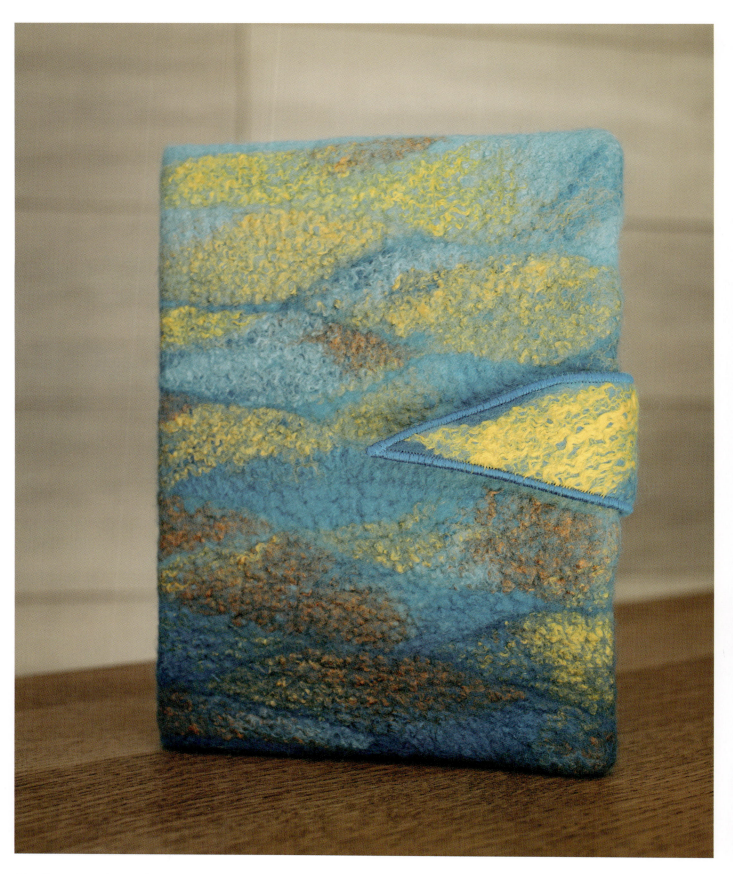

WAVE JOURNAL COVER PROJECT

This is a slightly more ambitious project, not least because we're creating a felted cover which has to fit an exact size (an A5 notebook). Although there are similarities with how we made the previous project (we're using another rectangular resist template and we'll be cutting away a piece of felt during the process to create flaps at either end), this time we're using a completely closed resist. We'll also be preparing a separate prefelt to create our surface design, using viscose fibres, which we'll cut into shapes to add to the main felt project. I've used the same wave template (*see* page 153) for this that I used to create the Wave Lampshade project variation in Chapter 3.

Although it's more complex, you can complete this project in stages, so it doesn't all have to be done at the same time. The first stage is the viscose prefelt, which can be quite quick to make. You'll see in the steps below that we don't have to be quite so particular about the felting process for this and we can move it along more quickly than normal. So even if the fibres haven't fully bonded after a few minutes of rubbing, we can move the process on to rolling them. There's a balance to be had between felting your prefelt just enough (so that it bonds more easily when you use it in the main project) versus overfelting your prefelt (so that it's harder to make it bond with the main project). Either option will create slightly different looks as to how integrated the viscose becomes in the finished felt project. But I've erred on the side of creating a light prefelt that is just holding together. Once dry, I used my rotary cutter and cutting mat, along with a simple card template, to cut out the shapes, which was a lot quicker than using scissors.

Stage two is laying out the fibre on top of the foam template, arranging the prefelt shapes on top and felting the journal cover to completion. I used Merino wool tops fibre throughout this project, in the Overlapping Tiles layout, mainly because it offers a greater colour range, in three horizontal bands of blue, ranging from light blue across the top to dark blue across the bottom. I used exactly the same colour configuration for all three layers of fibre.

The final stage is to add some kind of closure to the book. I wanted to reuse the cutaway piece of felt so felted a spare prefelt wave shape to that and cut it out once dry, along with a second wave shape. From these I created a flap with a magnetic clasp fastener, which I machine sewed to the finished book cover. These type of fasteners use prongs which are visible on the reverse, hence going to the trouble of sandwiching it between two layers of fabric (plus interfacing for added strength) for the flap, but if you don't want to do this you could use sew-in clasps instead. Or as a complete alternative, in the variation project I used the cutaway fabric to create a bead and cord closure. And if you'd prefer a very quick and simple closure option, just thread ribbon or cord through the inside centre edge of each flap, knotted at the end to stop it coming through, to make a tie closure.

Before you get started on this project, I just want to clarify an important difference between this and the variation project (aside from the obvious colours and orientation of the wave shapes). This project and the variation are a bit of a test to show the difference between felting something just enough and felting it more, and the effect this has on the surface design. You'll notice that the wave shapes and viscose fibres are more shiny and prominent in the autumn-coloured variation version (which was felted just enough), and less bright and well defined in the main blue version (which was felted much more). Neither option is wrong (they are both fully felted pieces), but I wanted to show how you can affect the look of the surface design by how far you go with felting something.

I achieved this difference by changing the size of the template used, whilst everything else largely stayed the same (that is, the fibre weights, felting process and finished size of 32cm × 22cm/12.5" × 8.5"). Here are the important measurement differences to note:

- Wave Journal Cover: template size 46cm × 32 cm (18" × 12.5") = 31 per cent (average) shrinkage.
- Autumn Journal Cover: template size 42cm × 28cm (16.5" × 11") = 23 per cent (average) shrinkage.

As well as showing the different surface design effect of felting something more or less, it also shows that you have quite a wide margin of how much you can felt a piece. Both journal covers were felted to the point of becoming thick, well-integrated felt with a crinkly surface. Yet one was felted significantly more than the other. So this is a good illustration of the flexibility and scope you have within your felting, and further proof that there are very few rights and wrongs!

And my final conclusion about which I prefer? Each version is different, so I like them both in different ways. However, I had to do significantly more fulling with the blue version to shrink it to the right size, whereas with the autumn version I was able to stop after throwing as it had already reached the

right size. So, for a slightly easier make I'd recommend the smaller starting template size. You might need to adjust the template size anyway if your notebook is a different size, in which case a calculation using a shrinkage rate of 25 per cent (if using Merino wool tops) should work out well.

WHAT YOU WILL NEED

Materials

For the prefelt
- For a 75cm × 35cm (29.5" × 14") prefelt, approximately 24g of dyed Merino wool tops in your chosen colours, in two layers (I've used light turquoise, dark turquoise and teal blue, 4g of each colour per layer = 24g total)
- Approximately 10g of viscose fibres in complementary colours (I've used five colours, 2g each of yellow, gold, copper, turquoise and cobalt blue)

For the main journal cover
- Approximately 72g of dyed Merino wool tops in your chosen colours, in three layers on each side (I've used the same colours as the prefelt, that is, light turquoise, dark turquoise and teal blue, 4g of each colour per layer per side = 72g total)
- A5 size notebook (15.5cm wide × 21.5cm high/6" × 8.5") (32cm × 21.5cm/12.5" × 8.5" when open)
- 25cm × 15cm (10" × 6") piece of iron-on interfacing
- 25cm × 15cm (10" × 6") piece of iron-on fusible/adhesive (for example, Bondaweb)
- Matching thread
- 18mm (0.75") pronged silver-coloured magnetic clasp fastener

Equipment

For the wet felting
- 46cm × 32cm (18" × 12.5") rectangular 5–6mm (0.25") thick foam resist template
- Minimum 75cm × 75cm (29.5" × 29.5") piece of small bubble bubble wrap
- Scales
- Large scissors
- Tape measure
- Ruler
- Spray bottle
- Washing-up liquid and warm water solution
- Rubbing tool
- Rolling tool
- Tea towel
- Large towel

For cutting the prefelt and the clasp
- Iron and ironing board
- Cutting mat
- Rotary cutter
- Card wave template
- Large scissors
- Sewing machine or hand sewing needle
- Seam ripper
- Pencil
- Clingfilm/plastic wrap

Step 1: Assembling your materials

Collect your Merino wool tops and viscose fibres together and ensure that you are happy with your colour palette before getting started. Starting with the 24g prefelt allocation of Merino wool fibre, divide each 8g colour allocation of the three colours in half lengthways, reserving half for each of the two prefelt fibre layers.

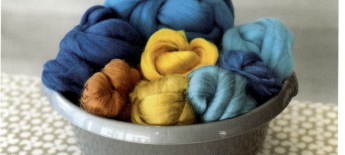

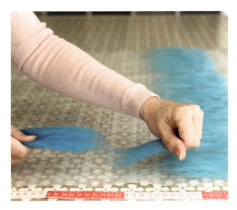

Step 2: Laying out the prefelt fibre (layer one)

On a hard, water-resistant work surface, open out the bubble wrap, smooth side up. Position it so that you use half as your 75cm × 50cm (29.5" × 20") working area. Lay out fibre in fine, overlapping wisps oriented north to south to build up a 75cm × 35cm (29.5" × 14") rectangle, in any colour distribution. NB I've used bands of colour.

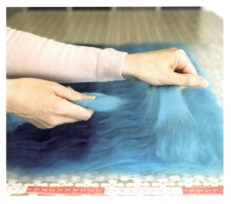

Step 3: Laying out the prefelt fibre (layer two)

Repeat Step 2 to create the second layer of fibre, keeping the same colour distribution, but this time laying the fibres in an east to west direction. Aim to create an even layer of fine, overlapping fibre. Keep patting to test for thin areas and add extra wisps to infill these until the overall thickness of the fibre feels even.

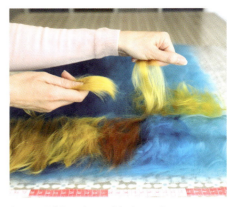

Step 4: Adding the prefelt viscose layer

Add a complete surface layer of viscose fibres on top of the wool fibre using the full 10g allocation. Treat them the same as the wool fibre, pulling wisps from the viscose tops and laying them down. Use any colour distribution you like. NB I used squares of colour in a 5 × 5 grid pattern, ensuring each colour appears in a different position.

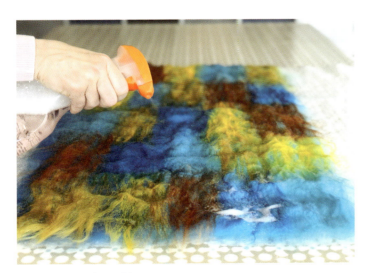

Step 5: Wetting the prefelt

Once happy with the viscose design layout, gently spray warm soapy water solution all over the fibre rectangle until soaked. Spray from above to avoid disrupting the fibres and make delicate adjustments with your fingertips to reposition stray fibres. Fold the other half of the bubble wrap over the fibre rectangle to sandwich it.

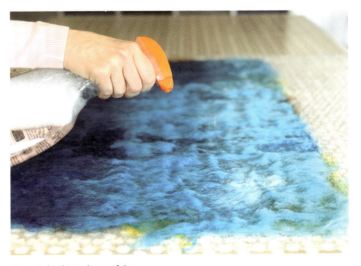

Step 6: Soaking the prefelt

Press down gently to disperse the soapy water throughout the fibre, either using your hands or with the rubbing tool. Then turn the whole fibre package over, peel back the bottom layer and spray the reverse until soaked. Replace the bubble wrap and again press down, ensuring the fibre is completely soaked through and flattened.

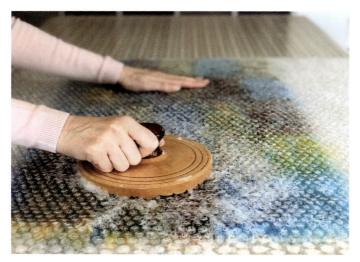

Step 7: Rubbing the prefelt

Spray the bottom of the rubbing tool to help it move more easily, then gently rub it all over the fibre through the bubble wrap for five minutes whilst a soapy lather develops. Turn the package back to the front and repeat. Then prepare for the next stage by rolling up the package around the rolling tool, then roll the whole lot up in a tea towel.

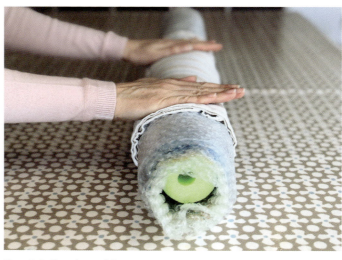

Step 8: Rolling the prefelt

Roll the package away from you to arm's length and back again, counting as one roll. Roll 100 times. Then turn the package 90 degrees clockwise and repeat three more times until the fibre has been rolled 100 times on each edge. Then turn over and repeat on the reverse, to make 800 rolls in total. Reshape after each 100 rolls.

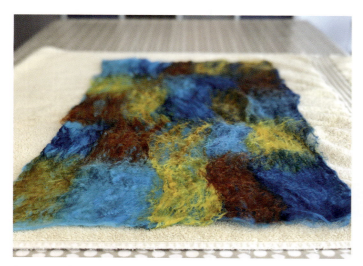

Step 9: Finishing the prefelt

Unwrap the package, discard the bubble wrap and gently rinse the prefelt under warm running water, or soak in a bowl of warm water, until the water runs clear. Squeeze out excess water by rolling the felt up in a dry towel, then reshape and leave to air dry. Once dry, steam iron flat on the reverse and it is ready to use.

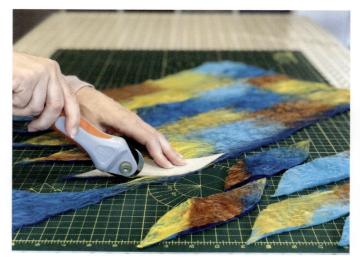

Step 10: Cutting the prefelt

Using scissors, or a rotary cutter and cutting mat, cut around the wave template as many times as you can fit on the prefelt, varying the placement to create as many differently coloured shapes as possible. Put the shapes aside. NB I created twenty-four wave shapes, with the template placed diagonally to get three colours on each one.

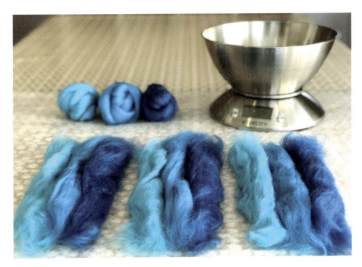

Step 11: Preparing the main fibre

Divide the 72g allocation of Merino wool fibre in half for each side of the template. For each side, divide the 36g allocation into three, that is, 12g for each layer (4g per colour if using three colours). Put the side two allocation aside. Prepare the bubble wrap as in Step 2 and lay the template on top, oriented landscape-style in front of you.

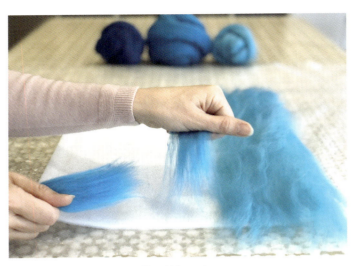

Step 12: Laying out the main fibre (side one)

Lay out the main fibre in the same way as the prefelt fibre in Steps 2 and 3, although this time lay out three separate layers of fibre. Lay directly on top of the template and overlap the edges all around by 2–3cm (1"). In layer one, lay the fibres in an east to west direction, alternating the direction each time for layers two and three.

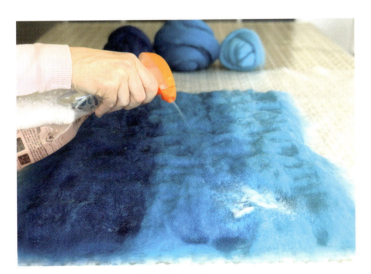

Step 13: Wetting the main fibre (side one)

Gently spray warm soapy water solution all over the fibre rectangle until soaked through, spraying from above to avoid disrupting the fibres. Fold the other half of the bubble wrap over the fibre rectangle to sandwich it. Press down and rub gently with your hands or the rubbing tool to disperse the soapy water throughout the fibre.

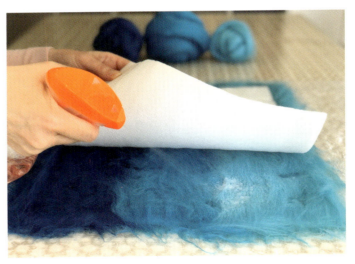

Step 14: Wetting the reverse of side one

Turn the template over to side two and gently peel back the bubble wrap. Remove the template and spray the reverse of the side one fibre to ensure it is completely soaked before replacing the template.

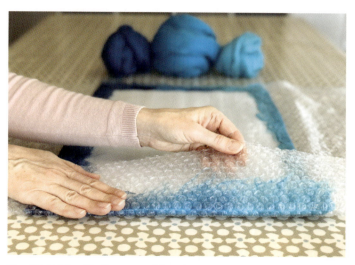

Step 15: Folding the fibre around the edges

Using the bubble wrap to help lift and fold the edges over, smooth the fibre overlap from side one onto side two, starting with the top and bottom edges and then the side edges. At the corners where there is a fibre fold, fluff out the edges and smooth them down until neat and tight against the template.

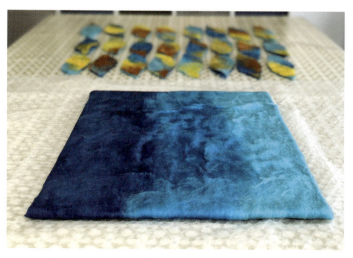

Step 16: Completing the main fibre layout (side two)

Take your side two fibre allocation and repeat Steps 12, 13 and 15 to complete the side two layout. The template will now be completely enclosed by three layers of fibre on both sides. Lay out the prefelt wave shapes next to the fibre package so that you can easily see all the colours available.

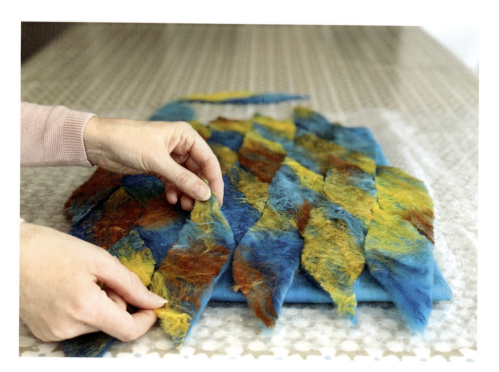

Step 17: Arranging the prefelt design

Arrange the wave shapes horizontally on top of one of the fibre sides, butting the shapes up against one another and varying the colour placement until you are happy with the overall arrangement. Leave one shape aside. NB The right-hand side of the fibre package will become the front cover of the book, and the left-hand side the back.

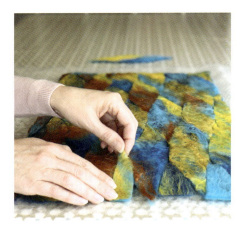

Step 18: Neatening the design edges

Trim the overhanging wave shapes to the edge of the cover along the top and bottom edges. Do the same for the side edges, or trim to an equal overhang length for folding over the edge if preferred (NB I trimmed the overhang to 4cm/1.5"). Use the excess trimmed prefelt pieces to infill the gaps in the design.

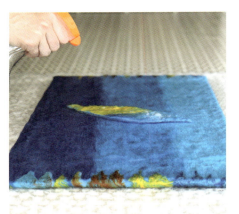

Step 19: Wetting and finishing the design

Repeat Step 13 to wet the design and soak the fibres throughout, then turn the package over. Peel back the bubble wrap and neaten/trim the overhang prefelt pieces before smoothing around the side edges. Place the reserved wave shape just left of centre, and at least 15cm (6") from the left-hand edge, and spray to secure.

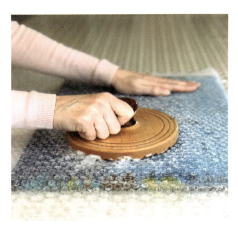

Step 20: Rubbing the fibre

Replace the bubble wrap, spray the bottom of the rubbing tool to help it move more easily, and gently rub it all over the package through the bubble wrap for 15 minutes each side. Check the viscose fibres and prefelt shapes regularly for movement and stop rubbing when they are largely staying in place.

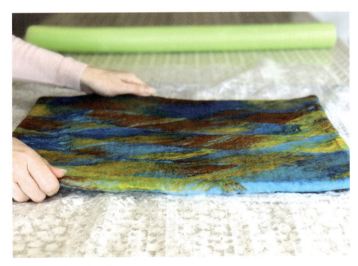

Step 21: Rolling the fibre

Roll up the package around the rolling tool, then roll the whole lot up in a tea towel. Repeat Step 8 to roll the fibre 800 times. Ideally, the fibre, which is now becoming felt, will feel tight and be starting to strain against the template. If it still feels soft and loose, repeat Step 8 for a further 400–800 rolls. Remove the bubble wrap.

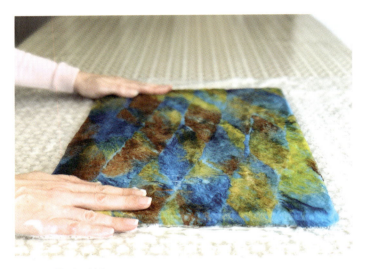

Step 22: Final rubbing

Rub the fibre package all over with soapy hands for at least 5 minutes each side until the viscose fibres and prefelt shapes appear fully bonded in place and the felt is feeling thicker. Focus also on rubbing all the edges into and against the template edges, to ensure the fibres stay as tight as possible around the template.

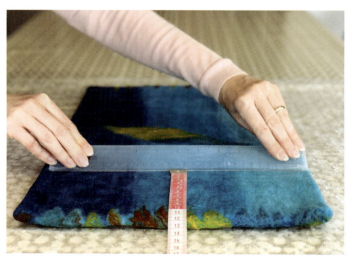

Step 23: Cutting the inside cover flaps

With the reverse of the felt facing up, measure 12cm (4.75") from each side edge and use a ruler to rub a temporary indented line vertically across the felt to mark the inside flap edges. Cut along each line, starting and finishing 5–10mm (0.25") from the top and bottom edges and being careful not to cut the template inside.

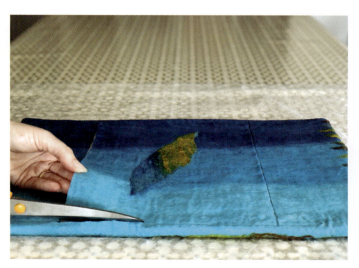

Step 24: Cutting the cover edges

Repeat Step 23 to mark lines and cut along the top and bottom edges of the cover between the inside cover flaps, 5–10mm (0.25") from the edges to account for later shrinkage of the cover. Remove the rectangle of excess fabric, which includes the spare wave shape, and put aside.

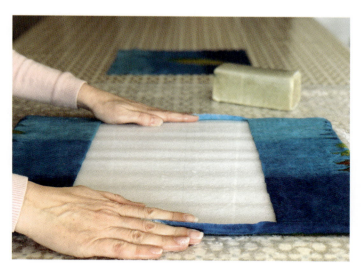

Step 25: Rubbing the edges

Spend at least 10 minutes rubbing all four cut edges with soapy hands to firm them up. NB Rubbing along the edges with them in between your fingers is a good way of achieving this, as is rolling the edges inwards. Remove the template and spend a further 5 minutes rubbing the inside of the cover to ensure the fibres are bonded.

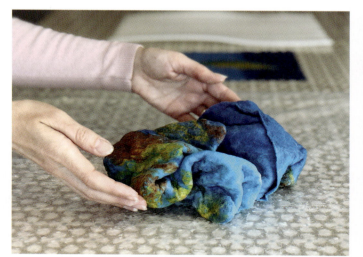

Step 26: Throwing the felt

Loosely pick up the felt and throw it down onto the work surface approximately 400–500 times, to shrink and harden it, in blocks of 100 (throw 100, reshape, throw 100, and so on). The felt should be starting to feel thicker and the surface should be developing a natural crinkle, like crocodile skin.

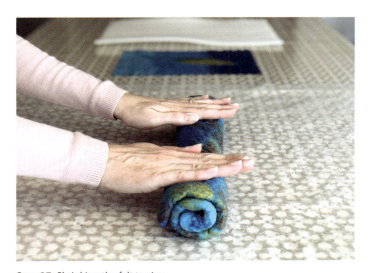

Step 27: Shrinking the felt to size

Cover the notebook with clingfilm and, as the felt shrinks, keep inserting the notebook to check the fit. For more focused shrinkage, roll the felt up on itself and roll north to south and south to north, to shrink the height, and east to west and west to east, to shrink the width, for 50 rolls each time and regularly checking the fit.

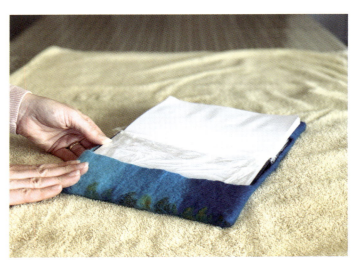

Step 28: Shaping the felt

If the corners are starting to flare out, roll the corners inwards for 20–25 rolls to straighten them. Once the felt shrinks to a minimum of 33cm wide × 22.5cm high (13" × 9") (that is, 1cm/0.5" bigger than the notebook), repeat Step 9 to rinse, towel dry and reshape the felt with the notebook inside before removing, then leave to air dry.

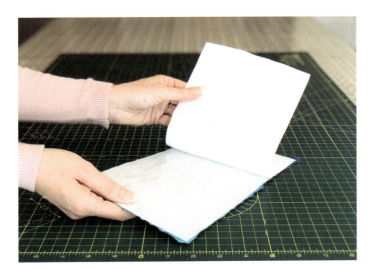

Step 29: Felting the closure flap

Repeat Step 26 to shrink and thicken the reserved felt rectangle, stopping when it reaches approximately 25cm × 15cm (10" × 6"). Rinse, reshape and leave to air dry. Once dry, steam iron and attach iron-on interfacing to the reverse. Then attach iron-on fusible/adhesive. Once cool, peel off the fusible's backing paper.

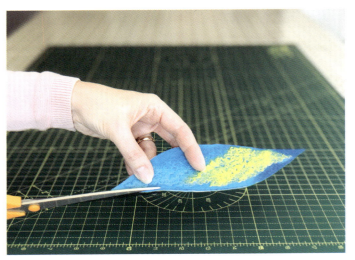

Step 30: Cutting out the closure flap

Use the wave template to cut out the prefelt shape as well as a second wave shape from the felt. NB Remember to flip the template over before cutting the second wave shape to create a mirror image. Place the two wave shapes wrong sides together and trim to match them as closely as possible.

Chapter 4 – 3D Wet Felting (with Flat Resists)

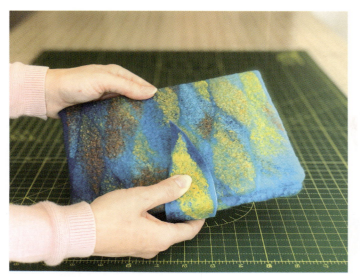

Step 31: Marking the clasp position

With the notebook inside the cover, fold the wave pieces around the side edge with the viscose side uppermost and decide which way round it should go. NB The two parts of the magnetic clasp will attach to the front cover and the second wave shape respectively. Mark the wave position with pins on the front and back cover.

Step 32: Attaching the clasp

Place the metal 'washer' to start 4–4.5cm (1.5") from the end of the second wave on the reverse, centrally width-wise, and mark the two prong slits. Use scissors or a seam ripper to cut the slits. Push the pronged part of the clasp through the slits from the front. Attach the metal 'washer' to the reverse; bend the prongs back to secure.

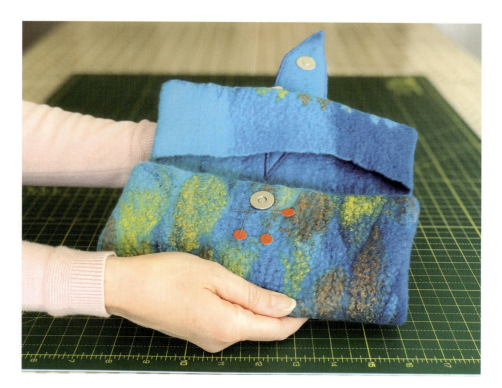

Step 33: Finishing the closure flap

Place the two wave felt shapes wrong sides together and iron to melt the fusible to secure. Hand or machine sew around the edges of the wave. Secure the flap on the reverse of the cover by sewing a triangle shape at the end. Measure, mark with pins and attach the other part of the clasp to the front cover in the same way to complete.

Project Variation

AUTUMN JOURNAL COVER

As outlined above, I made a second journal cover for the project variation, with the following differences:

- I used four colours of Merino wool tops (rather than three), in chocolate brown, tan brown, moss green and sand yellow = 3g per colour per 12g layer. I used three colours of viscose fibre (rather than five), in copper, green and gold = 3.5g per colour.
- I reduced the size of the template by 4cm (1.5"), in both width and height, to measure 42cm × 28cm (16.5" × 11"). This meant less overall shrinkage to reach the finished size, so the viscose fibres felted into the wool fibres less, hence the wave shapes being more defined and the viscose fibres being more prominent. I needed to do very little focused shrinking/shaping (Steps 27 and 28), as 450 throws was enough to shrink the cover down to the finished size.
- I laid the wave prefelt shapes vertically on top of the wool fibres (instead of horizontally). Along with the colours, my aim with the vertical orientation was to give more of an impression of autumn leaves.
- I created a felt bead and cord for the journal closure, instead of a closure flap, again using the excess centre felt. NB Bear in mind that the excess piece will be smaller than in the main project due to the smaller template size.

Overleaf are the steps for felting the bead and cord closure.

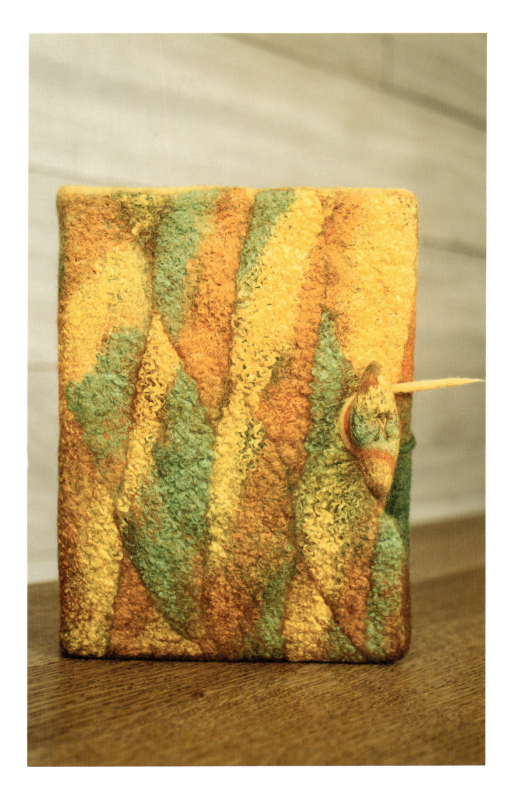

Chapter 4 – 3D Wet Felting (with Flat Resists)

Step 1: Cutting the felt shapes

From the excess centre prefelt rectangle, use the wave template to cut out the wave shape. Separately cut a 1cm (0.5") wide strip from the long edge of the felt.

Step 2: Creating the bead shape

Roll up the wave shape, from tip to tip and with the viscose side facing out. Keeping the roll shape secure in your hand, spray it with soapy water until soaked.

Step 3: Felting the bead

Gently roll the bead between your hands, increasing the pressure as it starts to firm up and shrink. Continue rolling it in your hands or on the work surface until firm.

Step 4: Creating the cord shape

Spray the felt strip all over to soak. Fold it in half lengthways and gently roll it between your hands to encourage a rounded cord shape to develop.

Step 5: Felting the cord

Roll the cord across the work surface (ideally on a textured mat) with both hands until firm. Rinse the bead and cord until the water runs clear and leave to air dry.

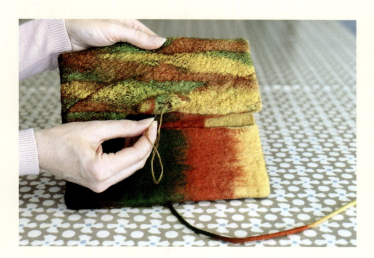

Step 6: Assembling the clasp

Tie a knot at one cord end and thread it through the side edge of the back cover from the inside. Sew the bead to the front cover and wrap the cord around to close.

SILK STRIPE CUSHION COVER PROJECT

For the final flat resist project, we're keeping the rectangle resist template shape of the last two projects but upscaling size-wise to create a large cushion cover. We're using two resists to create two overlapping flaps on one side (which will be the opening to insert the cushion pad inside), which are closed all around the edges but open in the middle. So we're harnessing the unique properties of felt to create our side seams to keep the two flaps in place and create the cushion's structure. This is a no-sew cushion, aside from adding optional closures (I've used sew-in magnetic clasps).

For the surface design, we're using strips of patterned sari silk, sparkly sari ribbon and wool/bamboo mix yarns to create different stripes of colour with lots of textural interest. This is another nuno felt project, but it incorporates the silk fabric as embellishment pieces rather than the whole layer we used in the Nuno Silk Scarf Project. Bear in mind that the sari ribbon isn't made of silk, it's made of nylon, so is man-made. However, it has a very loose-weave structure so works perfectly for nuno felting as the fibres can very easily migrate through the holes and bond with it. It's particularly lovely as it has a sheen to it and a sparkly metallic strip running through. Don't use ordinary ribbon, this is special ribbon yarn with a very open weave structure to it.

Since a cushion cover needs to be hard-wearing, I've aimed for felting it more rather than less to ensure that the felt is well felted and the embellishments are well bonded. As a result, the fabric strips are very integrated with the wool fibre, which means that their brightness has been dulled down. This is why I'd recommend using bright fabric pieces (like patterned sari silk, along with the sparkly sari ribbon) to ensure that they still stand out well in the finished cushion. As usual, it's a good idea to test your combination of fabrics and wool fibre before you start so that you're happy with the colour mixing and the ruching effect of the fabric. Another advantage of creating a sample first is that when you're in the middle of a big project like this you'll already have an idea of when the fibres are starting to bond to the fabric, and what it looks like, so when you see this you can feel more confident about moving on to the next stage in the felting process.

In terms of the wool fibre, I recommend using batt fibre (I'm using Finnwool), which is generally more suitable for hard-wearing items and, as this is such a large project, using batts will considerably speed up the layout stage. We're really just using one thick layer of wool batt fibre in this project to create a rectangle of fibre measuring 110 × 80cm (43.5" × 31.5"), and how you achieve that colour-wise is up to you, although it will probably be built up of several thinner layers depending on the colours you use and the size of your batts.

If you follow my design of using three bands of colour (pastel pink and two different shades of grey), or you're using a mix of colours all over, you'll probably need to tear up your batt into several smaller pieces to fit the design using the Patchwork Layout. But if you're only going to use one colour of batt fibre, then just lay it out and tear bits off and add bits until you've filled the shape. The important thing is that your finished fibre rectangle has an even thickness all over, so keep patting and adjusting until you achieve that. There's no advantage with this project of creating individual layers and working on them separately so just lay out all the fibre in one go.

You'll see that we soak and flatten the fibre before adding any embellishments, which helps create a flatter surface to lay them on so that they move around less during the layout stage. There's no need to wet any of the embellishment materials first, as just pressing them into the wet fibre is enough to soak them (and they're easier to lay out if they are dry).

I've deliberately kept ridges around the cushion edges to keep the rectangular, edged shape but you could smooth these out if you prefer once you remove the resists and start the fulling stage. You'll also find during fulling that the flaps, which are constrained at the side edges where they are joined but not in the central area of the cushion, will naturally be wanting to recede further in the centre. So keep an eye on these and keep stretching them back to try and maintain straight flap edges. This is why you might want to add some kind of clasp along the visible flap edge once the cover is finished to keep the opening closed. I used magnetic clasps underneath the flap, but you could also make a feature of the flap edge with buttons or ties.

The finished cushion cover measures approximately 51cm × 31cm (20" × 12").

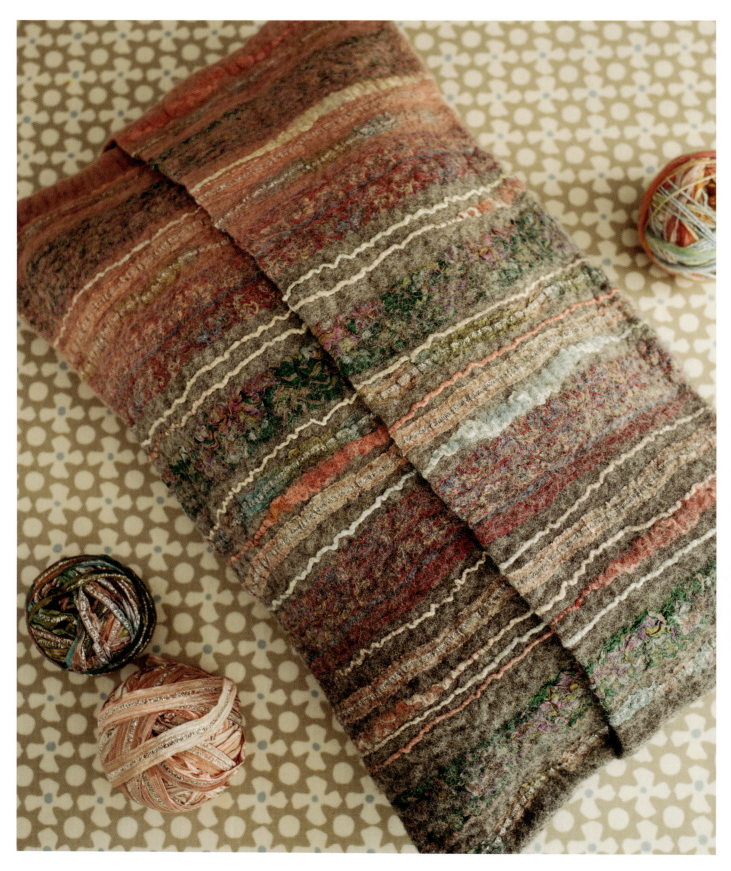

WHAT YOU WILL NEED

Materials
- Approximately 270g of wool batt fibre in your chosen colours (I've used Finnwool fibre: 90g each of rose pink, light grey and dark grey)
- Approximately 120cm × 30cm (47" × 12") in total in one piece or several pieces of sari silk, cut into five strips each 120cm long × 5–6.5cm wide (47" × 2"–2.5") (I used two pieces, one green and one pink, each approximately 120cm × 15cm/47" × 6" before cutting into strips)
- Approximately 8.5m (28ft) in total of two sari ribbons, cut into seven lengths each 120cm (47") long (I used Louisa Harding Sari Ribbon in a pastel pink/blue/green mix with silver and Louisa Harding Sari Soft in variegated light pinks with silver)
- Approximately 13m (43ft) in total of thick and thin wool/bamboo mix yarn, cut into eleven lengths each 120cm (47") long (I've used a variegated Bamboo Bloom Handpaints thick and thin bamboo/wool mix yarn in pastel pink, green and blue shades)
- Three 18mm (0.75") antique brass-coloured sew-in magnetic clasps (optional)
- Grey embroidery thread (optional)
- 50cm × 30cm (20" × 12") cushion pad insert

Equipment
For the wet felting
- Two 75cm × 45cm (29.5" × 18") rectangular 5–6mm (0.25") thick foam resist templates
- Two 115cm × 85cm (45" × 33.5") pieces of small bubble bubble wrap
- Scales
- Large scissors
- Tape measure
- Ruler
- Spray bottle or large water sprayer
- Washing-up liquid and warm water solution
- Olive oil soap
- Rubbing tool
- Rolling tool
- Tea towel
- Large towel

For sewing the optional clasp
- Tape measure or ruler
- Pins
- Needle
- Scissors

Step 1: Assembling your materials

Collect your wool batt fibre, sari silk, sari ribbons and wool yarn together, ensuring that you are happy with your colour palette and that the surface embellishment materials both complement and contrast with the colours of the wool batt fibre. On a hard, water-resistant work surface, lay one piece of bubble wrap, smooth side up.

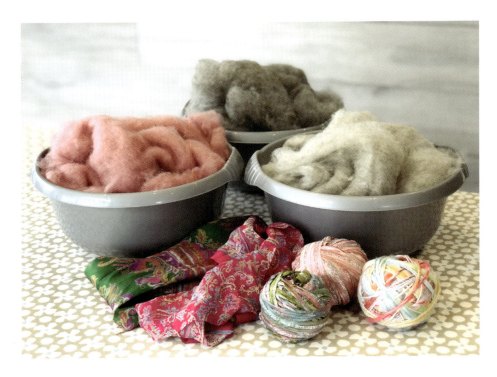

Chapter 4 – 3D Wet Felting (with Flat Resists)

Step 2: Laying out the fibre

Take your first colour of wool batt fibre and peel apart the layers/tear to size to create a band of fibre measuring approximately 110cm long × 27cm wide (43.5" × 10.5") along one edge of the bubble wrap. Repeat for the next 2 colour bands of fibre, to create a fibre rectangle measuring 110cm × 80cm (43.5" × 31.5").

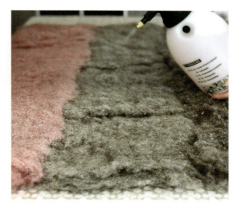

Step 3: Wetting the fibre

Pat to ensure the fibre is an even thickness all over (approximately 5cm/2" thick) and adjust by adding or removing fibre as necessary. Gently spray warm soapy water solution all over the fibre rectangle until at least the uppermost fibre is completely soaked, spraying from above to avoid disrupting the fibres.

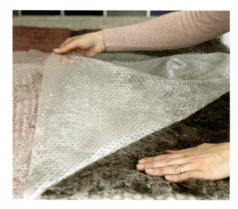

Step 4: Flattening the fibre

Cover the fibre with a second piece of bubble wrap, smooth side down, to sandwich it. Press down and rub gently with your hands or the rubbing tool to disperse the soapy water. The felt does not have to be completely soaked through, but ensure the visible uppermost fibre is soaked. Peel back the top layer of bubble wrap and add more water as needed.

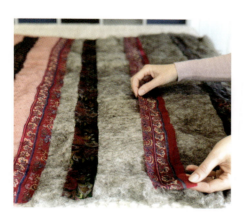

Step 5: Adding the silk fabric

Lay the strips of sari silk fabric on top of the flattened fibre rectangle in line with the long edge, ensuring the fabric ends meet or extend slightly beyond the fibre at each short edge. Lay them out in any placement order you prefer until happy with the arrangement. Press the fabric strips into the fibre to wet and secure them in place.

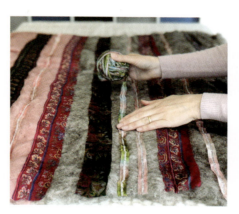

Step 6: Adding the silk ribbons and yarns

Repeat Step 5 to add the lengths of silk ribbons and yarns. When laying the ribbons, ensure they lie completely flat and aren't twisted or folded. Also ensure that all the embellishments lie at least 7cm (2.5") from each long edge to avoid the cushion side seams. Decide which short edge will be visible/not visible in the finished cushion.

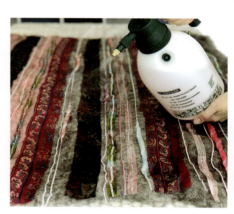

Step 7: Flattening the embellishments

Gently spray warm soapy water solution all over the fibre rectangle again to soak the embellishments. Cover with the second piece of bubble wrap, press down and rub gently with your hands or the rubbing tool to disperse the soapy water and flatten the fibre. Again, the fibre does not have to be completely soaked through at this stage.

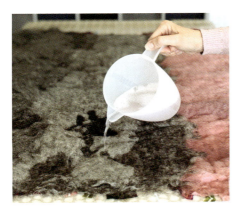

Step 8: Soaking the reverse

Turn the fibre package over to the reverse (NB Rolling it up before turning makes this easier) and peel back the top layer of bubble wrap. The fibre now needs to be completely soaked through, so either spray or pour on more soapy water. Replace the bubble wrap, press down and rub to disperse the water and fully flatten the fibre.

Step 9: Neatening the visible short edge

Remove the top layer of bubble wrap. To neaten the visible short edge of the cushion, fold it back to the reverse by at least 2–3cm (1"). To make this easier, use the bubble wrap to make the fold: fold the bubble wrap at the point you want the fibre edge to fold, then press down along the fold to flatten and secure it.

Step 10: Finishing the short edges

Peel back the bubble wrap fold and trim the embellishments to the same length, 2–3cm (1") from the fold. Then lay a thin strip of fibre along the edge, covering the ends of the embellishments to secure them and help thicken the edge overall. Soak and flatten in place to secure. Repeats Steps 9–10 for the non-visible short edge.

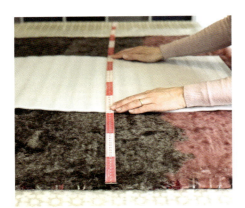

Step 11: Placing the template on the fibre

With the fibre reverse still facing upwards and oriented landscape-style in front of you, place the template centrally and oriented portrait-style onto the fibre. Adjust the template so that the gap between the long template edges and the short, folded fibre edges measures approximately 31cm (12") each side.

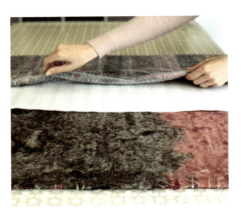

Step 12: Folding the inner cushion flap

Fold the non-visible short edge of the fibre over the template as far as it will go so that the fold sits tightly against the long template edge. This creates the inner cushion flap. To make picking up and folding the fibre easier, use the bubble wrap underneath to help fold it over, then peel back the bubble wrap.

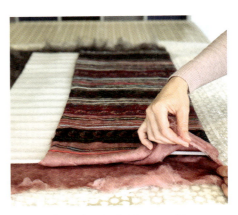

Step 13: Neatening the first inner cushion flap side edge

The unneatened inner cushion flap side edges overlap the short side edges of the template by 5–6cm (2"). These now need to be folded around and underneath the template. To do this, first make a 5–6cm (2") tear on the overlap at the fold on one of the side edges. Then tuck the side edge excess neatly underneath the template.

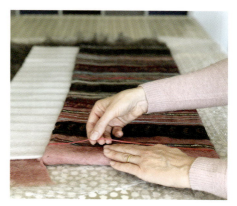

Step 14: Finishing the first inner cushion flap side edge

This leaves a similar 5–6cm (2") overlap from the bottom layer of fibre, which needs to be folded around and on top of the inner cushion flap. Tear the bottom side overlap in line with the long neatened inner flap edge and fold the side overlap over the inner flap, smoothing the fibre and tucking it under any embellishments.

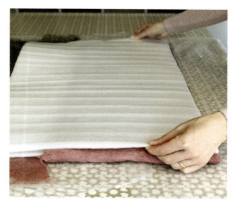

Step 15: Finishing the second inner cushion flap side edge

Repeat Steps 13 and 14 to neaten and secure the inner cushion flap's other side edge. Ensure all edges are fluffed out and smoothed onto the template, with no lumps. Then place the second template on top of the inner cushion flap, oriented exactly the same as the first template.

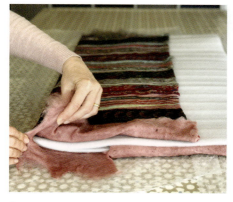

Step 16: Folding the outer cushion flap

Repeat Step 12 to fold the outer cushion flap over the second template. This again creates unneatened flap edges which overlap the short side edges of the template by 5–6cm (2") and need to be folded around the main fibre. For the first side edge, make a 5–6cm (2") tear on the overlap at the fold, tearing only as far as the template.

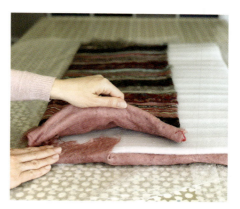

Step 17: Neatening the first outer cushion flap side edge

Fluff out the edges of the overlap on the bottom layer of fibre, fold it neatly up over the second template and under the outer cushion flap, smoothing it down to ensure there are no lumps. NB If you have an excessive overlap at any of the side edge folds, feel free to trim to no less than 3cm (1").

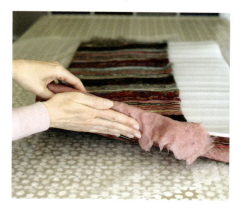

Step 18: Finishing the outer cushion flap side edges

Fold the remaining outer cushion flap overlap down over the template and rest of the fibre to meet the other side of the cushion. Fluff out the fibre edges and smooth them to the other side, tucking them under any embellishments, as necessary. Repeat Steps 16–18 to neaten and secure the outer cushion flap's other side edge.

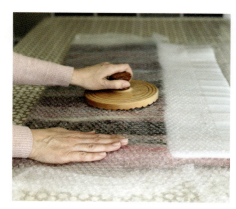

Step 19: Rubbing the fibre

With the cushion flaps still facing upwards, spray the fibre package all over, including the side edges, until the fibre is soaked and soapy. Replace the top layer of bubble wrap and spend at least 15 minutes rubbing the fibre package in line with the direction of the fabric and yarns to cause least disruption, as well as the side edges.

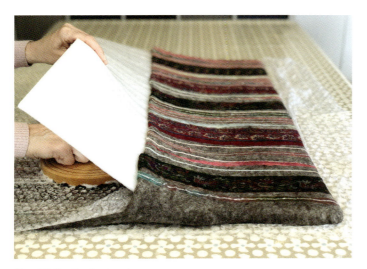

Step 20: Continuing to rub

Then spend at least 10 minutes rubbing the inner cushion flap. To access this, turn the fibre package around, lift up the second template, fold over the bubble wrap onto the inner cushion flap and rub the flap all over, again in the direction of the fabric and yarns. Then turn the fibre package over and repeat Step 19 to rub on the other side.

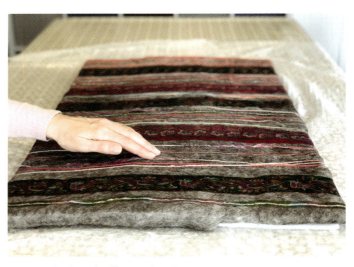

Step 21: Checking the fibres are bonding

Peel back the bubble wrap and check the yarns for movement by gently rubbing your fingers over the surface. Also check that the wool fibres are migrating through the fabric. If there is considerable movement and no migration, replace the bubble wrap and continue to rub, checking it regularly, until the yarns are mostly staying in place.

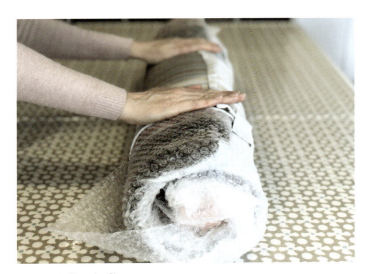

Step 22: Rolling the fibre

Move to the rolling stage, but only roll from the long edges in line with the yarns and fabric to avoid disrupting them. Roll up the package around the rolling tool, then roll the whole lot up in a tea towel. Roll the package away from you to arm's length and back again, counting as one roll. Roll 200 times from each long edge (that is, 400 rolls).

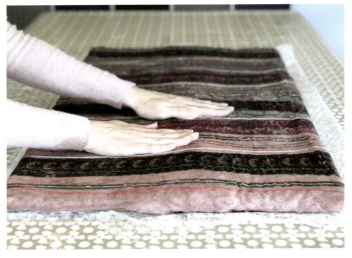

Step 23: Continuing to roll

Turn the package over and repeat on the reverse, to make 800 rolls in total. Check the fibre migration through the fabric and whether it appears to be securely bonded. If not, repeat Steps 22 and 23 for as many times as necessary until the fabric is secure. Then remove the bubble wrap and rub all over with your hands for 5–10 minutes.

Chapter 4 – 3D Wet Felting (with Flat Resists)

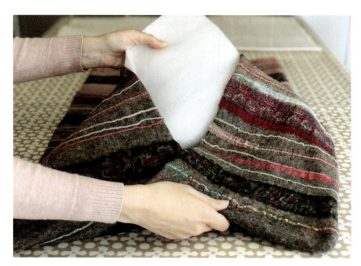

Step 24: Removing the templates

Carefully remove the two foam templates. Put your hand inside the cushion shape and rub all over to check the fibres inside are bonded. If not, spend a few minutes rubbing the inside. The fibre is now becoming felt. If the felt is very wet at this point, squeeze out some of the excess water. Reshape to maintain the cushion form.

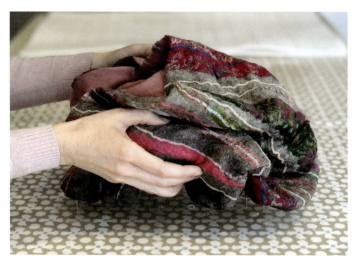

Step 25: Throwing the felt

Loosely pick up the felt and throw it down onto the work surface approximately 400 times, to shrink and harden it, in blocks of 100 (throw 100, reshape, throw 100, and so on). Each time you reshape it, focus on maintaining the rectangle shape by rubbing and stretching the sides, and stretching the flap edges to keep them straight and in line.

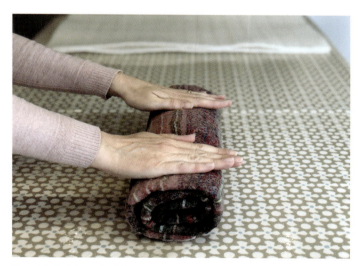

Step 26: Shrinking the felt

The felt should be starting to shrink, feeling thicker and developing a more crinkled texture. To shrink it to size whilst maintaining its shape, alternate between rolling it on itself from all four edges for 100 rolls (wrapped in a tea towel if this is easier) and throwing it down flat, or on its edges, for 100 throws. Reshape after each 100.

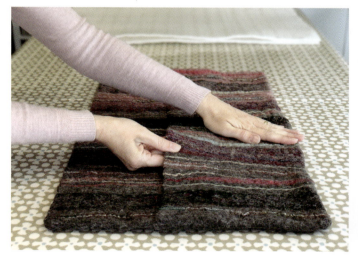

Step 27: Shrinking to size

Repeat Step 26, continuing to maintain its shape, until the felt reaches a final size of no less than 51cm wide × 31cm high (20" × 12"). For focused shaping, for example if the corners are flared, roll the corners inwards for 25 rolls. For focused shrinkage, for example to reduce the width, roll on the short edges (or the long edges to reduce the height).

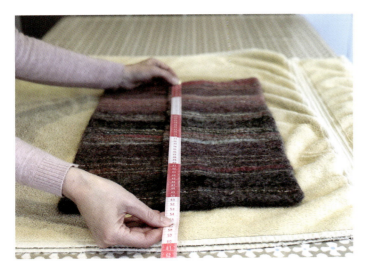

Step 28: Finishing the felt

Rinse the felt under warm running water, or soak in a bowl of warm water, until the water runs clear. Squeeze and reduce the excess by rolling the felt up in a dry towel, then reshape and leave to air dry. Once dry, iron if preferred and insert the cushion pad to finish (but temporarily remove it if completing Step 29).

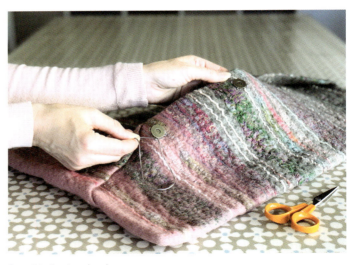

Step 29: Sewing the clasps

Use matching embroidery thread to hand sew three magnetic clasps to the reverse of the outer flap. Position and sew one clasp part onto the flap reverse, centrally and 1cm (0.5") from the flap edge. Match up and sew the other clasp part onto the inner flap. Attach the other clasps equally between the central clasps and each side edge.

Step 30: Finishing the cushion

Insert the cushion pad, plump up the cushion and attach the front flap to the main body of the cushion using the clasps.

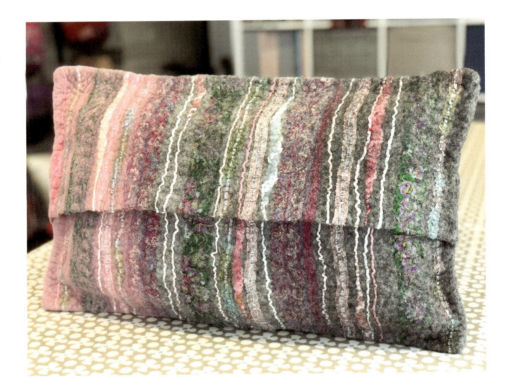

Chapter 4 – 3D Wet Felting (with Flat Resists)

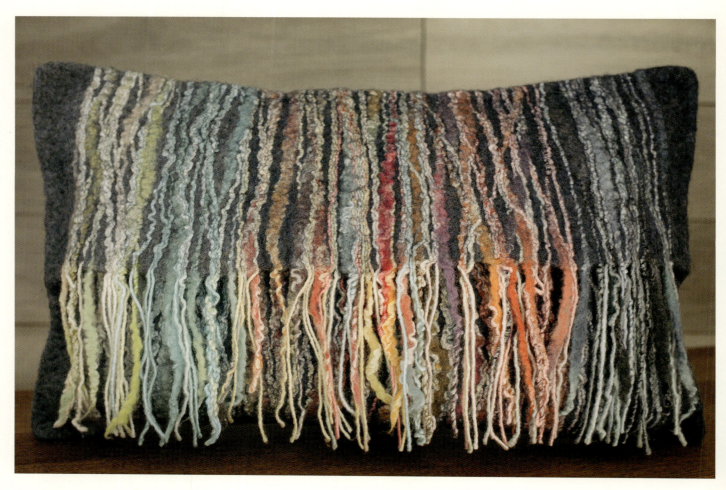

Project Variation

FRINGED CUSHION COVER

For the cushion cover project variation, I've created a fringed version, with the same fibre weights and measurements. The design is not dissimilar to the Fringed Clutch Purse Project (again taking advantage of a flap opening to create a fringe overlapping the edge), although this time I have only used yarns (not curly locks, although of course you could) and I've largely kept them in straight lines rather than overlapping across the whole piece. Here are some tips for creating this version:

- Lay wool batt fibre in any colour configuration, in an even thickness (I used Finnwool laid in three bands of colour lengthways, ranging from a light blue-grey to a dark blue-grey).
- Use a variety of yarns for added interest, or different colours of the same type of yarn for a cohesive design look (I used seven different colours of the variegated Bamboo Bloom Handpaints thick and thin bamboo/wool mix yarn, and laid 13–17 lengths of each colour in bands, varying the placement of the thick and thin parts, including on the fringe).
- Cut each yarn length to 140cm (55") (rather than 120cm/47") to create the extra length for the fringe.
- Make the decision at the start which will be your visible short edge (that is, the one with the fringe) and extend the yarn over the edge by at least 20cm (8"). Still follow Steps 9 and 10 to fold back the edge to neaten it, but when you peel back the bubble wrap, peel back the yarns at the same time and straighten them out to extend away from the edge.
- Don't trim the fringe until the cushion cover is finished and dry and you've checked how it looks with a cushion pad inserted (I used feltable wool yarn so some of my fringes were shorter than others by the end as they had felted together during the process). Trim to a consistent length just above the bottom of the cushion (I trimmed to 12cm/5").

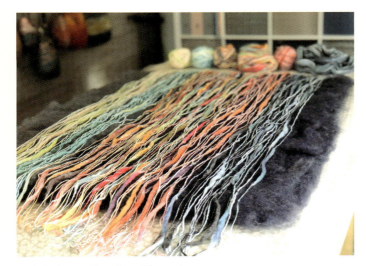
Final dry layout of wool batt fibre and yarns.

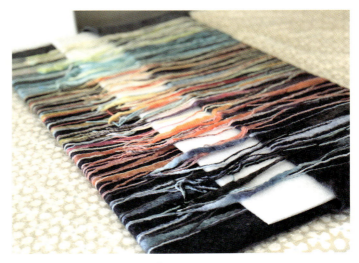
Fringed side after rubbing and rolling.

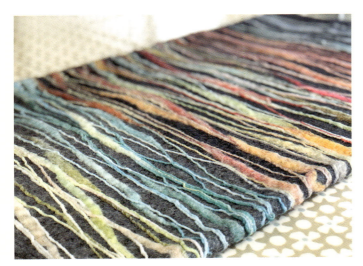
Yarns on the cushion back bonded in place.

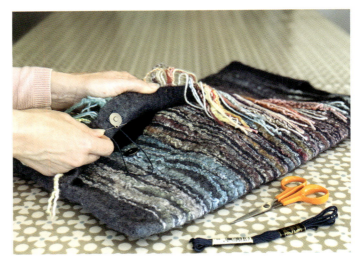
Sewing the magnetic clasps to the cushion cover.

Chapter 4 – 3D Wet Felting (with Flat Resists)

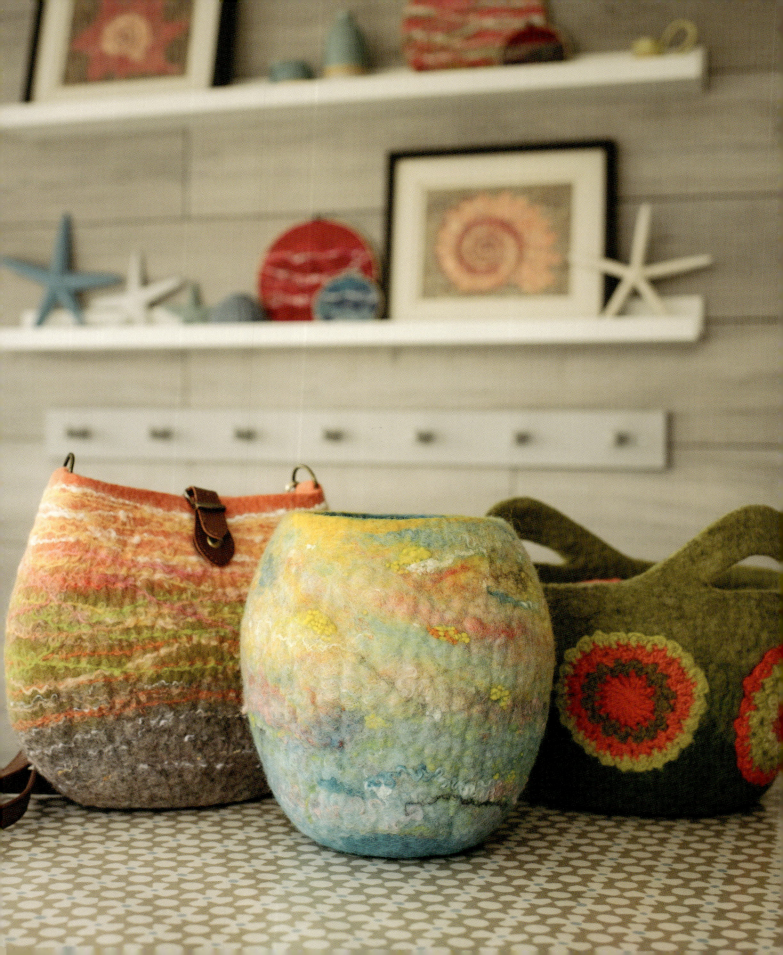

CHAPTER 5

3D WET FELTING (WITH 3D-SHAPED RESISTS)

We've learned that wet felting with flat resists is a brilliant way to create shaped, pocket-like felted forms. They can also be used to create hollow forms with more depth to them, like bags and bowls, just through shaping and stretching the felt once you've removed the resist. However, a really effective way of creating a felted form with greater depth to it, as well as an inherent structure and stability, is by moving from a flat resist to a three-dimensional one. So now we're going to look at wet felting with a three-dimensional resist.

WHAT IS A 3D RESIST?

A three-dimensional resist is essentially the same as a flat resist, with similar requirements of durability and being made of a non-feltable material. The main difference is that it's a three-dimensional, structured form to start with. Although we can change the final form of the felt through how we shape it once we've removed the resist, the resist starts us off and creates an initial three-dimensional shape. Importantly, this gives us the necessary depth to the felt (for example, the base of a basket) without us having to stretch the felt to create this.

An easy method of creating a square or rectangular three-dimensional resist is to use thicker packaging foam, or tape thinner pieces together, to build up the desired form, but a plastic box or even a cardboard box wrapped in clingfilm would work. For rounder shapes you can repurpose forms like a balloon or a plastic or rubber ball, which are particularly useful if you can inflate/deflate them. I've used children's footballs with great success, but there is actually a purpose-built option out there called a felting ball, which is specifically what we're going to use in this chapter.

WHAT IS A FELTING BALL?

A felting ball is a rubber ball that can inflate/deflate easily, is sturdy, durable and reusable and has a slightly tacky surface, which helps the fibres temporarily adhere to it. Really usefully, it is sturdy enough to use at a variety of circumference sizes, ranging from approximately 71.5cm–101.5cm (28"–40") or more – though the challenge at much larger sizes is finding large enough equipment to work with it. You can make a modest-sized vessel all the way up to a really large bag. The only current provider of felting balls I've found is Living Felt based in Texas, US, but of course, if you can find a similar-sized alternative to make the projects then that's fine (just try and find a ball with a similar circumference or you'll need to adapt the sizes and fibre weights accordingly).

So, what are the advantages of using a felting ball? As well as being able to create round shapes with depth to them, there are other advantages, such as:

- a completely seamless end result (unlike folding edges around a flat resist)
- an even thickness of felt all around, which also gives an even strength to the felt all around
- a continuous surface design.

And the disadvantages? If you want to create a very irregular form, then creating a flat resist and shaping it might be the simplest way to do this. Also, if you want a very square-edged end form, a box shape might be a better starting point.

WORKING WITH A 3D FELTING BALL RESIST

Wool Fibre: Type, Layout and Quantity

A really important aspect of felting on a ball is the fibre you use, not so much the breed but the form it comes in: we're exclusively using batt fibre rather than tops or roving. The main reason for this is that we're using the Papier Mâché Layout method of overlapping lots of small thin pieces of fibre, held in place after having been dunked in soapy water. Batt fibre works perfectly for this method because of its composition, being made up of fibres going in all directions. You can peel it apart in layers, and it has an inherent structure to it that holds together, even in small pieces. Batt fibre generally is made up of thicker fibres too, which again helps it keep a structure when wet and dry and is useful for making harder-wearing or more structural felted forms. Merino wool tops or roving, on the other hand, is made of finer fibres all combed in long neat lengths, which makes for a wispier and less structured form when both wet and dry, making it more difficult to add pieces to the ball to create the tight, even, overlapping layout structure that we ideally want.

The actual layout method is different to flat felting, but we're still going to create our layout in layers (usually three), as this helps us control the amount of fibre we're putting on the ball to ensure a more even thickness of the final felt. It's important to use the right amount of fibre too, because the finished hollow felted form needs to be strong and sturdy enough to keep its shape.

In terms of calculating sizes and shrinkage using the ball, I must confess that I don't tend to worry about this because the items I usually make with it don't have a critical end size (and trying to calculate shrinkage of a round/three-dimensional shape seems a bit of an unnecessary mathematical challenge!). But the usual rules of shrinkage still apply, so if you've made a sample piece with your fibre and you know that it has a shrinkage rate of 30 per cent, then this will also apply to the shrinkage of what you make on the ball. However, what's generally more important for the three-dimensional projects covered in this book is the thickness and stability of the finished felt, so I have developed a standard recipe for ensuring that there is a good amount of fibre, based on the circumference size of the ball (and always using three layers of fibre), as follows:

Ball Circumference	Fibre
76.5cm (30")	30g per layer
81.5cm (32")	35g per layer
86.5cm (34")	40g per layer
91.5cm (36")	45g per layer

It's also worth noting that using less fibre will make the felt shrink more and may create a less-structured result, but I've generally found that using more fibre doesn't make much difference to finished sizes, it just makes the piece thicker. So it is definitely better to err on the side of using more fibre rather than less to give a well-structured result.

The Wet Felting Process

In terms of surface design to decorate your three-dimensional felted piece, you can use exactly the same techniques as for other types of wet felting. However, there is one big layout difference to working on the ball, which is that we create our design inside out. You might wonder why we do that? Well, if we worked logically and put our fibre on the ball and then our surface design embellishments, there's a danger when we start felting that we'll disrupt or knock off those embellishments. So, by working inside out, and putting our embellishments on the ball first, followed by the wool fibre, we can both protect our design and hold it in place. So we're going to start our felting ball projects in this way and, later in the process once the surface design has had a chance to bond with the wool fibre, we'll be turning the prefelt the right way out to complete the felting. So you need to plan your projects slightly differently.

However, I do show you an alternative method to make the Art Batt Bowl, which creates the surface design in a more logical way to get you started.

You'll have seen from the tools (Chapter 1) that the equipment and felting techniques we use with felting on the ball are a bit different. The principles of agitation are the same, so we still rub the fibre all over as in flat felting, we just use a bowl and our hands as the means of rubbing it. We cannot use the rolling method, as the ball doesn't give the same flexibility as a flat resist surface, so instead we can bounce the ball to increase the agitation.

Once we have removed the ball resist, we can throw the felt to shrink it in the same way as we do for flat felting, although this is when deliberate shaping becomes more of an important element. We want to achieve some general shrinkage initially and then, once the felt has thickened and shrunk a little, this is when we can really control the shape that we want the felt to finally shrink into. If we focus on throwing the felt but keeping the same very round shape throughout, we can create a more rounded final shape. Whereas if we deliberately flatten the felt whilst throwing it, and roll it up on itself, we can create an end shape with more fixed sides and much less depth. So from the same round resist starting point, for example, we can shape the felt to become a very round, flat-bottomed basket with straight sides or a narrow cross body bag with a small oval base. So we have lots of control about the final form of the felt.

Marking Guidelines on the Felting Ball

To help with fibre and embellishment placement during the felting on a ball process, it's useful to mark some guidelines on the ball before we start.

WHAT YOU WILL NEED

Equipment
- Felting ball, inflated to 86.5cm (34") in circumference
- 28cm (11") diameter round bowl or similar (to prop up the ball)
- Permanent marker pen
- Tape measure

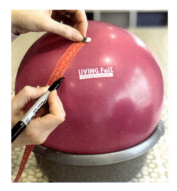

Step 1: Marking the top edge line

Inflate the ball to a circumference of 86.5cm (34"). To create the top edge opening line, measure 8cm (3.25") out from the centre of the plug. Measure and mark points all around the ball and then draw in the line to create a circle.

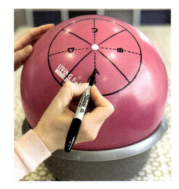

Step 2: Marking the bag placement lines

To mark the bag placement lines, measure and draw lines to divide the top circle into 4 equal quarter segments. Divide each quarter segment in half again with a dotted line. Assign and mark each segment a letter from A–D.

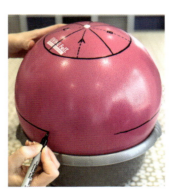

Step 3: Marking the middle design line

To mark the middle design line, which marks the centre of the main design area, measure 21.5cm (8.5") out from the centre of the plug. Measure and mark points all around the ball and then draw in the line.

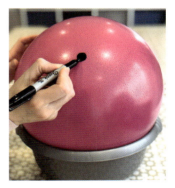

Step 4: Marking the bottom point

To mark the very bottom point of the ball, measure 44cm (17.25") out from the centre of the plug. Measure and mark points going right around the ball and draw a small circle to mark this point approximately.

Laying Embellishments on the Felting Ball

We've already looked at the Papier Mâché Layout technique for adding wool batt fibre to the ball (*see* Chapter 2), but here is some guidance on adding embellishment materials to the ball.

Every embellishment you place on the ball needs to be soaked through with soapy water, to wet it as part of the felting process and to temporarily fix it in place whilst you're working on the ball. You can either do this before putting it on the ball, by dunking it in soapy water as we do for the batt fibre pieces and then placing it on the ball, or by placing it on the ball and then spraying it with soapy water to soak and fix it in place. As a general rule, if you're laying an embellishment material

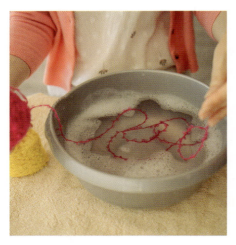

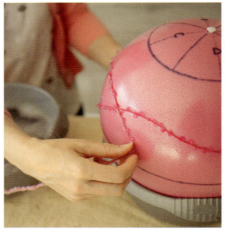

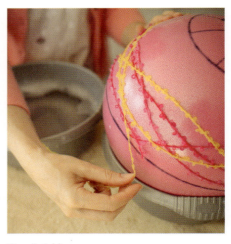

Step 1: Dunking the first yarn

Unroll at least 1m (40") of the first yarn from the yarn ball, without cutting it, and dunk it in soapy water to soak it. Keep the yarn loose and free in the water and keep an eye on the cut end, which you'll use first.

Step 2: Placing the yarn on the ball

Starting with the cut end, lay the wet yarn directly onto the ball and wrap it around the ball in a wavy organic line. Unroll and dunk more yarn as necessary. Wrap at least three times around the ball, varying the placement, before cutting the yarn.

Step 3: Adding more yarns

Repeat Steps 1 and 2 for any other yarns to build up the design, wrapping each around the ball at least three times. Vary their placement to avoid overlapping, and avoid more than two yarns crossing over each other in any one place.

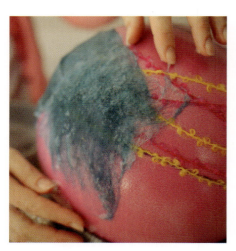

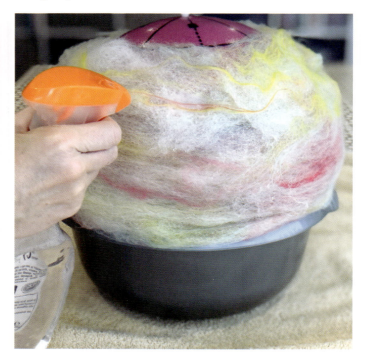

Step 4: Securing with fibre

Once you are happy with the design of your yarn or embellishments, secure them in place by dunking and adding batt fibre pieces on top using the Papier Mâché Layout method (*see* Chapter 2).

For delicate, wispy materials, such as wool tops fibre, or a large art batt design layer, which would become unmanageable if you tried to soak it first, add them to the ball dry and then spray to soak and fix in place before adding your batt fibre pieces.

that has a structure of its own and will hold together when wet, such as the batt fibre, prefelt, yarns, fabric, and knitted or crocheted pieces, then you can use the dunk and place method. However, if your embellishments are very wispy and fine and don't keep much structure when they're wet, so they become hard to work with, then a better method is to add them to the ball dry and then spray them to hold them in place (spraying the ball before you place them on it also helps to keep them in place initially). This especially applies to all tops fibres (protein, plant and synthetic) and curly wool locks.

Opposite is an example of laying out wool yarns on the ball using the dunk and place method in an organic wavy line design (though obviously you could use any pattern you like), plus an example using dry art batt fibres which are sprayed in place.

Further Tips for Using a Felting Ball

Here are some final tips for working with the felting ball and completing the projects in this chapter:

- When drawing the guidelines on the ball, you'll notice that there is a manufactured line going around the middle of the ball. You can use this to mark your middle design line, but be aware that this line isn't completely central around the ball (there is a variance of around 1–2cm/0.75") so it's more accurate to measure down from the top plug.
- For all the projects, use the middle design line on the ball as a guide to the middle of the main visible area of the finished bowl/bag/basket. So your main design area, where you should focus placement of your embellishments, is approximately 10cm (4") above and 10cm (4") below the middle design line.
- Avoid placing thick embellishment materials like yarn too close to the top edge opening line to ensure that they don't interfere with it (although wispy fibres are fine). Keep your main design elements 2–3cm (1") from the top edge.
- When using yarn, it's better to keep each piece in one continuous length to avoid lots of cut ends/short pieces, which need to felt in, unless short pieces is part of your design of course! Also, keep your yarn lines wavy (rather than tight rings) to leave some slack to account for the different felting rates of the yarns and fibre.
- Avoid layering up multiple embellishments over each other in exactly the same spot. Remember that the wool batt fibres need to make their way through all the embellishments to bond with whatever is at the front of the design, so if there is too much there then the fibres will have trouble locking everything in.
- Because the embellishments are laid on the ball first, you don't get any opportunity to really get 'hands-on' with them (for instance, to give them a good rub to help bond them to the fibre) until you remove the ball. It's also difficult to add those wisps of 'locking in' fibre on top of them if you're using synthetic yarns and fibres. As a result, to make the job of the embellishments bonding to the wool fibre more successful, it's a good idea to use your highest wool content yarns and other embellishments for felting on the ball. Or the alternative is to use a thin fibre layer all over the ball first to add as the 'locking in' element before you lay the more difficult to bond embellishment materials on the ball.
- Once your embellishments are in place on the ball, it's helpful initially to get a thin, even layer of fibre from your layer one allocation all over the ball as soon as possible, to help secure the embellishments, as well as to draft out where to put any fibre colour changes. Then go back and add the rest.
- It helps to use different colours for each fibre layer (or for the final layer at least), to enable you to see where you have/haven't already laid out fibre and therefore ensure a more consistent thickness to each layer. But bear in mind that the same colour mixing principles for flat or flat resist felting still apply, so the colours in layer one will affect the colours in layer three, and vice versa.
- I've used Finnwool for the majority of the projects in this chapter because it's what I regularly use, but you can use any batt fibre.

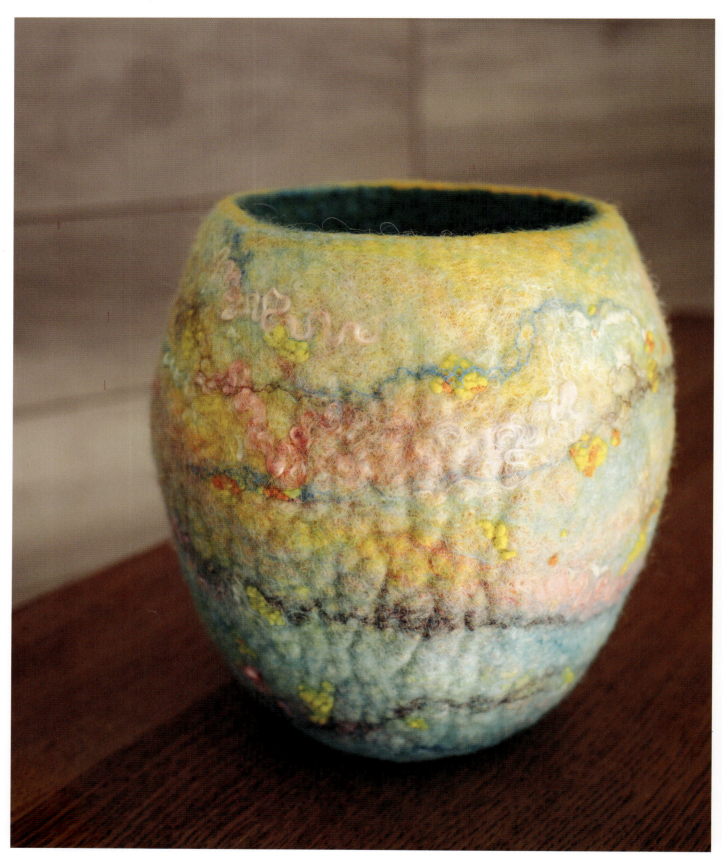

116　Chapter 5 – 3D Wet Felting (with 3D-Shaped Resists)

ART BATT BOWL PROJECT

For our first felting on a ball project, we're going to make a bowl, which is the most straightforward project because there are none of the extra parts to felt in (like tabs or handles) or extra resists (like pockets) that we'll be incorporating in the projects later in this chapter. We can just focus on practising the process and decorating our bowl. This project uses an art batt as decoration. If you've ever wondered what to do with those beautiful, hand-carded art batts that you can't bear to use (I know, we've all been there!), then this is the perfect project.

The finished bowl size is approximately 18cm wide/deep × 21cm high (7" × 8.25").

WHAT YOU WILL NEED

Materials
- Approximately 105g of wool batt fibre in your chosen colours, 35g per layer (I've used Finnwool fibre: 17–18g each of yellow and turquoise for layers one and two, and 35g of turquoise for layer three)
- Approximately 15g of hand-carded art batt fibre in complementary colours to the main batt fibre (I've used a Barn2Yarn art batt called *Japanese Sunset* in white, pink, yellow and turquoise Merino wool fibre with added silk fibres and wool nepps)
- Approximately 5g of hand-dyed long curly wool locks in pink and turquoise (I've used Barn 2 Yarn Teeswater locks in colourway *Hydrangeas*)
- Approximately 1g of yellow wool nepps

Equipment
- Felting ball, inflated to 81.5cm (32") circumference
- 28cm (11") diameter round bowl (to prop up the ball)
- A large bowl of any size to hold the washing-up liquid and warm water solution
- 32cm (12.5") diameter square bowl (to push/roll the ball within)
- Two pairs of Medium/Large (102–122cm/40–48" hips) tights/pantyhose, 20 denier (*see* Chapter 1 for preparation)
- Scales
- Tape measure
- Washing-up liquid and warm water solution
- Spray bottle or ball brause
- Olive oil soap
- Several large towels
- Several tea towels

Step 1: Assembling and preparing your materials

Collect your wool batt fibre, art batt and other embellishment fibres together, ensuring that you are happy with your colour palette. Weigh 35g of wool batt fibre in your chosen colours for each of the three layers and keep the amounts separate. Tear all fibres into small pieces. Inflate the felting ball to 81cm (32") in circumference.

Chapter 5 – 3D Wet Felting (with 3D-Shaped Resists) 117

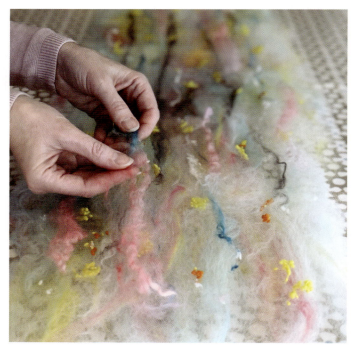

Step 2: Preparing the art batt

Unroll and spread out the art batt. Peel off a fine, even layer incorporating the most interesting colours and elements and tear it down to a rectangle shape approximately 90cm × 30cm (35.5" × 12"). It should weigh approximately 10–15g. Adjust it to thin out any thicker areas or add wisps to any thin areas.

Step 3: Adding embellishments

Spread out the existing art batt fibre embellishments (in this case, silk fibres and wool nepps) into a pleasing arrangement. Then add additional embellishments as you prefer. I added extra wool nepps to balance the design, plus curly Teeswater locks, which I teased out before laying down onto the fibre rectangle.

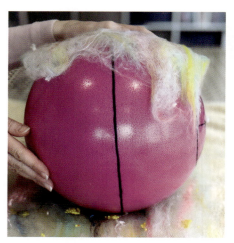

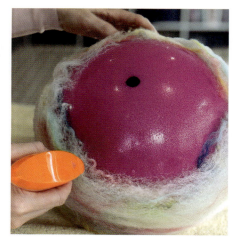

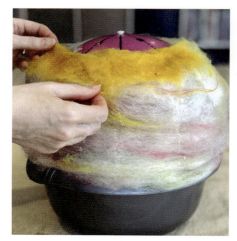

Step 4: Laying the art batt fibre on the ball

Place the ball onto one short end of the fibre rectangle, with the embellishments still facing upwards and the centre line of the ball running parallel with the long edges of the rectangle, and roll it up in the fibre. Where the fibre ends meet, fluff out the edges and add or remove wisps to even out the join.

Step 5: Wetting the art batt fibre

Adjust the fibre at the top so that it meets the top marked edge of the ball, as well as at the bottom so that the edge is even. Gently spray a small amount of warm soapy water solution all over the art batt fibre to temporarily secure it in place (it doesn't need to be soaked). Place the ball upright in a bowl for stability.

Step 6: Laying out layer one with colour one

Using the 35g wool batt fibre allocation for layer one (divided into 17–18g of each colour if using two colours), take a piece of the first colour, dunk it in soapy water, ensure it is spread out and completely soaked and place it directly along the top marked edge of the ball. Repeat to cover the top half of the ball with colour one.

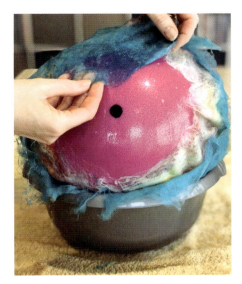

Step 7: Finishing the layer one layout

Repeat Step 6 with the second colour of fibre to cover the bottom half of the ball. NB It's helpful initially to get a thin, even layer of fibre all over the ball as soon as possible, to help keep the art batt fibre in place and work out where to put the colour changes, and then go back and add the rest.

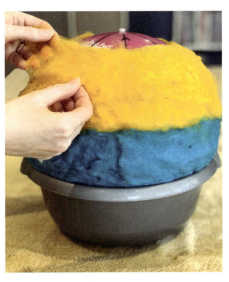

Step 8: Laying out layer two

Repeat Steps 6–7 with the layer two wool batt fibre allocation (again divided into 17–18g of each colour if using two colours), laying out the different colours in the same areas as layer one. Work down the ball until all the fibre has been used, patting regularly to check evenness and adding fibre where needed.

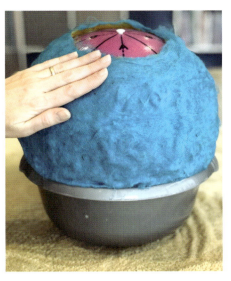

Step 9: Laying out layer three

Repeat Step 8 with the layer three wool batt fibre allocation (35g). NB It helps to use a different colour on this final layer to be able to see where you have/haven't already laid out fibre and therefore ensure a more consistent thickness to the layer. Give a final pat around the ball to check evenness and add extra fibre if necessary.

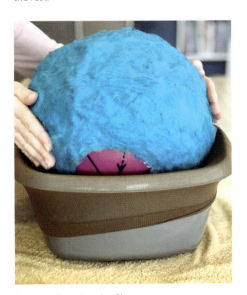

Step 10: Covering the fibre

Stretch one pair of tights over the 32cm (12.5") square bowl, place the ball inside with the plug facing downwards and gently pull up the edges of the tights as high as they will go, taking care not to disrupt the wool fibres. Repeat with the second pair of tights, this time placing the ball to cover the area not covered by the first pair.

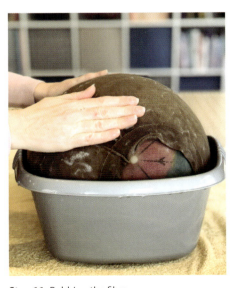

Step 11: Rubbing the fibre

Place the ball inside the bowl, pour on a little soapy water to ensure the whole ball is soaked, and gently push the ball around the bowl in all directions, ensuring that the ball makes contact with the sides of the bowl but not pushing so hard that the fibres are being moved out of place. Repeat the pushing/rubbing action for 300 pushes.

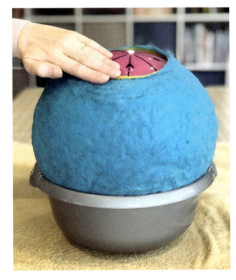

Step 12: Neatening the edges

Gently peel each pair of tights away from the ball and back over the edge of the plastic bowl, smoothing any fibres which have lifted. Remove the ball completely from the tights to ensure they do not felt together. Then neaten the top edge by fluffing it out, folding it back and securing it by rubbing firmly with a wet soapy hand.

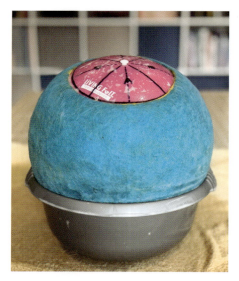

Step 13: Completing the rubbing

Repeats Steps 10 and 11 three more times, pushing more firmly each time. Remove the ball from the tights after each round of 300 pushes and check/rub the top edge to maintain the neat edge and shape. After the fourth round, the fibre will feel thicker, tighter and look more integrated. If not, complete an extra round.

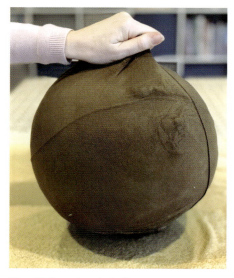

Step 14: Bouncing the ball

Place the ball in the tights and bounce it on your work surface 500 times. The easiest method is to keep a loose hold of the tights above the ball whilst bouncing. After 500 bounces, remove the tights to check/rub the top edge as before. Replace the tights and repeat this process two more times, making a total of 1,500 bounces.

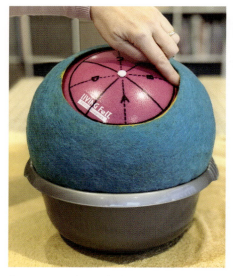

Step 15: Completing the bouncing

After the third round of 500 bounces, deflate the ball very slightly, enough to enable you to easily get a finger between the ball and the fibre. Then replace the tights and complete another round of 500 bounces. The fibre should again feel tight against the ball. If not, replace the tights and complete a further round of 500 bounces.

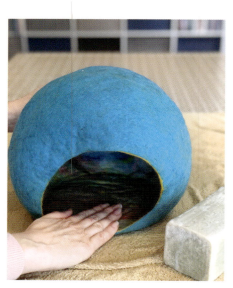

Step 16: Removing the ball

Deflate the ball and remove it from the felt bowl shape. Next check whether the art batt and embellishment fibres have felted to the inside by gently running your fingers across them. If they are still moving or not fully adhered, with a very wet and soapy hand rub around the inside of the felt bowl until they stay firmly in place.

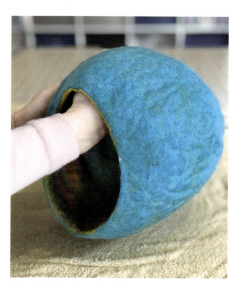

Step 17: Throwing the felt

Put your hand inside the bowl and spin it around on its sides so that it hits the worksurface 100 times. Maintain the round bowl shape throughout. After 100 throws, check and reshape the bowl, including flattening the base. Throw a further 200 times, reshaping after each 100, to make 300 throws in total.

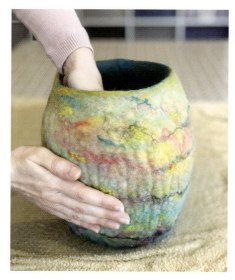

Step 18: Completing the throwing

The felt should be starting to shrink, feeling thicker and developing a crocodile skin texture. Turn the bowl the right side out, reshape the bowl shape and then repeat a further two rounds of 100 throws in the same way as Step 17, along with throwing the bowl with its base on the table to flatten and shape it.

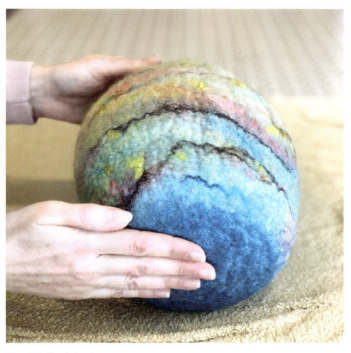

Step 19: Final shaping

Your felt bowl should now feel thick and sturdy and be keeping its shape and structure. If not, continue to alternate between throwing it on its side, throwing it on its base and shaping/stretching the inside with your hands to create the bowl shape until you are satisfied with the overall shape and structure.

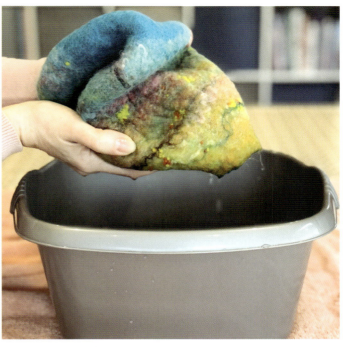

Step 20: Rinsing the felt

Rinse the felt under warm running water, or soak in a bowl of warm water, squeezing gently until the water runs clear. Remove excess water by rolling the felt up in a dry towel, then reshape it.

Step 21: Finishing the felt

To create a final smooth finish, wipe clean and then reinsert the felting ball and inflate it as much as possible. Rub your hand against the bowl to shape it, then deflate and remove the ball. Give the bowl any final shaping necessary and then leave to air dry on a towel.

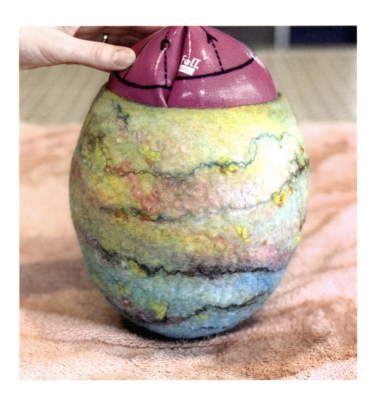

Chapter 5 – 3D Wet Felting (with 3D-Shaped Resists)

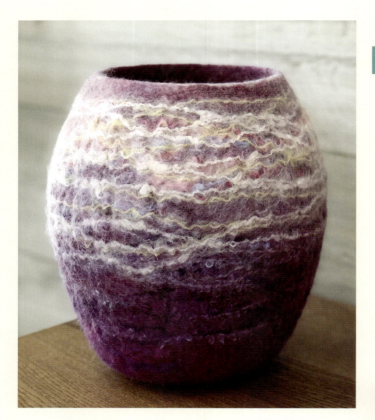

Project Variation

YARN WRAPPED BOWL

For the first bowl project variation I've created a version using the same yarn-wrapping technique we'll be using in the next main project to make a bag (*see* the Cross Body Bag Project for full details). The starting ball size (81.5cm/32" circumference) and amount of wool batt fibre (105g) are the same as for the main bowl, although I've used just two shades of purple fibre: light purple on the top half and darker purple on the bottom half for layers one and two, and the dark purple again on the inside (layer three). The colour interest therefore comes primarily from the six colours of mohair yarns, which include white, yellow, lilac and purple in a range of textures (thick mohair, thin mohair, mohair bouclé and slubby mohair). I've also included a few lengths of lilac/pink curly wool locks.

Start off by wetting and wrapping each yarn around the ball at least three times, then add your fibre on top and complete the rest of the wet felting process as for the main bowl.

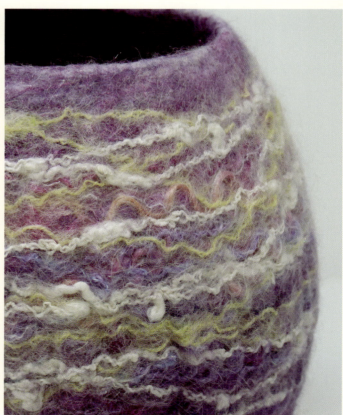

Felting ball during layout stage of mohair yarns and curly wool locks.

Detail of the finished felt bowl with embedded wool yarns and locks.

Project Variation

INLAID YARN BOWL

For the second bowl variation I've used a cutaway resist technique to create inlaid lines of mohair yarn which cross over. I again used the 81.5cm (32") circumference ball, but this time with an extra 10g of wool fibre (to make 115g in total). I still used 35g per layer as before, but in layers one and two I deliberately added an extra 5g per layer to strengthen the felt in the area of the resist. Here are some key steps I took to achieve this design:

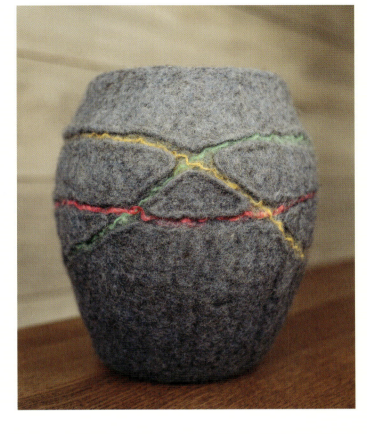

- Working inside out as usual, I first added a complete fibre layer one (the outer layer) to the ball with the 35g allocation. Then I added a further 5g of fibre just on the top half of the ball where the resists would go (to thicken the felt in the areas where the resist would be cut open). I deliberately used a plain darker grey-blue colourway to contrast with the bright colours of yarn inside.
- I then wetted and added three long, 1cm-wide (0.5") strips of thin foam resist around the ball, crossing over in three areas. I soaked and laid a different colour of yarn along each of the three resist lines, again crossing over at three points.
- Before adding the layer two fibre allocation, I added a second extra 5g of fibre directly over the yarns/resist to give those areas more stability (because once the top layer has been cut away, there would only be two layers of fibre in the finished felt in those areas).
- I then added the layer two and three fibre allocations as before and felted the bowl to prefelt stage before removing the ball.
- With the ball removed, I then turned the felt right side out and carefully cut channels in the outside of the ball and removed the resists. I trimmed and rubbed the flap edges and along the revealed lines of mohair to neaten them and ensure everything was secure before fulling, shrinking and shaping the bowl as before.

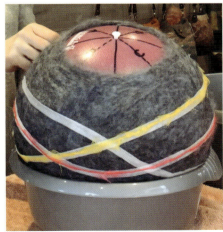

Cut-out resist bowl during layout of the foam resist strips and mohair yarns.

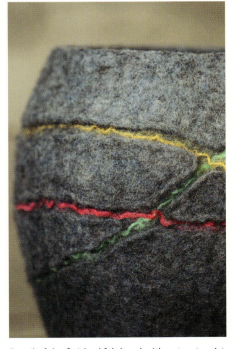

Detail of the finished felt bowl with cut-out resist technique revealing mohair yarns.

Chapter 5 – 3D Wet Felting (with 3D-Shaped Resists)

Project Variation

CROCHET CIRCLES BOWL

For the final bowl project variation, I've created a version using the crochet circles technique that we'll be using to make a basket at the end of this chapter (*see* the Yarn Basket Project for full details). The only difference to the main bowl is the starting ball size (86.5cm/34" circumference) and amount of wool batt fibre (120g, 40g per layer). I used a single grey-blue Finnwool for layers one and two, and chartreuse green for layer three, with six differently sized crochet circles in nine coordinating colours of alpaca yarn (three turquoises, three blue-greys and three lime greens). I also fulled the bowl slightly differently to create a shorter, wider shape overall.

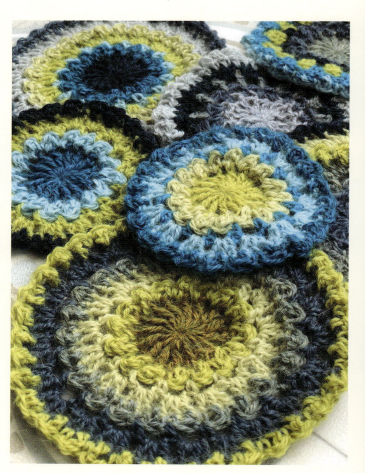

The bowl at prefelt stage after removal of the felting ball, prior to fulling.

Crochet circles prior to felting.

124 Chapter 5 – 3D Wet Felting (with 3D-Shaped Resists)

CROSS BODY BAG PROJECT

Now that you've had a chance to practise with a more straightforward project using the ball, creating a simple bowl shape using a more logical art batt layer method for adding the surface design, we're going to move on to a slightly more complicated make with a bag. The basic process is the same as for the bowl (it's the shaping once we remove the ball that creates the different, flatter bag shape), but we're going to be including felted-in D-ring tabs at the sides (to attach a bag strap) as well as an inside pocket using a separate thin rectangular resist. We're also going to be using the yarn-wrapping technique to create our surface design, working inside out and adding the yarns to the ball first.

This project is also slightly bigger (we're inflating the ball to 5cm (2") larger than the previous project) and we're using an extra 5g of fibre per layer accordingly. I've used three bands of colour (light to dark going down the ball) for the first two layers and a single colour for the final layer to unify everything, but you could use any colour combination you like.

There's an interesting colour mixing aspect to consider in this project (*see* Step 10), where you could add 5g of extra fibre (which must be the same colour as the layer three fibre) underneath the pocket resist. If the colours of your three fibre layers are the same/similar or blend closely with each other, then you won't need to do this. But imagine you used all white for layers one and two and then added your pocket allocation and layer three in bright pink. On the finished bag, your white outside would have a halo of pink coming through all over **except** in the area of the pocket resist, as this would block the pink fibre bonding with the white fibre. So to ensure your fibre colour mixing is even all over when using a pocket resist, it's a good idea to add some of the layer three colour underneath the resist so that the colour mixing from layer three right through to layer one is consistent all over the finished bag. It also helps to thicken that area of the pocket, which is no bad thing.

This is intended as a cross body bag, so I've deliberately used flattening techniques during shaping to create a narrower profile bag. However, if you want to create a more rounded bag shape, you would do fewer flattening throws/rolling on itself and try to maintain more depth in the bag by rubbing it with your hands instead.

The finished bag size is approximately 27cm wide × 23cm high × 10cm deep (10.5" × 9" × 4").

WHAT YOU WILL NEED

Materials

- Approximately 140g of wool batt fibre in your chosen colours: 40g per layer (I've used Finnwool fibre: 13–14g each of orange, chartreuse green and mid-grey for layers one and two, and 40g of orange for layer three); 4g for the side tabs (in orange); and up to 20g for the pocket (in orange, 5g beneath the pocket resist, 15g on top)
- Approximately 3–5m (10–16ft) each of at least three wool yarns (I've used eight yarns in total: four mohair bouclé yarns and four mohair/slubby mohair yarns in complementary colours to the wool fibre in shades of orange, green, pink, cream and grey)
- Two 25mm (1") metal D-rings
- 120cm (47") detachable cross body bag strap with metal lobster clasp (or similar) ends
- Leather magnetic sew-on buckle clasp (optional)
- Matching embroidery thread (optional)

Equipment

- Felting ball, inflated to 86.5cm (34") circumference
- 35.5cm × 12.5cm (14" × 5") rectangular 1mm (0.04") thick foam or plastic template
- 28cm (11") diameter round bowl (to prop up the ball)
- A large bowl of any size to hold the washing-up liquid and warm water solution
- 32cm (12.5") diameter square bowl (to push/roll the ball within)
- Two pairs of medium/large (102–122cm/40–48" hips) tights/pantyhose, 20 denier (*see* Chapter 1 for preparation)
- Scales
- Tape measure
- Washing-up liquid and warm water solution
- Spray bottle or ball brause
- Olive oil soap
- Several large towels
- Several tea towels

For sewing the optional clasp
- Tape measure or ruler
- Pins
- Needle
- Scissors

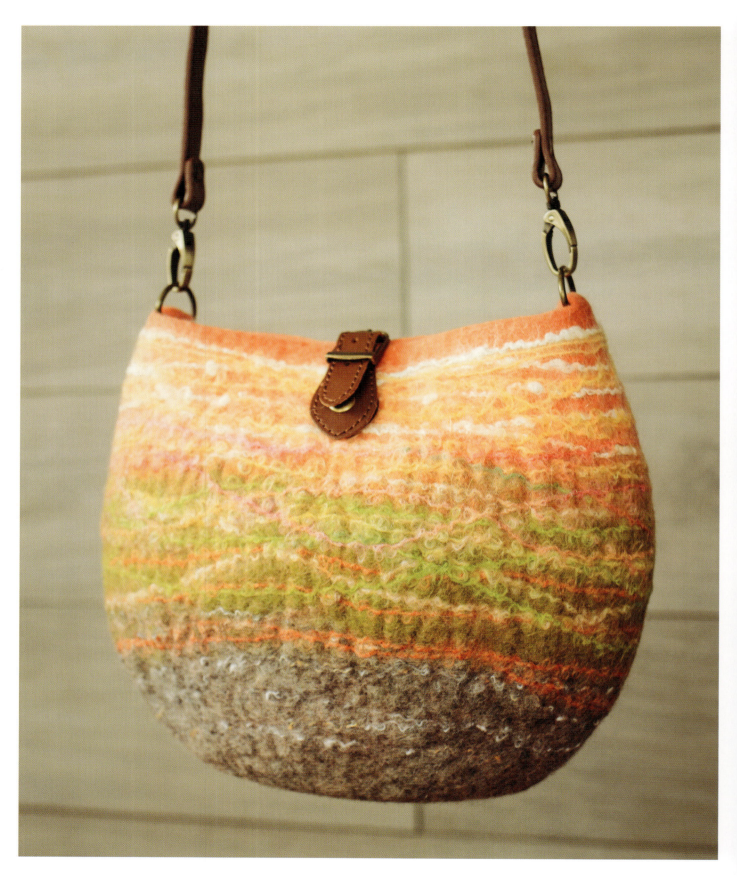

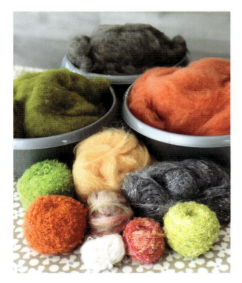

Step 1: Assembling and preparing your materials

Collect your wool batt fibre and yarns together. Weigh 40g of wool fibre in your chosen colours for each of the three layers (plus 4g for the tabs, 15g for the pocket and 5g for under the pocket resist if needed) and keep the amounts separate. Tear all fibre into small pieces. Inflate the felting ball to 86.5cm (34") in circumference.

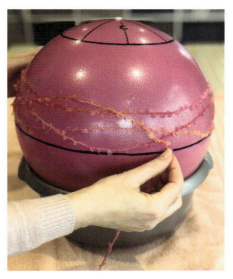

Step 2: Adding the first yarn

Unroll at least 1m (40") of the first yarn from the yarn ball and dunk it in soapy water to soak it. Starting with the cut end, lay the wet yarn directly onto the ball and wrap it around the ball in a wavy organic line. Unroll and dunk more yarn as necessary. Wrap at least three times around the ball, varying the placement, then cut the yarn.

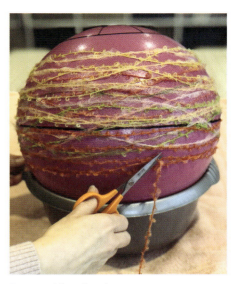

Step 3: Adding the other yarns

Repeat Step 2 for all the other yarns to build up the design, wrapping each around the ball at least three times. Vary the overall yarn placement to avoid overlapping and avoid more than two yarns crossing over each other in any one place. Once happy with the design, choose which area will be the front of the bag (I chose C).

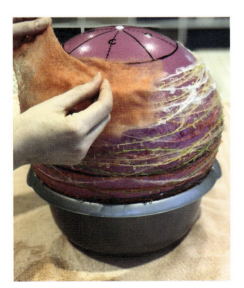

Step 4: Laying out layer one with colour one

Using the 40g wool batt fibre allocation for layer one (divided into 13–14g of each colour if using three colours), take a piece of the first colour, dunk it in soapy water, ensure it is spread out and completely soaked and place it directly along the top marked edge of the ball. Repeat to cover the top third of the ball with colour one.

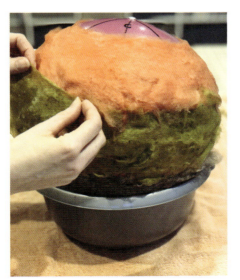

Step 5: Laying out layer one with colours two and three

Repeat Step 4 with the second and third colours of fibre to cover the middle and bottom thirds of the ball until the whole ball is covered. Work down the ball until all the fibre has been used, overlapping all the pieces slightly and patting regularly to check evenness, adding fibre where needed.

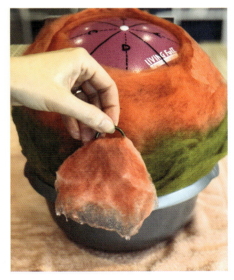

Step 6: Creating the side tabs

Divide the 4g tab allocation into two and create two even rectangles of fibre each measuring 12cm × 8cm (5" × 3"). Fold each rectangle in half lengthways and push through a D-ring. Match up each half of fibre, with the straight part of the D-ring at the fold and spread out the fibre edges. Ensure the edges are wispy; dunk to soak.

Chapter 5 – 3D Wet Felting (with 3D-Shaped Resists)

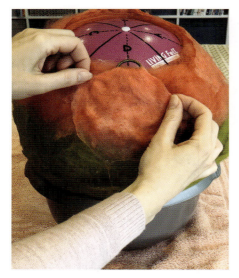

Step 7: Preparing the side areas

With the front of the bag facing you (for me, area C), the tabs need to be placed at the sides (in line with the dotted lines of areas B and D). First, add a couple of pieces from the layer two fibre allocation to each side area (areas B and D) to help thicken the fibre in those areas.

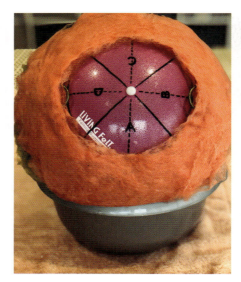

Step 8: Adding the side tabs

Dunk the first tab again to soak and place it in line with the appropriate dotted line and with the straight edge of the D-ring in line with the top edge line. Ensure the fibres are spread out and smooth. Then add another couple of pieces from the layer two fibre allocation on top to secure. Repeat for the second tab on the opposite side.

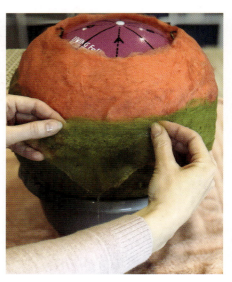

Step 9: Laying out layer two

Repeat Steps 4–5 with the layer two wool fibre allocation (again divided into 13–14g of each colour if using three colours), laying out the different colours in the same way as layer one. Work down the ball until all the fibre has been used, overlapping all the pieces slightly and patting regularly to check evenness, adding fibre where needed.

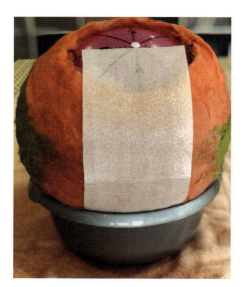

Step 10: Adding the pocket resist

With the back of the bag facing you (for me, area A), the pocket resist needs to be placed laying straight down from the plug and central within both the back area (A) and the side tabs. Before doing this, in the area beneath the pocket resist add the extra 5g allocation to match the layer three colour, if necessary.

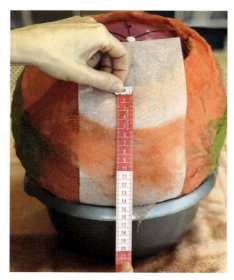

Step 11: Adding the pocket fibre

Add the 15g pocket allocation all over the template, starting 5cm (2") below the top edge line in a slight curve to match the curve of the top edge. Overlap the edges of the template by at least 3cm (1") all around (except the pocket's top edge). NB The template must stay in place throughout the rest of the process to create the pocket space.

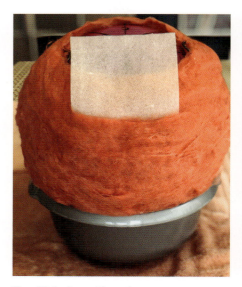

Step 12: Laying out layer three

Repeat Steps 4–5 with the layer three wool fibre allocation (40g if using one colour). Lay the fibre evenly all over the ball, including on top of the pocket area fibre and in the strip underneath the template between the top edge line and the top edge of the pocket fibre. Give a final pat all over to check evenness; add extra fibre if necessary.

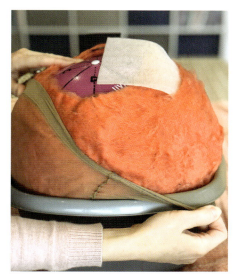

Step 13: Covering the fibre

Stretch one pair of tights over the 32cm (12.5") square bowl, place the ball inside and gently pull up the edges of the tights as high as they will go, taking care not to disrupt the wool fibres. Repeat with the second pair of tights, this time placing the ball so that the area not covered by the first pair is covered.

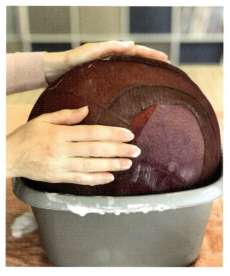

Step 14: Rubbing the fibre

Place the ball inside the bowl, pour on a little soapy water to ensure the whole ball is soaked, and gently push the ball around the bowl in all directions, ensuring that the ball makes contact with the sides of the bowl but not pushing so hard that the fibres are being moved out of place. Repeat the pushing/rubbing action for 300 pushes.

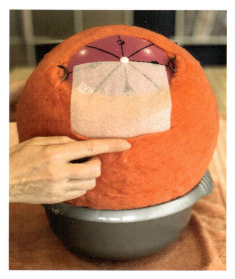

Step 15: Neatening the pocket edge

Gently peel each pair of tights away from the ball and back over the edge of the plastic bowl, smoothing any fibres which have lifted. Remove the ball completely from the tights to ensure they do not felt together. Then neaten the top edge of the pocket by gently folding it back and securing by rubbing it with a wet soapy hand.

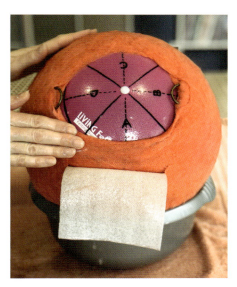

Step 16: Neatening the top edge and tabs

Neaten the top edge of the pocket by fluffing it out, folding it back and securing by rubbing it firmly with a wet soapy hand. Then spend a few minutes rubbing each side tab, to integrate all the fibre layers around each tab. NB Using extra soap (for example, olive oil soap) on your hands will help this process.

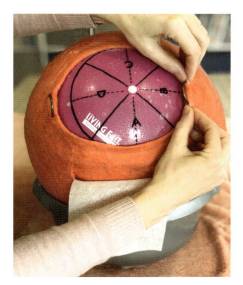

Step 17: Completing the rubbing

Repeats Steps 13–16 three more times, pushing more firmly each time. Remove the ball from the tights after each round of 300 pushes and check/rub the pocket edge, top edge and tabs to maintain their neatness and shape. After the fourth round, the fibre will feel thicker, tighter and more integrated. If not, complete an extra round.

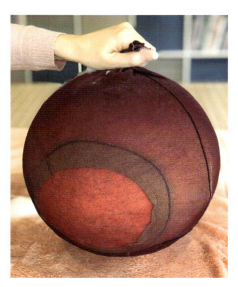

Step 18: Bouncing the ball

Place the ball in the tights and bounce it on your work surface 500 times. The easiest method is to keep a loose hold of the tights above the ball whilst bouncing. After 500 bounces, remove the tights to check/rub the top edges and tabs as before. Replace the tights and repeat this process twice more, making a total of 1,500 bounces.

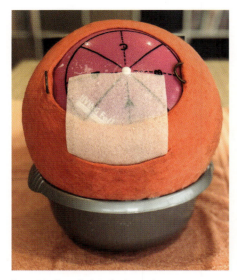

Step 19: Completing the bouncing

After the third round of 500 bounces, deflate the ball very slightly, enough to enable you to easily get a finger between the ball and the fibre. Then replace the tights and complete another round of 500 bounces. The fibre should again feel tight against the ball. If not, replace the tights and complete a further round of 500 bounces.

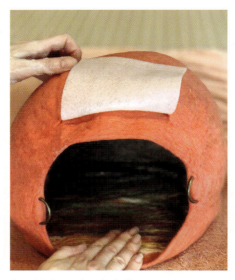

Step 20: Removing the ball

Deflate the ball and remove it from the felt bag shape. Next check whether the wool yarns have felted to the inside by gently running your fingers across them. If they are still moving or not fully adhered, with a very wet and soapy hand rub around the inside of the bag along the direction of the yarns until they are staying firmly in place.

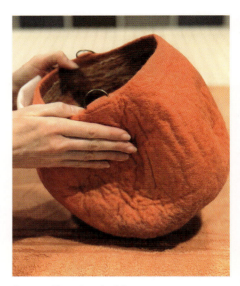

Step 21: Throwing the felt

Loosely pick up the felt and throw it on the worksurface 100 times, spinning the bag around as you throw and largely maintaining the round shape. After 100 throws, check and reshape the bag and check/rub the top edges and tabs. Throw a further 100 times and reshape. The felt should be starting to shrink and feel firmer.

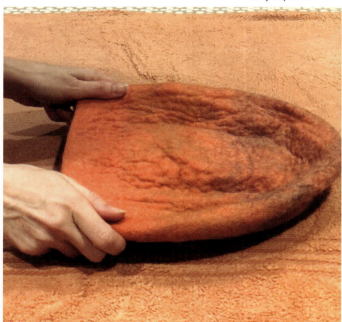

Step 22: Flattening the bag

To create a flatter-profiled bag, push the front and back sides together to match them, ensuring the tabs are equidistant each side, and flatten the bag down onto the work surface. Throw the bag down flat for 100 throws, flipping it over each time. Turn the bag the right side out, flatten and throw it down flat a further 100 times.

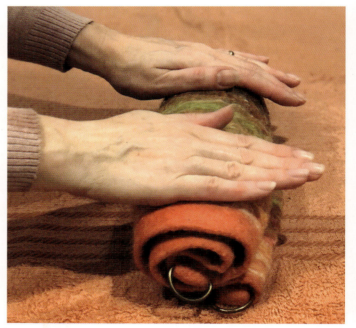

Step 23: Completing the shrinking

Encourage further shrinkage by rolling the bag up on itself on each of its four sides, for 20 rolls each time. Continue throwing flat and rolling until the felt feels noticeably thicker, with a crocodile skin texture. Then concentrate on stretching, shaping and rubbing it with your hands, inside and out, to create the final, gently-rounded bag shape.

Step 24: Final shaping

Once you are satisfied with the overall shape and structure, rinse the bag under warm running water, or soak in a bowl of warm water, squeezing gently until the water runs clear. Remove excess water by rolling the bag up in a dry towel, then reshape it and leave to air dry on a towel.

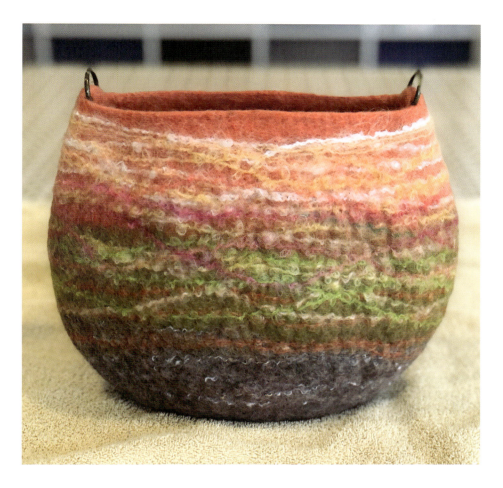

Step 25: Finishing the bag

Once dry, hand sew a clasp closure to the bag, if preferred. Measure the centre of the bag, both front and back, and mark with pins to show the desired placement. Use a 1m (40") length of three strands of embroidery thread, folded double and knotted, to sew each clasp part to the bag. Attach a strap to the side tabs to finish.

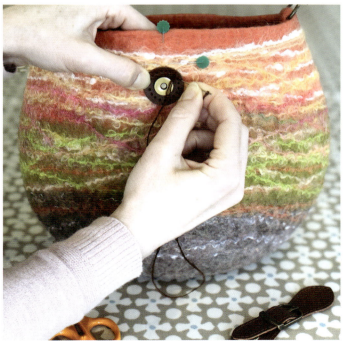

Chapter 5 – 3D Wet Felting (with 3D-Shaped Resists)

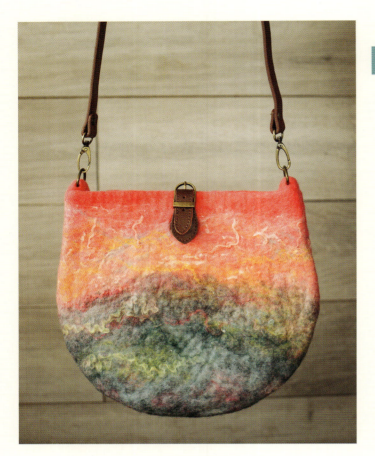

Project Variation

ALTERNATIVE DEPTH BAGS

The first bag variations illustrate some of the different bag depths you can achieve from exactly the same resist starting size (86.5cm/34" circumference) and fibre weights that we used for the main bag project.

- The pink bag uses the same art batt surface design technique as in the Art Batt Bowl Project, using the same art batt colours, but the overall effect is very different because of the fibre colours behind being completely different. It uses Maori wool batt fibre in two colours for layers one and two: 20g each of bright pink above the middle design line and a dark greeny teal below; and 40g of bright pink for layer three. During fulling, I focused on setting the side seams and flattening the bag completely and, by using some of the extra width of the bag at the top, was able to create a folded gusset at the top side edges (to give extra depth at the top when opening the bag). The finished bag size is approximately 28.5cm wide × 26.5cm high × 5.5cm deep (11.25" × 10.5" × 2.25").
- The blue bag uses the same yarn-wrapping techniques as the main bag, using ten different yarns in mainly yellows and blues, along with some sparkly Merino blend fibre. It uses Finnwool batt fibre in three shades of blue for layers one and two (approximately 13g of each colour), and 40g of the lightest blue for layer three. I deliberately made this bag more rounded during fulling by avoiding flattening throws or rolling and instead keeping its round shape by doing general loose throws and then rubbing it with my hands more to maintain the more rounded shape. The finished bag measures approximately 27cm wide × 22.5cm high × 12cm deep (10.5" × 8.75" × 4.75").

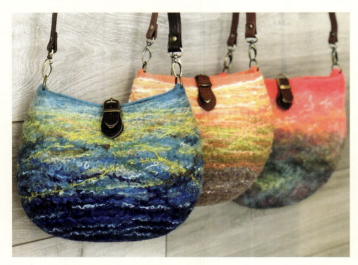

The blue, orange and pink bags showing their shapes and surface designs.

The pink, orange and blue bags showing their relative depths and heights. Depths are (from left to right): 5.5cm (2.25"), 10cm (4") and 12cm (4.75"). The deeper the bag, the shorter the height.

Project Variation

SILK CLOUDS BAG

For the final bag variation, I made a smaller bag using different surface design embellishments, as follows:

- I reduced the size of the felting ball to 76.5cm (30"), which is around the smallest size you can inflate the ball to be sturdy enough to use. The usual 28cm (11") 'propping up' bowl was too large, so I used a plastic kitchen bowl to prop it up instead.
- For the surface embellishments, I peeled apart some light green/orangey hand-dyed silk hankies and added a fine layer all over the ball (but thicker on the main middle design area). Then I added some green/orange wool locks (*Seaweed* Teeswater locks from Barn2Yarn) and orange bamboo tops.
- I used just over 100g in total of three colours of Finnwool fibre: royal blue, bright green and dark blue, in bands on layers one and two (11g per colour), and just the royal blue for layer three (33g). I felted in the D-ring side tabs as usual (2g per tab), but did not include a pocket.
- The felting process was the same as the main bag. The finished bag measures approximately 25.5cm wide × 20.5cm high × 11cm deep (10" × 8" × 4.25").

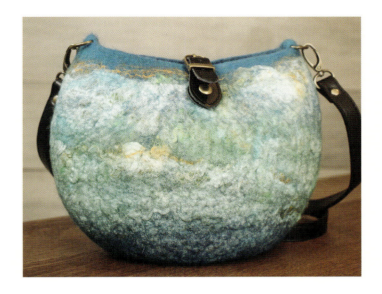

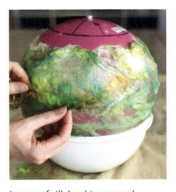

Layers of silk hankies spread across the felting ball and sprayed in place to hold them. A few lengths of Teeswater curly locks are added on top of the silk hankies.

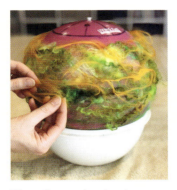

Wisps of orange bamboo tops are added as the final embellishment before the first layer of Finnwool batt fibre is put in place.

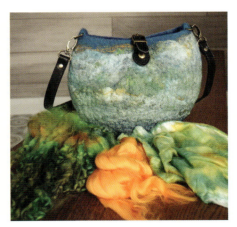

The finished bag alongside the embellishment materials.

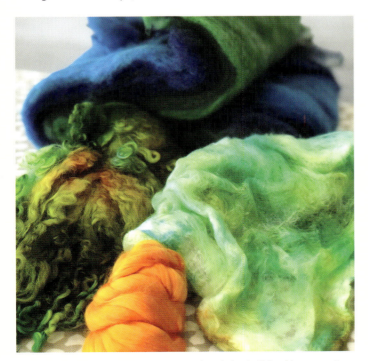

Finnwool fibre in blues and greens, green hand-dyed silk hankies, green/orange Teeswater curly locks and orange bamboo tops.

Chapter 5 – 3D Wet Felting (with 3D-Shaped Resists) 133

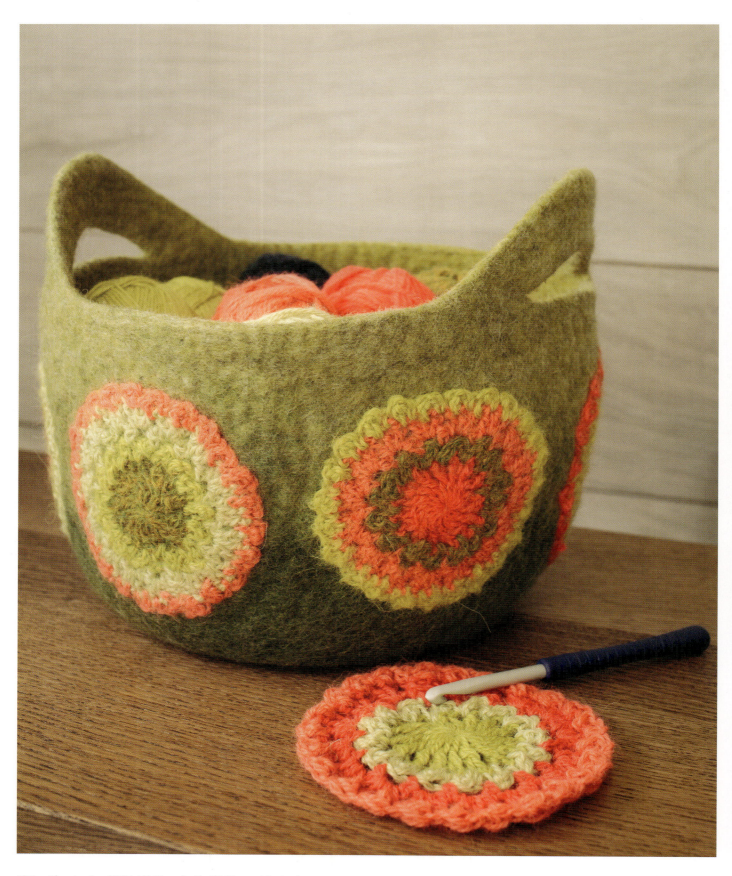

YARN BASKET PROJECT

I've called this final project a yarn basket because it's got a yarn design on it and it works well as a container for balls of yarn, but you could use it for any kind of storage. We're scaling up the felting ball size again for this project to 91.5cm (36") in circumference, and also marking and using additional guidelines on the ball. Aside from this, the overall felting process is the same as for the bowl and bag projects, but this time we're creating integral felt handles and our surface design uses crocheted 'granny' circles. This is a different way of incorporating yarn, using a more definite pattern.

You could create a circular design using yarns laid straight on the ball (which I've shown in the variation project), but the advantages to creating crocheted (or knitted or woven) pieces to use is that they have their own structure to start with, which helps keep the shape/design better. Although the circles still distort, you would struggle to wet felt such a definite symmetrical pattern like this with yarns laid out. Again, just make sure with this that you've got an easily feltable yarn. I've used 100 per cent alpaca and, to make the crochet pattern stand out, I've used five colours of yarn in different orders for the rounds and used a much larger hook to make a more lacy crochet. That way, once felted and shrunk, the circles design can be seen quite clearly.

I've used five graduated shades of green batt fibre for an ombre effect going light to dark down the basket: approximately 9g of each colour for layers one and two (45g per layer), plus 5g of the lightest colour for the handles. We're calculating fibre for the handles separately to deliberately ensure that they end up with enough fibre to give them good structure and strength. I've used Finnwool for the main project (and Maori for the variation), but you can use any batt fibre.

The finished basket size is approximately 24cm wide/deep × 16.5cm high (22cm to the top of the handles) (9.5" × 6.5", 8.75" to the top of the handles).

WHAT YOU WILL NEED

Materials
- Approximately 150g of wool batt fibre in your chosen colours, 50g per layer (I've used Finnwool fibre: 9g each (45g in total) of five shades of green for layers one and two, plus an extra 5g per layer of the lightest green for the handles; and one colour, chartreuse green, for layer three: 45g for the main layer and 5g for the handles)
- Six crochet 'granny' circles, each measuring approximately 11cm (4.25") in diameter when dry (I've used Drops Alpaca yarn in five colours: lime, dark lime, olive mix, coral and dark coral, made with a 6mm (J-10 in the US) crochet hook, using the free online *Circle of Friends Square* pattern by Priscilla Hewitt)

Equipment
- Felting ball, inflated to 91.5cm (36") circumference
- 28cm (11") diameter round bowl (to prop up the ball)
- A large bowl of any size to hold the washing-up liquid and warm water solution
- 36cm (14") diameter round bowl (to push/roll the ball within)
- Two pairs of XXL (up to 152cm/60" hips) tights/pantyhose, 20 denier (*see* Chapter 1 for preparation)
- Scales
- Tape measure
- Permanent marker pen
- Washing-up liquid and warm water solution
- Olive oil soap
- Several large towels
- Several tea towels

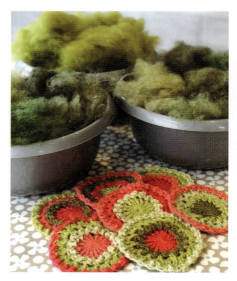

Step 1: Assembling and preparing your materials

Create your crochet circles and collect your batt fibre together, ensuring that you are happy with your colour palette. Weigh 50g of fibre for each of the three layers and keep the amounts separate. In addition, from each layer's 50g allocation, put aside 5g specifically for the handles for that layer. Tear all fibre into small pieces.

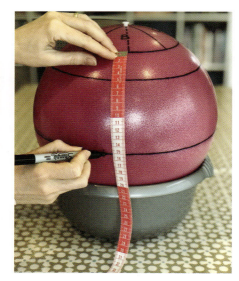

Step 2: Preparing the felting ball part 1

Inflate the ball to a circumference of 91.5cm (36"). Measure 5cm (2") below the original top edge line to create a new top edge for this project. Measure and mark points all around the ball and then draw in the line. Note that the original middle line should be 10cm (4") below this line (and 15cm (6") from the original top edge line).

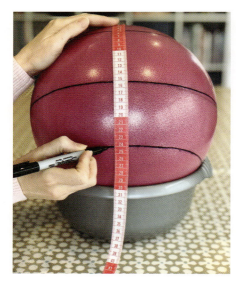

Step 3: Preparing the felting ball part 2

Measure 9cm (3.5") below the original middle line (24cm (9.5") from the original top edge line) to create a new bottom edge line for this project. Measure and mark points all around the ball and draw in the line. Note that the ball now has new top and bottom edge lines marking the main design area (with the middle line central).

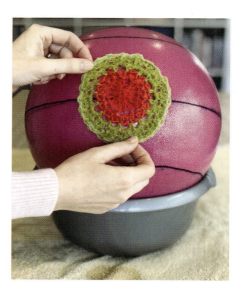

Step 4: Adding the first crochet circle

Decide on the order of the crochet circles. Dunk the first circle in the soapy water until it is completely soaked, then place it directly on the ball, using the original middle line to match up with the centre of the circle. If the crochet has a front side, ensure it is directly placed against the ball. Note that the circle will stretch when wet.

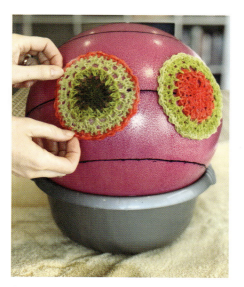

Step 5: Completing the crochet circles design

Add the remaining crochet circles to the ball, adjusting their placement as necessary to ensure an equal distance between each. Once happy with the overall placement, make any other necessary adjustments, such as stretching them out equally and ensuring they are completely flat.

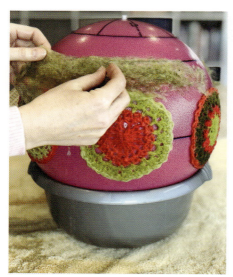

Step 6: Laying out layer one with colour one

Using the main 45g fibre allocation for layer one (divided into 9g of each colour if using five colours), take a piece of the lightest colour of fibre, dunk it in soapy water, ensure it is spread out and completely soaked and place it directly along the new top edge of the ball. Repeat to cover the top fifth of the ball with colour one.

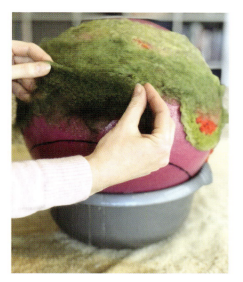

Step 7: Finishing the layer one layout

Repeat Step 6 with the next lightest colour of fibre to cover the next fifth of the ball. Repeat with the other colours until the whole ball is covered. NB It's helpful initially to get a thin, even layer of fibre all over the ball, to help keep the crochet in place and work out where to put the colour changes, and then go back and add the rest.

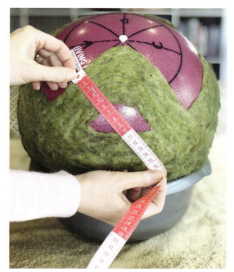

Step 8: Adding the first layer one handle

Take the 5g fibre allocation for the layer one handles and divide in two to give 2.5g per handle. For the first one, dunk and add each piece to build up a triangle shape which follows the edges of one of the top quadrants marked on the ball and extends down into the main layer. The handle should be around 6cm (2.5") wide.

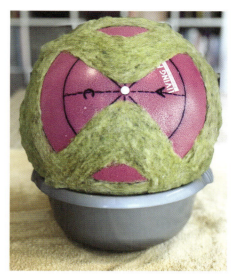

Step 9: Adding the second layer one handle

Repeat Step 8 for the second handle opposite the first with the remaining 2.5g of fibre. For each handle, adjust the shaped handle opening to measure approximately 8cm (3") wide and 4cm (1.5") high. Note that the top of each handle should be rounded rather than pointed.

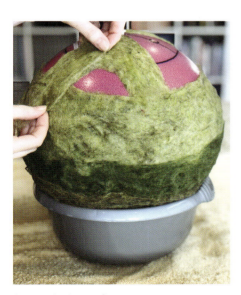

Step 10: Laying out layer two

Repeat Steps 6–9 with the layer two fibre allocation (45g for the main ball, 5g for the handles), laying out the different colours in the same areas as layer one (to help reinforce the ombre effect). Lay out the handle fibre allocation first and then work down the ball until all the fibre has been used, patting regularly to check evenness.

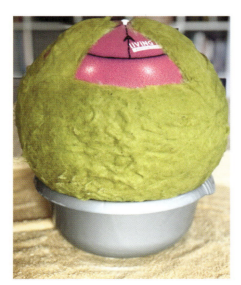

Step 11: Laying out layer three

Repeat Step 10 with the layer three fibre allocation (45g for the main ball, 5g for the handles). NB It helps to use a different colour on this final layer to be able to see where you have/haven't already laid out fibre and therefore ensure a more consistent thickness to the layer.

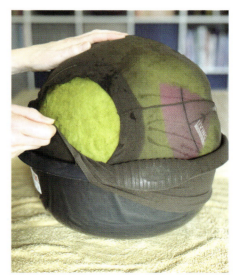

Step 12: Covering the fibre

Stretch one pair of tights over the 36cm (14") bowl, place the ball inside with the plug facing downwards and gently pull up the edges of the tights as high as they will go, taking care not to disrupt the wool fibres. Repeat with the second pair of tights, this time placing the ball inside so that the area not covered by the first pair is covered.

Chapter 5 – 3D Wet Felting (with 3D-Shaped Resists)

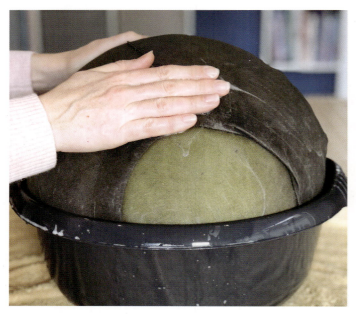

Step 13: Rubbing the fibre

Place the ball inside the bowl, pour on a little soapy water to ensure the whole ball is soaked, and gently push the ball around the bowl in all directions, ensuring that the ball makes contact with the sides of the bowl but not pushing so hard that the fibres are being moved out of place. Repeat the pushing/rubbing action for 300 pushes.

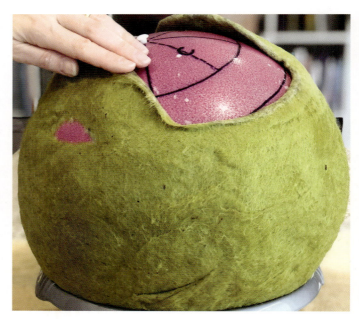

Step 14: Neatening the edges

Gently peel each pair of tights away from the ball, smoothing any fibres which have lifted. Remove the ball completely from the tights to ensure they do not felt together. Then take some time to neaten the top edge and all handle edges by fluffing out the edges, folding them back and securing them by rubbing them with a wet soapy hand.

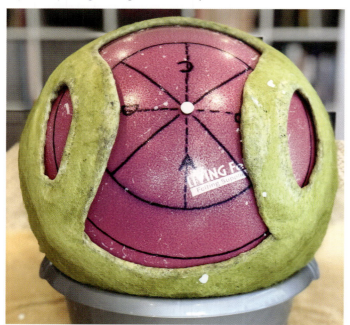

Step 15: Shaping the handles

The width of each handle should now be around 4cm (1.5"). The shaped handle openings should now measure around 10cm (4") wide and 5cm (2") high. Before moving on, check that the two handles look similar and are a pleasing shape; adjust as necessary. Then rub them all over with wet soapy hands to secure the shape.

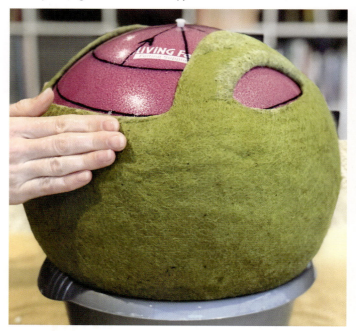

Step 16: Completing the rubbing

Repeat Steps 12 and 13 three more times, pushing more firmly each time. Remove the ball from the tights after each round of 300 pushes and check/rub the top edge and handles to maintain the neat edge and shape. After the fourth round, the fibre will feel thicker, tighter and look more integrated. If not, complete an extra round.

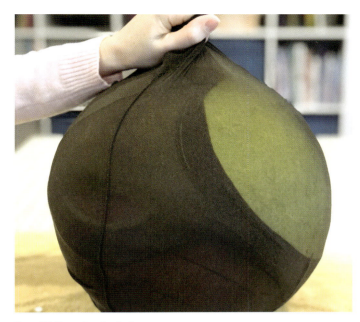

Step 17: Bouncing the ball

Place the ball in the tights and bounce it on your work surface 500 times. The easiest method is to keep a loose hold of the tights above the ball whilst bouncing. After 500 bounces, remove the tights to check/rub the edges and handles as before. Replace the tights and repeat this process three more times, making a total of 2,000 bounces.

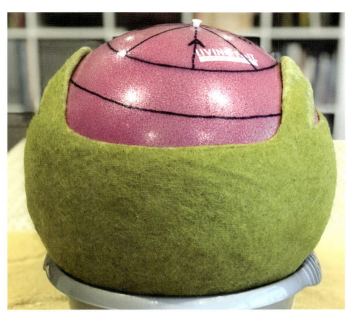

Step 18: Checking the ball

The fibre around the ball should now feel much firmer, tighter and thicker. It should also have noticeably shrunk away from the top edge. If not, replace the tights and complete a further round of 500 bounces or more until the fibre is feeling more solid and fully integrated with itself.

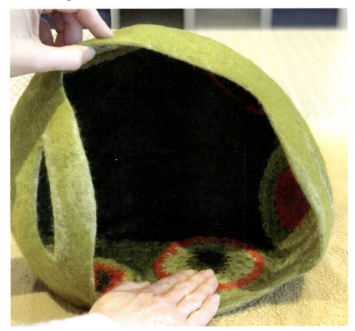

Step 19: Removing the ball

Deflate the ball and remove it from the felt basket shape. Next check whether the crochet circles have felted to the inside by gently running your fingers across them. If they are still moving or not fully adhered, with a very wet and soapy hand do some focused rubbing along the direction of the yarns until they stay firmly in place.

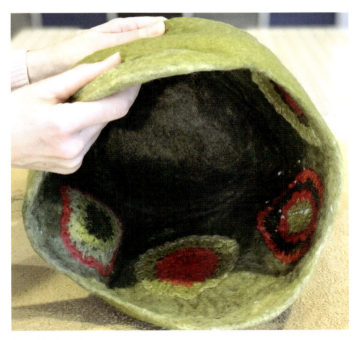

Step 20: Throwing the felt

Loosely pick up the felt and throw it on the worksurface 100 times, with the sides of the basket facing down. Spin the basket around as you throw and maintain the basket shape at all times. After 100 throws, check and reshape the basket and rub the top edge and handles. Throw a further 200 times, reshaping after each 100.

Chapter 5 – 3D Wet Felting (with 3D-Shaped Resists)

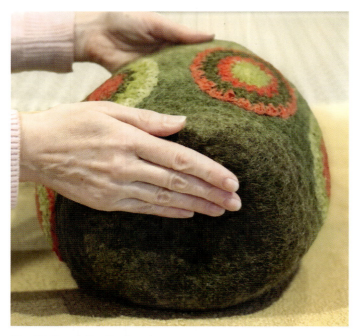

Step 21: Completing the throwing

The felt should be starting to shrink, feel thicker and be developing a crocodile skin texture. Turn the basket the right side out, reshape the basket shape and then repeat a further two rounds of 100 throws in the same way as Step 20, along with throwing the basket with its base on the table to flatten and shape it.

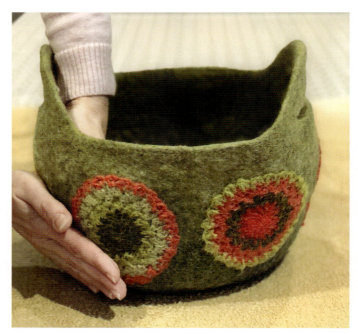

Step 22: Final shaping

Your felt basket should now feel thick and sturdy and be keeping its shape and structure. If not, continue to alternate between throwing it on its side, throwing it on its base, shaping/stretching the inside with your hands to create the basket shape and rubbing the handles until you are satisfied with the overall shape and structure.

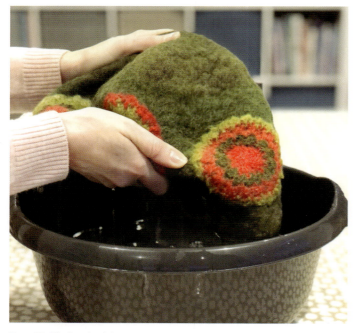

Step 23: Rinsing the felt

Rinse the felt under warm running water, or soak in a bowl of warm water, squeezing gently until the water runs clear.

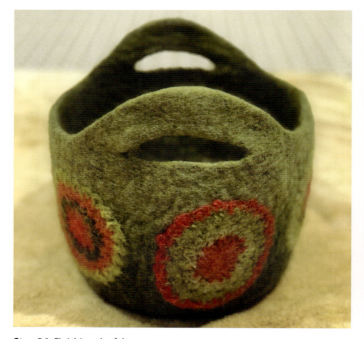

Step 24: Finishing the felt

Remove excess water by rolling the felt up in a dry towel, then reshape and leave to air dry on a towel.

Project Variation

YARN CIRCLES BASKET

For the Yarn Basket Project variation, I created another circles design with yarn, but this time using chunky wool art yarns laid in spirals. I also used a completely different wool fibre, Maori wool batt fibre from DHG, which is their own blend of New Zealand carded wools (but at 27mic the fibres are a very similar thickness to Finnwool). The felting ball size, amount of fibre and wet felting process are exactly the same as for the main basket. Here are some key steps to creating this version:

- Inflate the felting ball to 91.5cm (36") in circumference.
- Use 50g of wool batt fibre per layer, again reserving 5g of each layer's allocation specifically for the handles (I used two colours for layers one and two: 25g each of bright pink above the middle design line and a dark greeny teal below; and 50g of bright pink for layer three).
- For the circles design, create a close spiral, starting at the middle design line and finishing no more than 2.5cm (1') from the top and bottom edge design lines (I used two yarns per spiral, one starting from the centre outwards and the other one from the outside into the centre. I used four different chunky art yarns to make six circles, varying the yarn combination each time and without the yarns overlapping).

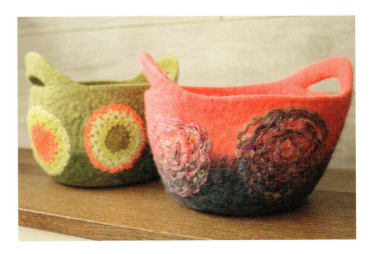

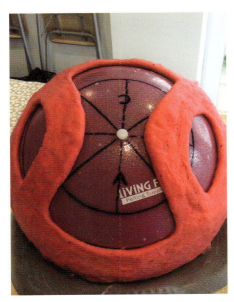

Layout of wool batt fibre towards the end of the rubbing stage.

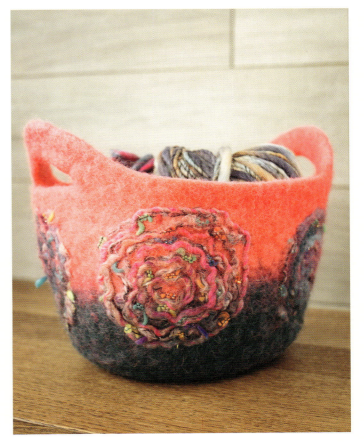

The finished basket.

Chapter 5 – 3D Wet Felting (with 3D-Shaped Resists) 141

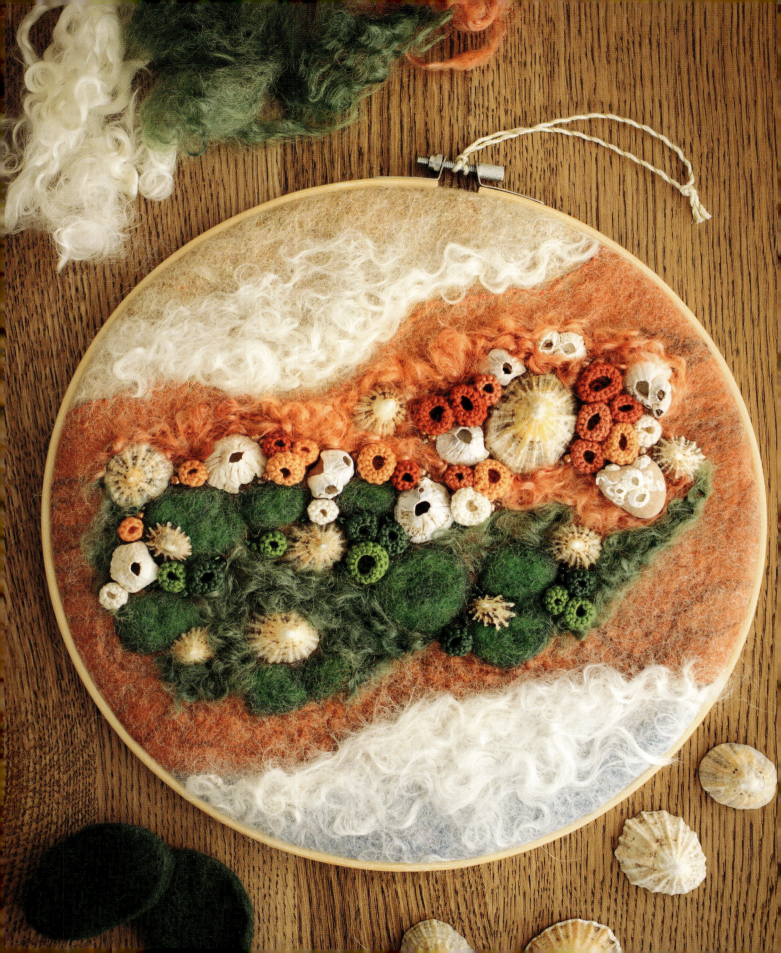

CHAPTER 6

DEVELOPING YOUR WORK

It has become really apparent to me, as this book has developed, that I've only touched the tip of the iceberg as far as wet felting techniques are concerned. The creative possibilities wet felting offers are truly endless, with such a variety of wool fibre breeds, embellishment materials and techniques to try (that's before we go exploring non-sheep wool fibre like alpaca or adding in wider feltmaking techniques like needle felting). I've aimed to show you a broad snapshot of what's possible, focused on core techniques with detailed explanation of to make a variety of felted items, which I hope will help excite your interest in this amazing art form. It will also give you a good grounding in the basics of creative wet felting. But this really is only a fraction of what else is out there to explore.

In developing your own work further, I'd really encourage you to experiment as much as you can, make samples and test things out. If you're wondering whether you can use a coarser fibre like Shetland (29–31mic) on a lampshade, or if you can create felt just by rubbing because you find rolling difficult, then just try it. As long as you stick to the core principles of water and agitation (along with soap and heat), it will work, so don't be put off by the 'can I?' question, because the answer will pretty much always be 'yes'. Of course, the end result might not be what you were aiming for, but it will help you move in the right direction.

Another important aspect is to keep learning from others. There are so many in-person workshops, online courses, free online videos, books and other resources out there about wet felting. Getting an insight into how different feltmakers create felt, using different techniques, tools and materials, will only enhance your own feltmaking, so it's worth investing your time and money in your own learning and development. Many wet felters spend their life just mastering one particular aspect of wet felting, so if you have an opportunity to learn how they do it, then I would encourage you to take it (although being careful not to copy what you learn but to be inspired by and move on from it to develop your own creative voice).

Once you've got some all-round experience, you might be wondering where to go with your feltmaking. Obviously, you'll have a different perspective if you're planning to make felt full-time as a business versus it being a hobby you enjoy in your spare time. I started out as the latter, but I think the creative lure of wet felting and its endless possibilities has been driving me ever since! For many years, I made a wide variety of wet felted items, which is great for developing your confidence with the technique and different materials. Then my wise husband suggested that if I wanted to take more of a business approach, I should find a niche and really focus on exploring one area of feltmaking. So, for me, this has led to creating felt bags and specializing in using the felting ball as a three-dimensional resist, though I still feel that there's so much more to explore on both fronts. But whether you're still exploring all aspects of feltmaking to increase your overall knowledge, or you just enjoy making a variety of things that interest you, or you've reached the point where you want to concentrate on just one aspect of the craft, I hope this book has contributed to your wet felting journey.

Here are a few more surface design techniques to leave you with, some of which I've tried and some of which are still on my own learning/testing wishlist. You'll notice that a lot of them involve creating your felt to prefelt stage, then stopping and applying different processes, before carrying on to the fulling stage and completing the felt. The advantage of this is to help integrate whatever process or addition you have made to the felt early on, so that by the end it looks as though that element was there all along.

Felted Knitting/Crochet/Weaving

Similar to the crochet circles in the Yarn Basket Project, try including pieces of knitting or weaving on top of the wool fibre. Very lacey, open designs will keep the definition of the pattern better, and you'll see the background fibre colours through it, whilst a tight pattern might shrink up completely to create an entire top layer. A very fine yarn will give a different result to a thick, chunky yarn. As always, a high wool content yarn will be the easiest to felt in, but you could still try a man-made yarn, just remember to lock it in with some wisps of fibre on top if in any doubt about its feltability.

Yarn-Only Felt

This is a way of creating a delicate piece of felted fabric, which will have lots of deliberate holes/spaces all over, made solely from wool yarn and no additional fibre. Lay out the yarn in lines or squiggles (or create a piece of knitting/crochet/weaving), ensuring that there are lots of yarn crossovers and intersections so that the yarns felt together where they meet to help create some structure to the finished piece. You will need a lot of yarn for this. Try this out with high wool content, feltable yarn only as there is no additional wool fibre to help the felting. NB You could also try a version of this with pencil roving (which is a continuous long strand of thin fibre) or with fine lengths of tops fibre to create lace-like structures.

Cobweb Felt

Cobweb felt is a general term for a very lightweight and fine felt with lots of drape to it, perfect for things like scarves and shawls. You can create it with just one or more fine layers, and you might deliberately include both thicker and thinner areas, the latter ranging from almost sheer to deliberate holes, to add lots of textural interest. You might also include any kind of embellishment fibres on top for further interest, as the sheerness of the wool can make your embellishment fibres even more visible (in a not dissimilar way to a lampshade). Similar techniques (using a very fine layer of fibre and leaving deliberate holes) also work well with nuno felting (with the layer of fabric giving extra stability to the finished felt).

Cutting Techniques

Cutting out holes or shapes in the felt is another useful design technique, or you might want to cut the edges of your felt to shape them in a particular way. You could also add a thin

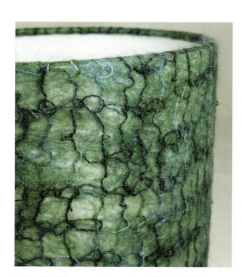

Felted knitting on a lampshade. The knitting was created on a knitting loom with a very loose structure in a fine mohair/silk yarn, then felted onto a fine layer of Merino.

Nuno felt using cotton cheesecloth with yarn stitching on top, along with deliberate holes in the Merino wool layout, allowing the fabric to ruche up into the space.

Felted bowl with cut-out resist technique to reveal embedded mohair yarns.

resist within the layers of your fibre and cut into the top layer to remove the resist and reveal the bottom layer underneath, leaving excess flaps or edges around the reveal. The general rule with any cutting technique is, the earlier in the process you make the cut, the less you'll notice it as anything other than an organic natural feature by the end. So ideally you would do any cutting at around prefelt stage, when the prefelt is firm enough to cut but the piece has not yet moved into the fulling stage. Give the cut edges a good rub to firm them a little, and shape them as necessary, and then continue on to complete the fulling process. Bear in mind that, once cut, any edges will be unconstrained by the main body of the felt piece so are likely to shrink more. So if you've cut open a flap, for instance, leave it a bit bigger than you want as the edges will recede during fulling. On the other hand, cut any holes smaller than you want them to be in the end as they will expand.

Felted Layers

You can also use resists to create multiple layers in your felt, for example to create petals within a flower. Use thin plastic or foam resists in between fibre layers, to keep them separate, next to an area where there are no resists so that the layers are anchored and will felt together at some point. Keep the resists in place until at least prefelt stage and check the felt layers regularly during fulling to ensure they don't felt together.

Raised Techniques

In contrast to cutting away parts of the felt, you could add additional pieces of felt or prefelt to create raised areas and patterns. You would add these on top of your initial fibre layout, then add additional fibre to cover them so that they completely felt in with the rest of the piece. You'll find that the pieces do sink down into the rest of the felt, so if you want them to appear very raised it's a good idea to test out thicknesses before you start on your final felted piece. To help accentuate their raised appearance, during fulling you might also want to focus on really flattening down the non-raised areas around them. You might also want to test out colours for the additional pieces you incorporate, depending on whether you want them to be textural only (in which case you'd use the same colours as for your main background) or you'd like a halo coming through from them of another colour to give a more visible pattern.

Inlaid Technique

Another way of creating a more definite pattern, which works particularly well for a series of pieces, is to use an inlaid technique. Create at least two pieces of felt the same size and thickness but in different colours, place one on top of the other and then cut out the same pattern from both together. Swap pieces and you have two differently coloured versions of the same design. You'll see this technique used in traditional felt rugmaking in Kyrgyzstan, where the felt pieces are fully felted and dried before the pattern is cut and pieces swapped. The

Nuno felted flower using circular resists to create separate petals.

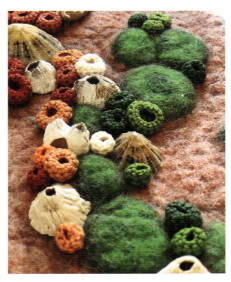

Raised felted 'stones' created from thick prefelt shapes under a layer of fibre.

Three coasters created using the inlaid technique at prefelt stage.

pieces are then sewn together, with braid added around the edges of the design to disguise the sewing/cuts and a backing layer added. You could also try a prefelted version of this if you don't want to add sewing or braid on top, by cutting out the pattern at prefelt stage, then swapping pieces, adding some fresh fibre to the reverse for stability and then felting the pieces to completion.

Yarn Stitching

To incorporate a stitched pattern in your felt (which is part of the finished felt rather than just lying on the surface), first create a piece of prefelt (either flat or, if using the felting ball, at prefelt stage once you have removed the ball). Once dry, stitch a pattern onto the prefelt using different wool yarns and any kind of stitches (though a simple running stitch is as effective as any). Then rewet the prefelt and finish the felting process as normal. You'll have an integral stitch design inlaid into the felt, which creates an interesting look and makes the stitching less delicate. As always, it's worth creating a sample to see how the different yarns and stitches felt in and shrink. You'll probably want to make the stitches larger and more exaggerated than you want the finished stitches to be in order to account for shrinkage. NB You could try this with standard sewing or embroidery thread, but the likelihood is that these are so fine that they will disappear within the felt during shrinkage, so thicker yarns are a better option.

Adding Non-Feltable Elements

We've already looked at integrating within your felt different textile elements that have feltable properties, but what if you want to add something that cannot felt? This might include anything hard or shiny, like glass beads, seashells, metal findings (like the metal D-ring tabs in the Bag Projects), plastic, recycled or foraged items. These won't felt on their own, and the usual trick of adding some wisps of fibre on top to lock them in won't be enough to hold them in place either. The trick is to attach them, again probably at prefelt stage when the felt has some stability to it, using wool fibre, yarn or sewing thread. But you will need some kind of hole in the item to be able to attach it. If the item already has holes (like beads) or has a continuous ring-like shape to it (like the D-rings), then you'll be able to attach those quite easily; for everything else you'll need to create or drill a tiny hole. Then you can sew the item into the prefelt (or wet felt or needle felt it in place if you're using wool fibre to attach it) and continue the usual felting process, albeit taking care with your fulling techniques if the addition is fragile. Due to the shrinkage of the felt, any stitching with sewing thread usually disappears by the end.

Of course, if you cannot create a hole in the item you want to attach to make it integral to the felt, then you can still add it as a surface design element by using glue. There are still ways you can make it appear more integrated afterwards, perhaps by needle felting more fibre around it.

Shibori Felting

Shibori is a traditional Japanese tie-dyeing technique used to create incredible patterns in cloth. Fabric is manipulated in various ways (for example, folded, pleated, gathered, wrapped around buttons or stones), and held in place by stitches, knots and other bindings, before dyeing. The bindings act as resists to the dye, so when they are removed, they reveal patterns where the dye has not been able to penetrate the fabric. Shibori felting is a version of this using prefelt as the fabric. Once you have created your bindings, complete the felting process as usual (you could even dye the felt too). Once the bindings are removed, the felt will have shrunk and set permanently

Blue felted bowl with chartreuse green mohair bouclé yarn stitch detail.

Close-up of a metal D-ring felted into the side of a bag.

146 Chapter 6 – Developing Your Work

to create interesting textures, patterns and three-dimensional shapes. If you have created round three-dimensional shapes around buttons or stones, you can then always cut these open to reveal cup-like shapes.

Sewing Techniques

Finished felt is a lovely base fabric for sewing, so you can add any kind of sewing techniques on top to create or add to your design: hand stitching and embroidery, machine embroidery, couching, beading, and so on. The most interesting designs are often a combination of many techniques.

Needle Felting

Another way of adding a design to your finished felt is to needle felt wool or embellishment fibres on top. Needle felting involves stabbing into dry fibres with a barbed needle to force the scales to lock together. This is a way of creating a more defined design than the smudgier effect you get with wet felting alone, although it has the disadvantage of sitting on the surface more and often you can see the stab hole marks. A good way to make the piece more integrated is to give it a gentle wet felt after needle felting.

Needle felting is also a good way of joining felt pieces or fabrics without sewing. Add a little wool fibre in between two pieces to help the intermingling of the fibres before needle felting them together. You could also try this to mend holes, again combined with a gentle wet felt to integrate and smooth all the fibres together.

Needle felting can be done by hand with a single needle, or multiple needles in a holder, and a foam block underneath. Commercial felt is created using industrial needle punch machines. There is also a home version called an embellisher machine, which may have up to twelve needles and it enables you to very quickly create designs using multiple embellishment materials, all without the need for any sewing.

Finally, if you are looking to create a solid, three-dimensional shape, then needle felting would probably be your preferred technique for greater accuracy when building up a solid form like a small sculpture.

Printing Techniques

You can print on top of felt as you would any fabric or print your own fabric for use in nuno felting, which adds an interesting dimension to your prints as they will crinkle and ruche to different effect. Eco printing/dyeing is a popular technique for transferring prints of plants, flowers and leaves onto fabric, which again would create interesting patterns when used in nuno felting.

Felting into Paper

This is similar to nuno felting, but instead of felting into fabric you felt into paper, which enables you to create different textures and felt with more inherent structure due to the incorporation of the stiffer paper. You can also write, draw and paint onto the paper prior to felting to create further interesting patterns within the felt.

Felted quilt wallhanging with yarn and nuno felt strips outlined with hand stitching.

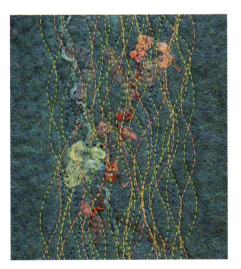
Machine embroidery in a wave pattern on top of finished felt with embedded yarns.

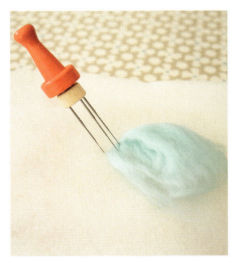
Multiple felting needles in a holder with a foam block underneath.

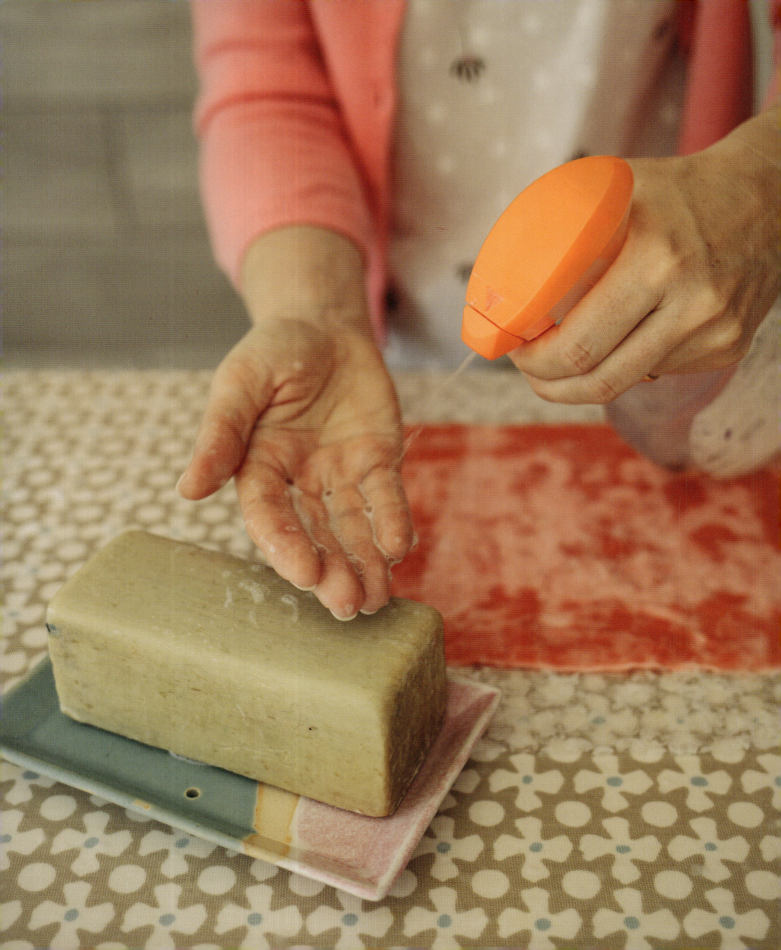

CHAPTER 7

FAQS/TROUBLESHOOTING

I've been teaching wet felting for several years and issues can often crop up for students during the process, particularly for a brand new feltmaker or if you're learning techniques or using materials with which you're not familiar. This is perfectly natural when you're learning something new, and is a good reason to attend in-person workshops so that you can ask questions and, importantly, get immediate answers and see how your tutor tackles potential problems.

The important thing is not to panic! In my experience, everything is recoverable in some way (you might just need to be flexible in your response), and things not going to plan is a useful learning point in developing your expertise. I'm regularly frustrated by felting projects not quite turning out as I'd hoped, but I find that the problem-solving aspect of feltmaking drives me forward (Why have I not had the shrinkage I was expecting, was it the fibre? Why is the fabric taking so long to bond with the fibre, what should I do differently or did I use a difficult fabric? Why are the embellishment fibres not standing out, should I have used more?), until I get a result I'm happy with.

So, I've set out below some common questions that you might be pondering, as well as some specific problems that could arise. And remember that, above all, the more experience you have of wet felting, the easier it will be for you to confidently work out the solutions to the problems yourself.

Can I mix fibres, for example, add Merino tops to a Finnwool batt layout?

Yes. Different wool fibres will mix together quite happily. As with anything, do a test to check that the end result is what you want and doesn't radically affect the shrinkage and final size, especially if size is important (for instance for a garment). If it's for purely decorative purposes, or the exact finished size isn't important, go ahead!

I've got lots of yarns in my stash and I don't know whether they're wool or man-made, can I still use them for felting?

Yes. Ideally you would make a small sample with them first, to see whether they will felt. If not, err on the side of caution and, when you're laying out your yarns and fibres, treat them as though they are man-made and sandwich them within your felt by adding extra wisps of wool fibre on top to keep them in place.

How do I ensure I lay out my fibre on the ball evenly?
It takes a bit of practice to ensure you've laid out the fibre evenly on the ball (and it's especially tricky when you're laying fibre in layers two and three, particularly if the colours you're using are the same), but here are a couple of tips which might help:

- Keep patting the ball during layout to help you feel for thinner areas.
- To be really methodical and even with your layout, try dividing up the dry fibre in each layer into four equal amounts. Take four long pieces of spare yarn and lay each one from the centre plug along each quadrant line on the felting ball right round to the bottom point (as if you're extending the quadrant lines). The yarns should all meet at the centre plug and again at the bottom point. That divides up your surface into four equal areas. Then lay each quarter allocation of fibre within each quadrant/segment, to give you a greater chance of laying it out evenly (just remove each bit of yarn once you're done).
- If you really want to be belt and braces about it, just add another few pieces of fibre in any areas you're worried about before you finish the layout – it's definitely better to have too much than too little, and you'll never notice if there's a bit extra there.

I've deflated the felting ball and none of my yarns seem to have felted to the inside of my bowl/bag/basket and they're all moving around and loose, what do I do?
Definitely don't panic, everything is recoverable! There are two main things you can do. Firstly, with a VERY wet and VERY soapy hand, rub directly on the yarns, in the direction they are laying in order not to disrupt them. Focused rubbing for 30 seconds or more along each yarn should help secure them. If this still doesn't work, or you realize that perhaps your yarns are man-made and just aren't going to felt, then use a felting needle (with foam mat underneath) to needle felt the yarns to the felt. You can do this when everything is wet, but it's easier to give your work a squeeze in the sink to get rid of most of the water (don't bother rinsing out the soap), leave it to dry and then needle felt the yarns in place.

Failing this, use sewing thread to sew or couch the yarns in place. Once secure, re-wet the whole piece, ensure the yarns are covered in a good layer of soapiness to keep them in place, and then carry on the process to the next stage. Because the piece is still at prefelt stage, when you move to the fulling stage when the felt shrinks and the wool fibres and embellishments unify more, you probably won't notice what happened (even small stitches in a fine thread will probably sink into the felt completely and disappear).

I've removed the resist from my 2D or 3D felting project and there's a hole in my project, what do I do?
Again, don't panic! And again, there are two main things you can do. Firstly, as you are just at the end of the felting stage, it might still be possible to felt some fresh fibres over the hole. Add fibres over the hole (on the wrong side) so that they extend quite far around it, add soapy water and give the whole area a very focused rub for at least five minutes. If the fibres seem to have integrated, you can then move on to the next stage. If not, or they have only partially integrated, then use a felting needle to completely secure the new fibres over the hole (either do this wet or leave to dry and then needle felt). Again, once the fibres are secure, carry on to the fulling stage and after shrinkage you probably won't notice that there was ever a hole. If you only notice a hole at the very end of the whole process, your only options are to needle felt extra fibres over the hole or sew the hole shut.

I've removed the ball from my bowl/bag/basket project and I can see/feel a noticeable thin area where I didn't lay enough fibre, what do I do?
If the area is thin (for example, you hold it up to the light and you can see the light coming through) but still covered, and just a small area, then your best bet is to leave it. It's likely that the thin spot will disappear during the fulling process as the felt shrinks and thickens. Start off the fulling process by gently scrunching that area (rather than going straight to throwing) to encourage shrinkage there first and keep an eye on it. If at any point it seems to be becoming a hole, then treat as for a hole above.

Do I have to complete the whole project in the same session?

No. Some projects can be quite time-consuming and also physically tiring, so stopping and coming back later or the next day is absolutely fine and shouldn't make any difference to the end result. Just a few things to bear in mind: try to stop at the end of a process, for example, when you've completed all the rolling stage rather than halfway through, so the fibres aren't interrupted from the momentum of what they are doing in that stage. Or once you have completed the felting/prefelt stage, before moving on to fulling. Another good option is to stop when you have finished all the dry layout for a project and before you add any water (just ensure your work is left somewhere that others can't access and is not located near an open window or door!).

With felting on the ball, I like to complete all the initial decorative layout and then add all the fibre layers to the ball and the tights before stopping, in order to protect the decorative layout and keep the fibre in place (which is liable to peel off the ball if it dries out). Remember, when you come back to any project, to refill your bowl or spray bottle with fresh warm soapy water and soak your project again before continuing, to 'reactivate' it. If you're planning to leave your project for much longer than a day or two, uncover it and allow it to air dry before putting aside so that it doesn't start to rot or smell. There's no need to wash out the soap first before stopping unless you're planning to leave it for weeks or months.

I don't have the correct size of fabric to make the nuno silk scarf or for the strips in the nuno cushion, is there anything I can do?

This isn't a problem at all and you have a few options. You can patch it together, by laying the fabric out as normal, with a slight overlap (for example, 1cm/0.5"), and adding a few fine wisps of fibre in between the join to help the two pieces felt together. Or hand or machine sew your fabric pieces together in advance with a fine thread. The ruching of the fabric during shrinkage should mean that the stitches aren't visible by the end (or you could remove them). Alternatively, create a whole patchwork (with slight gaps in between pieces) and make a feature of it!

I don't have a spray bottle to wet the fibre, can I just pour water on from a jug?

You can, but I would generally recommend some kind of spray, especially when dealing with dry fibre. Pouring water directly onto a thick pile of dry fibre has the effect of instantly flattening and sinking that area, creating a lot of uneven disruption, which isn't helpful if you're trying to preserve a carefully laid-out design. A spray is much gentler and gives a finer amount of water over a larger area, so is less disruptive. You'll see in a couple of the larger projects where I've poured water directly onto the fibre, but this was when the fibre was already wet and either a very thin layer or it was on the reverse where there were no embellishments.

How do I know if I've used enough wool fibre or used too much?

The amounts shown in the projects are minimum amounts, which I think will give you a good result for those projects (for example, enough fibre in a bowl to give it enough structure to hold itself up, and so on). But if you don't quite use enough fibre and it seems to still be a bit floppy, just keep fulling (for example, throwing) the piece and eventually it should thicken up enough to hold its shape. The downside is that your piece will probably end up smaller than planned, and your decoration might start to get lost and disappear into the wool fibre. So, if in any doubt, it's actually better to use more fibre than less (unless deliberately making a thin felt). I find that adding 10 or 20g of extra fibre to a bag, for instance, makes very little difference to the end result, and has the advantage of ensuring that any thin spots are evened out. The best advice is to continually be patting your felt in the early layout stages to check for thinner areas, and if in any doubt, add more.

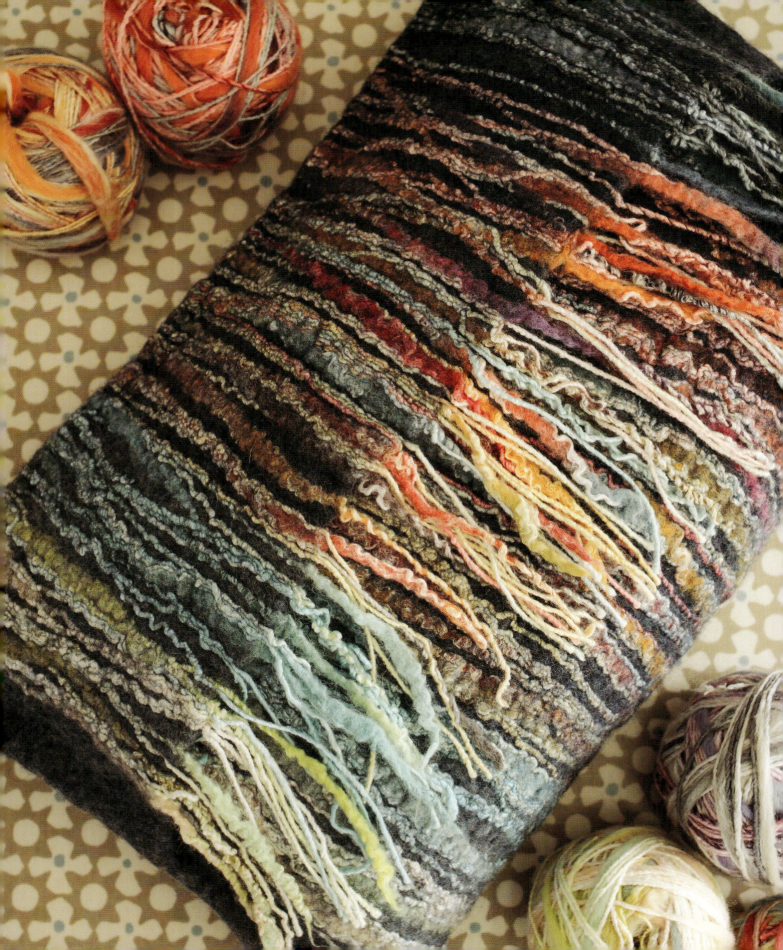

CHAPTER 8

TEMPLATE AND TABLES

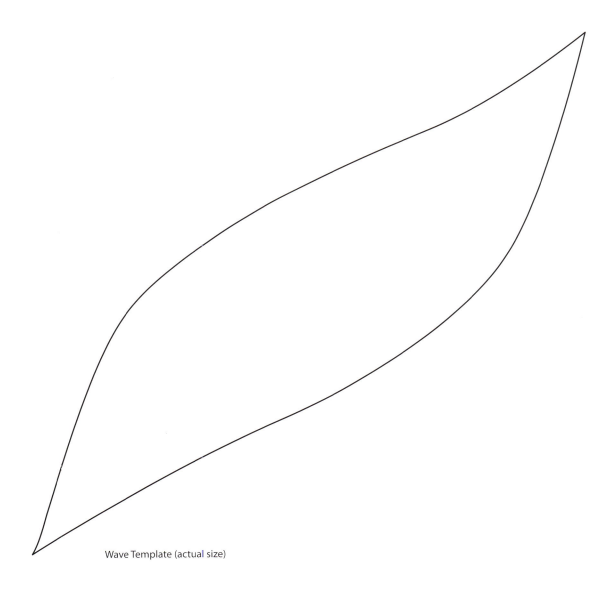

Wave Template (actual size)

CONVERSION TABLES

Length: Metric to Imperial

Centimetres	Inches (Decimal)	Inches (Fraction)
0.1 cm (1mm)	0.04 in	3/64 in
1 cm	0.39 in	25/64 in
2 cm	0.79 in	25/32 in
3 cm	1.18 in	1 3/16 in
4 cm	1.57 in	1 37/64 in
5 cm	1.97 in	1 31/32 in
6 cm	2.36 in	2 23/64 in
7 cm	2.76 in	2 3/4 in
8 cm	3.15 in	3 5/32 in
9 cm	3.54 in	3 35/64 in
10 cm	3.94 in	3 15/16 in
20 cm	7.87 in	7 7/8 in
30 cm	11.81 in	11 13/16 in
40 cm	15.78 in	15 3/4 in
50 cm	19.69 in	19 11/16 in
60 cm	23.62 in	23 5/8 in
70 cm	27.56 in	27 9/16 in
80 cm	31.5 in	31 1/2 in
90 cm	35.43 in	35 7/16 in
100 cm (1m)	39.37 in	39 3/8 in

Weight: Grams to Ounces

For simplicity's sake, I've only included weights in grams (g) throughout this book. So below is a basic conversion table you may find useful if you need to convert grammes to ounces (NB These have again been rounded up or down).

Grams	Ounces
1 g	0.04 oz
2 g	0.07 oz
3 g	0.11 oz
4 g	0.14 oz
5 g	0.18 oz
6 g	0.21 oz
7 g	0.25 oz
8 g	0.28 oz
9 g	0.32 oz
10 g	0.35 oz
20 g	0.71 oz
30 g	1.06 oz
40 g	1.41 oz
50 g	1.76 oz
60 g	2.12 oz
70 g	2.47 oz
80 g	2.82 oz
90 g	3.17 oz
100 g	3.53 oz

Glossary

Wool terminology can be interchangeable (especially between countries), so here is a brief guide to some of the main terms as used in this book.

Batt fibre: fibre (usually wool) that has been cleaned and brushed in a process called carding to create a sheet or **batt** of fibre, in which the fibres are all laying in different directions. Also synonymous with **carded wool**, **carded batt** and **carded fleece**.

Carded batt: *see* **batt fibre**.

Carded fleece: *see* **batt fibre**.

Carded wool: as a general term, wool fibre which has been cleaned and brushed in a process called carding. Also synonymous with **batt fibre**.

Felt: a non-woven fabric comprising interlocking wool fibres.

Felting: is a general term for making felt. As a specific term, the **felting** stage is the first stage (of two) during the wet felting process, when the scales on the wool fibres lock together and the fibres start to bond to create a very loose fabric (called **prefelt**).

Fibres: the individual wool (or other material) strands.

Fleece: the unprocessed wool shorn from a sheep.

Fulling: the second stage of the felting process when the wool fibres bond together completely and, as they grab each other more tightly, the loose **prefelt** shrinks to create a firm felt fabric.

Laminated felt: *see* **nuno felt**.

Nuno felt: wool fibre felted into cloth to create a new combined and completely integrated fabric, also known as **laminated felt**.

Pencil roving: a thin, pencil-thickness continuous length of unspun tops fibre or pre-yarn, often used to spin yarn.

Plant fibre: any fibre originating from a plant, such as viscose, bamboo or flax.

Prefelt or pre-felt: a sheet of wool felt that has been only partly felted. The fibres have started to felt together, but the fulling/shrinking stage has not yet occurred.

Protein fibre: any fibre originating from an animal, such as wool, mohair or silk.

Resist: a template shape or form made of plastic or another non-feltable material used between fibre layers to stop them felting together, to create hollow or pocket-like felted shapes.

Roving: *see* **tops fibre**.

Sliver: a narrower, flat length of batt fibre.

Tops fibre: fibre (usually wool) that has been processed a stage further than batt fibre to comb it into long tube-like lengths, with the shorter hairs removed and all the remaining longer fibres combed neatly in one direction. Synonymous with **roving**. NB Other protein and plant fibres can also be processed into tops form.

Wet felting: the general term for the process of applying water, friction, soap and heat to wool fibre to create **felt**.

Wool fibre: the general term for processed wool of any kind.

Wool yarn: wool fibre that has been spun into thin, twisted lengths of wool for knitting, crochet and weaving, etc.

Useful Resources

SUPPLIERS OF FIBRES AND WET FELTING EQUIPMENT

Although most of these suppliers are UK-based, please note that they all deliver internationally.

UK

Adelaide Walker
Unit 22, Town Head Mills, Main Street, Addingham, Ilkley, West Yorks LS29 0PD
www.adelaidewalker.co.uk

Barn2Yarn
Stotfold, Hertfordshire
www.barn2yarnshop.com

Norwegian Wool
2 New Street, Carnforth, Lancashire LA5 9BX
www.norwegianwool.co.uk

Wingham Wool Work Ltd
70 Main Street, Wentworth, Rotherham, South Yorks S62 7TN
www.winghamwoolwork.co.uk

World of Wool
Unit 8, The Old Railway Goods Yard, Scar Lane, Milnsbridge, Huddersfield, West Yorks HD3 4PE
www.worldofwool.co.uk

Europe

DHG Shop
Prato, Italy
www.dhgshop.it

Piiku
Piesalantilantie 17, 41900 Petäjävesi, Finland
www.piiku.fi

Schapenvacht en Lifestyle
Hoogstraat 32, 3962ES Wijk bij Duurstede, Holland
www.schapenvachtenlifestyle.nl

Wollknoll GmbH
Forsthausstraße 7, 74420 Oberrot-Neuhausen, Germany
www.wollknoll.eu

Australia

Fibre Arts Shed
Jilliby NSW
www.fibreartsshed.com.au

Highland Felting and Fibre Supplies
Deloraine, Tasmania
www.highlandfeltingandfibresupplies.com

Kraftkolour
Unit 2, 99 Heyington Ave, Thomastown, Victoria 3074
www.kraftkolour.net.au

Sally Ridgway Designs
P O Box 683, Quoiba, Tasmania 7310
www.sallyridgway.com

Unicorn Fibres
Churchlands, Perth
www.unicornfibres.com.au

Canada

Custom Woolen Mills Ltd
30453 Range Road 27-2, Alberta
www.customwoolenmills.com

Legacy Studio
212 West Terrace Point, Cochrane, Alberta T4C 1S1
www.legacystudio.ca

The Olive Sparrow
19 Waterman Avenue, Suite 202, Toronto, Ontario M4B 1Y2
www.theolivesparrow.com

SUPPLIERS OF OTHER MATERIALS AND EQUIPMENT

Bag Hardware
www.blossombitsandbags.com
www.trimmingshop.co.uk
www.valuebeltsplus.com

Lampshade Kits
www.dannells.com

Wool Yarns, Haberdashery, Crochet/Knitting
www.purplesheepyarns.co.uk
www.universalyarn.com
www.woolwarehouse.co.uk

For most of the non-felting-specific materials (for example, bag straps, embroidery hoops, magnetic clasps, and so on) and equipment (for example, plastic bowls), also visit online sites such as Ali Express, Amazon, eBay and Etsy.

USA

Big Sky Fiber Arts
Montana
www.store.bigskyfiberarts.com

HeartFelt Silks
243 Third Street, North
Bayport, MN 55003
www.heartfeltsilks.com

Living Felt
2440 E, US-290, Ste E1, Dripping Springs, TX 78620
www.feltingsupplies.livingfelt.com

Mohair and More
231 Gibbs Street, Hwy 150, New Waverly, TX 77358
www.mohairandmore.com

You will also find lots of independent smaller-scale fibre suppliers based worldwide on **Etsy** (www.etsy.com) and elsewhere online.

FURTHER INFORMATION AND RESOURCES

Books
There are numerous wet felting books available, many of which focus on a specific technique. For an excellent all-round and in-depth grounding in all aspects of wet felting, I highly recommend *Uniquely Felt* by Christine White (Storey Publishing, 2007).

Websites

International Feltmakers Association (IFA)
The International Feltmakers Association is a not-for-profit organization established to promote felt in all its forms. Membership offers access to a wealth of information and education about all aspects of feltmaking worldwide and includes a quarterly magazine, *Felt Matters*.
www.feltmakers.com

YouTube is an incredible resource with hundreds of wet felting videos showing you how to make a variety of felted items in a variety of different ways.
www.youtube.com

Further information about Natasha Smart's in-person and online wet felting workshops and tutorials is available online.
www.natashasmarttextiles.co.uk

Main Project Guide

Flat Felt Sample

Hoop Wall Art Project

Seascape Lampshade Project

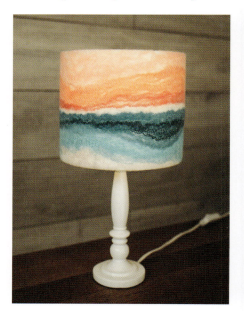

Nuno Silk Scarf Project

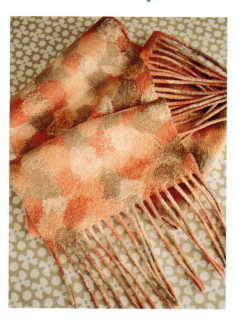

Fringed Clutch Purse Project

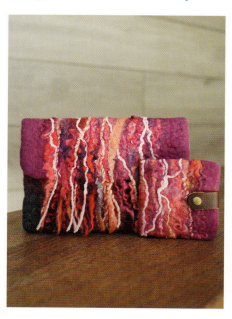

Wave Journal Cover Project

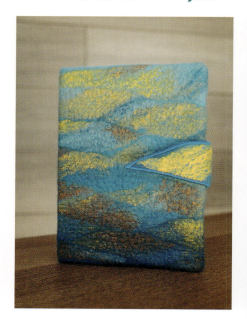

Silk Stripe Cushion Cover Project

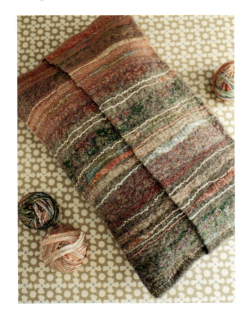

Art Batt Bowl Project

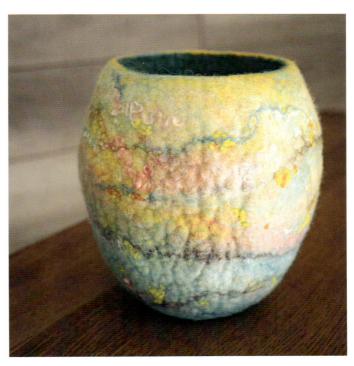

Cross Body Bag Project

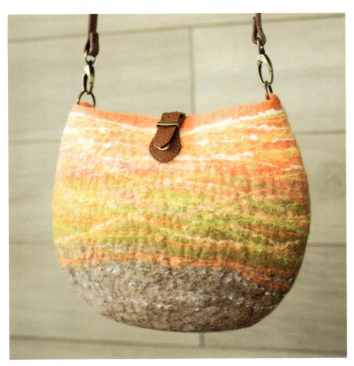

Yarn Basket Project

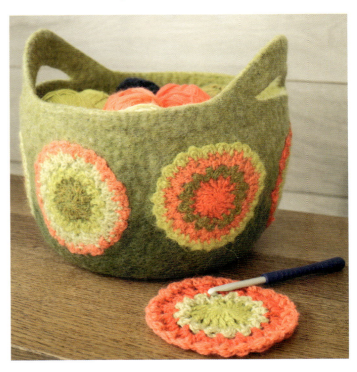

Index

art batt 15–16, 47, 114–115, 117, 132

batt fibre 12, 36–39, 79, 99, 112–115, 117, 125, 135
Bradford count 12

colour mixing 40, 76, 125
corners 33, 95
crochet 14–15, 52, 115, 124, 135, 144
curly wool locks 14, 52, 79, 115, 117, 122

edges 30, 33, 83, 94

felting ball 20, 24, 38–39, 111–115, 117, 125, 135, 150
felting stage 7, 23, 27–28
Finnwool 12–13, 36, 52, 77, 79, 99, 108, 115, 117, 122–125, 132–133, 135, 149
fulling stage 7, 22–24, 28, 32, 40–42

layouts 34–39, 76, 112–115, 149–150
 Chevron 35
 Overlapping Tiles 28–30, 34, 47, 87
 Stretched-Out 34, 55, 63
 Papier Mache 37–39, 112, 114, 117, 125, 135
 Patchwork 37, 79, 99

Maori 12, 132, 135, 140
Merino 11–13, 28–35, 45, 47, 52, 55, 61–63, 73, 87, 97, 112, 117, 149
microns 12

nuno felting 13, 17–18, 22–23, 34, 40, 62–63, 99, 144, 147, 151

pinch test 33
plant fibres 16, 18–19, 115
prefelt 7, 13–14, 27–28, 52, 61, 84, 87, 144–146
protein fibres 15–16, 18–19, 115

resists
 closed 77, 87, 99
 flat/two-dimensional 20, 75–77, 79, 87, 99, 111–112, 123, 125, 144–145
 open 77, 79, 99
 three-dimensional 20, 24, 111–113, 117, 125, 135
reverse percentages 41

shrinkage 20, 40–42, 47, 63, 77, 87, 112–113
silk fabric
 Margilan silk 17
 sari silk 17, 62, 99
 silk chiffon 17–18, 63

silk fibres 15–16, 18–19, 117, 133
surface design embellishments/materials 13–19, 40, 42–43, 112–113
surface design techniques 18–19, 47, 52, 55, 61–63, 79, 87, 99, 108, 114–115, 117, 122–125, 132–133, 135, 140, 144–147
synthetic
 fabric 18
 fibre 16, 47, 52, 115
 yarn 16–18, 47, 115

templates
 card 20, 61, 87, 97, 153
 foam 20, 75–77, 79, 87, 99
tools/equipment 19–25
tops fibre 11, 28, 34–35, 45, 47, 55, 63, 87, 112, 115, 144

viscose fibre 13, 16, 18–19, 47, 55, 61, 63, 87, 97

wool nepps 15, 117
wool yarns 14, 47, 52, 79, 108, 114–115, 122, 124–125, 135, 140, 144, 146, 149–150